ON ART
AND
ARTISTS

Also by T. G. ROSENTHAL

Jack B. Yeats, 1964.
(with Alan Bowness) *Ivon Hitchens*, 1973.
(with Ursula Hoff) *Arthur Boyd*, 1986.
The Art of Jack B. Yeats, 1993.
Sidney Nolan, 2002.
Paula Rego: the complete graphic work, 2003; revised and enlarged, 2012.
Josef Albers Formulation: articulation, 2006.
L. S. Lowry: The Art and the Artist, 2010.

ON ART AND ARTISTS

Selected Essays

T.G. ROSENTHAL

With a Foreword by
WILLIAM BOYD

UNICORN PRESS LTD

First published by
Unicorn Press Ltd
66 Charlotte Street
London W1T 4QE

in association with
the Bridgewater Press

ISBN 978 1 906509 55 2

Designed by Camilla Fellas
Printed in the United Kingdom by
TJ International Ltd, Padstow, Cornwall

CONTENTS

With love for Ann, Adam, Daniel, Bruno and Arne, who for many years sustained an always difficult human being through failing health which has resulted in my coffee mug bearing the legend 'Grumpy Old Man'.

ACKNOWLEDGMENTS

A publisher can rarely have a more difficult author than one who is himself a publisher and who is, on grounds of age alone, even more experienced although not wiser. I therefore apologize to Hugh Tempest-Radford for all the hoops I made him jump through.

Having edited other people's manuscripts for over half a century I salute Emily Lane, an old friend and former colleague, who repeatedly saved me from error in her meticulous editing of my essays.

FOREWORD BY WILLIAM BOYD

Vladimir Nabokov, no lover of critics – and yet no mean critic himself – had this to say about the profession: 'The purpose of a critique is to say something about a book the critic has or has not read. Criticism can be instructive in the sense that it gives readers, including the author of the book, some information about the critic's intelligence, or honesty, or both.' It's the second sentence that has most bearing on this wonderful collection of essays by T. G.Rosenthal (whom we will dub TGR for the purposes of this introduction). The title says it all very straightforwardly: these are critical essays on art and artists TGR knows or admires (sometimes both). Their focus is largely on what art auctioneers term 'Modern British', a loose term that covers most British art of the 20th century, now that we are firmly into the 21st. 'Contemporary' is reserved for the currently faddy and briefly new – to paraphrase Robert Hughes. British 20th-century artists have not fared well when measured against their peers and rivals on the continent of Europe or across the Atlantic. Where, in the first few decades of the 20th century, is the British Picasso or Matisse, one might wonder? Or even the British Edward Hopper or Jackson Pollock? British art has always seemed somewhat parochial and safe – a bit like British music of the 20th century: competent but not mould-breaking; thoroughly enjoyable but not blood-stirring; technically assured but not challenging or controversial in any way.

These are generalisations, of course, and there are no doubt a few exceptions that could be advanced to attempt to argue otherwise. But such plaintive voices are rare and I think it would be fair to say that this mildly patronising attitude reflects the consensus of international artistic opinion – perfectly good but not outstanding, being the broad note. British art is a placid oxbow lake when set beside the wide foaming torrent of creativity to be found abroad.

Personally, I've always felt that this demotion into the second division of the artists' league table has been unfair. British art of the 20th century deserves a more studious and forensic examination. It has consistently been under-appreciated and therefore undervalued (sale prices being the great initial arbiter of a work of art's worth). One of the delights of reading TGR's essays is to see that this is a point of view he powerfully upholds – even though, I have to remind myself, that of the ten artists that are the subjects of the bulk of the essays in this volume two are Australian, one is Portuguese, one is Irish, and then there is August Strindberg. Arthur Boyd, Sidney Nolan, Paula Rego and Jack B. Yeats are not British, true, but it's fair to say their reputations were made in this country, to a large degree, and so they can be included in the conspectus of British

art. It's through that lens that they are scrutinised and evaluated. What makes TGR's thinking about these artists more rewarding is that in many cases he knew the subjects personally or had an acquaintance with them that goes beyond the tunnel-vision of critic commenting on artist. TGR, as these essays testify, is a man of wide culture, as well. There is nothing of the pinched academician about his world-view, nothing of the vainglorious aestheticism of the scholar possessively ring-fencing his small area of notional expertise. TGR loves art, literature and music, but he also relishes society's gossip, sport, fine wine and a good cigar. He can write a sentence about Benjamin Britten, Sidney Nolan and Patrick White (in the context of an unwritten opera) with effortless authority and, equally, pass assured judgment on the elegance of David Gower's off-drive. There is an urbanity and a worldliness (not the same thing) about his take on art and artists that is extremely rare in this day and age, and these essays illustrate the huge advantage of being fully engaged in the world and its multifarious business. 'More is more' in this case – to contradict the usual adage. Art seen in its full cultural and human context is all the better for the wide-screen view: Panavision, in this instance, is far more discerningly revealing than the pinhole camera.

However, to read a critic whose opinions you largely share can be a little dangerous, on occasion – the complacent reader seeing the critic's judgment as a confirmation of his own excellent taste rather than a common disinterested appraisal. In my case this is particularly true when I read TGR on Michael Ayrton. I'm a great admirer of Ayrton (and own a few of his drawings and small oils) yet I'm fully aware that Ayrton is still something of a controversial, not to say pariah, figure in the history of British 20th-century painting. The envious, pusillanimous sneers that affected his reputation during his short lifetime can still be heard today. TGR's essay on Ayrton is both the best defence and the best vindication of this complex artist's superabundant gifts and his posthumous merit that I have read. Ayrton's real and original *donnée*, it seems to me, now that some time has passed since his death, was in his sculpture – though he was a brilliant and idiosyncratic draughtsman as well. His drawings are as incisive and individual as Schiele's. TGR sums up the Ayrton problem with great insight and shrewdness. Ayrton was a 'Painter – sculptor – draughtsman – engraver – portraitist – stage designer – book illustrator – novelist – short-story writer – essayist – critic – art historian – broadcaster – film-maker ... he had also prodigious gifts as a clubman, a wit, a conversationalist and a friend.' But of course in 'Pudding Island', as Laurence Durrell referred – with understandable bitterness – to the

British Isles, to be a polymath in the Ayrton mode was a kind of artistic suicide. Maybe this is our cultural problem as a nation, and maybe this explains why our artists labour under slights and misconceptions, whereas elsewhere such burgeoning, rich profligacy would have been seen as an incredible boon. 'Versatility', as TGR refers to the capacity to excel in different media, is a question of individual artistic temperament, surely, and one is baffled as to why it should be deplored. Would we have preferred Picasso not to have spent time in Vallauris, for example, dabbling in ceramics? Would we have wished that Hockney had never picked up a Polaroid camera? Or, as TGR shows in his essay on Strindberg, the playwright's reputation is indeed enhanced and underscored by the fact that he was a painter as well. TGR analyses the problem with dry acuity: 'as any student of English culture and society knows, the greatest crime is to be too clever by half. ... If you really are brighter than the other fellow you'd better not show it and if you want to get ahead, keep your talent under your hat for as long as you possibly can.'

Jack of all trades, master of none. TGR's essay on Ayrton proves the lie here; and in his essay on another underrated English painter, Ivon Hitchens, he shows how, for another type of artist, dogged persistence – the constant reworking of a familiar theme – is equally exemplary. Both studies are models of the essay as corrective reassessment. TGR knew both artists personally and so brings a level of understanding to his analysis that the common-or-garden art critic simply cannot. Both artists bloom afresh in the light cast by TGR's particular revisionism; both artists can be seen anew in the glow of such constructive criticism.

But there is another test for the TGR aficionado. I happen to admire almost all of the artists TGR treats in this selection of essays. Almost all. Heretical statement though it may be, TGR's taste and mine diverge when it comes to the case of L. S. Lowry. I'm wholly with him on Ayrton and Hitchens; I concur in his reassessment of Wyndham Lewis (another polymath); Paula Rego – super artist; Arthur Boyd (no relation) and Sydney Nolan – yes, absolutely. Jack Yeats – I see what he's getting at. But... Lowry...

Lowry is one of those artists who suffer terribly from over-familiarity. From tea-towel to greeting card, from wrapping paper to tourist brochure, from placemat to oven glove, the Lowry world has become as omnipresent as Mickey Mouse's. No benefit accrues to the artist's reputation thereby. The same problem is sometimes apparent when any artist's work is viewed collectively, as in a retrospective. Works of art that shine individually can diminish when seen beside another hundred broadly similar canvases.

Lowry, perhaps more than any other artist of his time, has suffered from the explosion of the Lowry 'brand' to such an extent that he has become a Salford Jack Vettriano – the Bernard Buffet of North-West England.

Consequently I came cautiously to TGR's admiring essay on Lowry. Lowry seemed an unusual addition to a list of artists whose integrity was unquestioned – even if their reputation had declined, in some cases. And maybe this is, for me at least, the vindication of TGR's critical potency. TGR met Lowry on a few occasions; he interviewed him for the radio; he even had the opportunity to visit Lowry in his studio, and he is a great champion of his merit as an artist of the first rank. Here is when critic and opinionated reader lock horns. Who will give ground? In this instance I happily yield to TGR: as a result of everything he writes about Lowry I am now going to look again at the artist's work with new intensity and new insight. This, it strikes me, is the benevolent function of criticism – perhaps its essential function. A really good critic will make you think twice, or thrice, will make you cast prejudices aside, will make you appreciate things you thought were forever beyond your cultural pale.

On Art and Artists also contains three 'personal essays'. Two of these deal with people who were vitally important influences and presences in TGR's life. In the third of these essays, 'On Anti-Semitism in England', TGR reminds us that he is the child of refugees from Hitler's Germany, that he is a 'German Jew'. I wonder if this legacy is his great blessing. On occasions it's an enormous asset to feel you are still something of an outsider in the country that you claim as your own. In some ways TGR seems as typical a member of the English intellectual establishment as you could imagine – eminent publisher, art historian, former army officer, member of the MCC and the Garrick Club, etc., etc. – and in some ways he is resolutely not. And perhaps this slightly skewed angle on the place he calls home gives his comments on our artistic life a unique resonance. As a result, *On Art and Artists* also stands as a form of intellectual and cultural autobiography of T. G. Rosenthal – which can only add to its fundamental importance. Those of us lucky enough to know TGR – Tom – will hear his rich, bass voice echoing in every line. Those readers who haven't had the pleasure of making his acquaintance will have the privilege of being able to discover a little of what makes up this remarkable man and his remarkable mind.

INTRODUCTION

For more than half a century as publisher and writer I have expressed scorn, even contempt, for the habit of publishing one's own essays. As a publisher I have groaned at the circumlocutions I have had to use to prevent authors from this deplorable habit; as a writer I have almost invariably written off such publications as mere vanity which, in a normal human being, should be repressed.

But repression, as Freud has taught us, is not necessarily a good thing, and, come to think of it, Freud, whom I still revere and have frequently consulted and used to illuminate critical points in my own writing, occupies a yard or so in my reference library with his twenty-four volume collected works which consist, I would guess, of at least 75% of essays rather than full-length works. And, from a commercial point of view, one can hardly ignore the wild best-selling success of the bits and bobs that constitute the weekly effusions of Jeremy Clarkson in the *Sunday Times*. I am constantly both astounded and depressed that the British reading public should want to preserve such froth in volume form and that it should outsell Booker and Costa prize-winners.

And, having over the years published several thousand books and reviewed several hundreds, I know it's dreadful even to contemplate a writer's collected book reviews... Pelion upon Ossa seems the politest comment.

Furthermore, in all fairness, there are some writers whose essays are so brilliant that not to publish them in book form is itself a literary crime. Having had the honour of publishing a large part of Herbert Read's opus, much of which is in essay form, and having, for a long period, issued at four- or five-yearly intervals massive volumes of dazzling essays and reviews by John Updike and Gore Vidal, I recognise that clearly circumstances alter cases. Sadly one has to note that all three such brilliant essayists are dead; the only heir Vidal had was Christopher Hitchens, and he has now also departed.

So why do I have the gall and the temerity to reprint just a few of my own essays? This is not a rhetorical question. In the first place it is only my *selected* essays. If I include my scripted as opposed to extempore broadcast essays I have probably topped a thousand pieces, perhaps more. A thousand is only twenty a year for fifty years but you would have to have a doctorate in vanity even to contemplate publishing the lot, let alone invite comparison with the dead masters mentioned above.

On the subject of essays I am a firm believer in the two monsters that Cyril Connolly in that wonderful, self-revelatory autobiography and *vade mecum, Enemies of Promise,* warned every writer against: the pram in the

hallway and the writing of any piece of less than two thousand words. Since I have wife, children and grandchildren I have frequently stumbled over the pram in the hallway, and as for the two-thousand-word target, it has all too often been overtaken by book reviews of less than one thousand words and, indeed, opera reviews of four hundred.

The reader who has persevered thus far will perhaps be relieved to know that, apart from the deletion of plate references when there were no plates to be seen, changing 'this century' to 'the twentieth century' and revising any numbers such as prices to a contemporary level, I have followed the original printed text except where I've added a necessary note.

The alert reader will notice some repetitions of Ayrton material in the Wyndham Lewis essay. I make no apology for this, since the two essays were separated by more than three decades and each was quite carefully structured, so that the omission of some Ayrtoniana would damage the impact of the Lewisiana and vice-versa.

So, in short, why this book? I think that, of all the many essays I have written, these are the most interesting for both the art historian and the art lover in the general public. Also, with the exception of the portrait of L. S. Lowry (which is currently available as the first chapter of my book *L. S. Lowry: The Art and the Artist*), all these pieces are not only long out of print or available only in publications which are either very difficult to access (such as the Nolan essay) or from defunct or obscure magazines. Where they are taken from particular art books one encounters one of the great problems of art book publishing: no matter how good or beautiful or important they are, for reasons of cost, they can very rarely be reprinted. Consequently specialist art booksellers mark up the prices very severely: for example, the Hitchens book to which I contributed can, if located at all, be nearly four hundred pounds.

For what it is worth, since I could not come up with any satisfactory order for the table of contents, I have set the titles out in alphabetical order and I append below the circumstances surrounding the original publication and any other minor nuggets of information that might be relevant.

Michael Ayrton

This was commissioned from me by the then co-editor of *Encounter* (now, alas, defunct) at a dinner party just after Ayrton had died, late in 1975. Melvyn Lasky had posed the question why Ayrton had had such a scrappy and uneven reputation, a position I vigorously challenged, whereupon Lasky asked me to write a piece on him for *Encounter*. This I agreed to both

readily and anxiously on the grounds that I felt I knew him too well for the necessary objectivity. I was his publisher and he had loyally followed me from Thames & Hudson to Secker & Warburg. We were close friends and he was in many ways a mentor to me, and as I lacked an older brother, he fulfilled that role for me too. Such was the nature of our friendship that the only non-family members permitted to attend the funeral in the country were a distinguished ambassador and me. I had arranged a company car and driver to take us to the ceremony. The car arrived and five minutes later the ambassador. As soon as he entered my office my phone rang and it was one of Michael's step daughters to say that the funeral was off because her mother, Michael's widow, had just tried to kill herself. It was about eleven in the morning and I pressed the buzzer under my desk which signalled to my secretary that she had to drop everything and rush into my office to rescue me from an importunate visitor or long-winded person on the telephone. She rushed in and was appalled to find two middle-aged men in floods of tears; when I was able at last to speak I asked her to bring in two glasses and a bottle of whisky, a task she managed in half a minute. Since Elizabeth Ayrton was a novelist and leading authority on English food and hence a superb cook and Michael was not only a great but sober drinker of whisky, the ambassador and I consumed the bottle by a late lunchtime. We then decamped to that great restaurant, once the home of Wyndham Lewis and the Vorticists, the White Tower (alas, now also defunct), and lunched with far too much wine. Neither of us made our way back to our office after a two-person wake which I believe the two Ayrtons would have much enjoyed.

Arthur Boyd

While at Thames & Hudson, I had published the first big monograph on Arthur Boyd, by Franz Philipp, but so prolific was Boyd's later work that by that time I was running Secker & Warburg. Arthur, whose publisher I had become, felt that a more up-to-date book was necessary. So another distinguished Australian art historian was commissioned to write it. She did and it was a first-rate piece of Australian art history and a proper scholarly interpretation of Boyd's work. We both read it and then met for lunch to discuss it. Arthur, for all his brilliance, could be, when he wanted to be, a major verbal bumbler who hated to indicate a lack of satisfaction. So, after his halting mutterings began to dry up, I interrupted and said 'Arthur, what you mean to say is that, for all its impeccable scholarship, it's not very exciting and if you weren't such a good bloke, you'd say it was downright dull.' There followed another two or three minutes of dithering

bumbling before this great artist and superb intellect grinned and said, 'Yes. That's exactly what I meant.' So I responded by suggesting that we took Hoff's text exactly as it was but got an introductory essay from someone else who could provide some personal insights and some direct analysis of individual masterpieces.

There followed a few more minutes of Arthur's genuinely delightful bumbling, ending with his categorical statement that the only person he would consider for this task was sitting opposite him and would I please do it. I had no choice; although I was the undisputed boss of Secker & Warburg, I explained to Arthur that I would not, could not, do this if my editorial colleagues thought it a bad, because somewhat incestuous, idea. Arthur saw the point but, when I put his wishes before the firm's next editorial meeting, my senior and most sophisticated colleague said at once 'Of course you must do it. Everyone knows that people who buy art books always read the introduction, always look at the colour plates and never read the main text'. Hence the inclusion of my contribution to the Boyd book, which had followed me from Secker's to my new home running André Deutsch Ltd.

Ivon Hitchens

A long friendship with Hitchens began with a favourable review by me in *The Listener* followed by a long and searching letter from the artist. Unsurprisingly, he agreed with some of what I had written but, in a wonderfully civilized and highly literate manner, he challenged some of my views and interpretations. A meeting followed and a close relationship ensued with visits to my house by Ivon and Molly and, more importantly, a series of visits to Hitchens's almost unfindable Sussex rural fastness. To penetrate that was to enter his painterly territory in a quite literal manner. There was the jungle that surrounded the low, long and chaotic house. There was the pond, complete with crumbling boat. There was the improbably gigantic forest of luxuriant and immense rhododendrons and, more importantly, a fully furnished caravan.

The studio was huge and, allowing for the different materials involved, was also jungle-like, with hundreds of canvases, most unfinished, many with their faces turned to the walls. As is well, if not notoriously, known, Hitchens had a frame fetish and no picture was allowed out of the studio without a frame meticulously designed by him so as to show the painting precisely as he envisaged it and created the desired effect upon the viewer. At dinner I asked him why he painted, relative to his outflowing of landscapes, so few nudes, since those he managed to do were so dazzling.

His response was swift and more or less irrefutable. 'Oh, it takes several days to do a good female nude, for which you need a good model, and very few women are prepared to stay in the jungle here when there's absolutely nothing to do but pose, eat and sleep.'

At this point my wife intervened and, knowing that I was shortly to go on a three-week business trip to the United States and Canada, said that she would be proud and happy to model for him. Ivon accepted with alacrity. Ann took a few days' holiday time owed by her employers and spent a week in the caravan. Ivon was sufficiently pleased with the result to give Ann, as her sitting fee, a full-size, perfectly framed à la Hitchens, oil sketch, in effect an unfinished but otherwise beautiful picture which, to this day, hangs in my bedroom.

Thelma Hulbert
The origins and progress of this article are fully revealed by its contents.

Wyndham Lewis
The title represents only a tiny fragment of the article. I never knew Lewis, but had studied him and had a long publishing relationship with his estate, and had absorbed much Lewisiana from his long-term amanuensis, my friend Michael Ayrton, so I had joined the Wyndham Lewis Society. Because of this I began to absorb various minutiae of Lewis's life and work. I realised that in an interest in Lewis sparked by the Third Programme in the 1950s, with a marvellous radio dramatization of *Tarr* starring Stephen Murray, I had picked up several minutiae of my own. I thought I should record them in the Lewis Society's scholarly journal so that, trivial as several of the minutiae indubitably are, as a whole they might one day seem useful to more experienced Lewis scholars than myself. I was also, of course, drawn to the subject by my own accession to the post of art critic of *The Listener*, a position previously held by Lewis.

L. S. Lowry
Although this is readily available in print, being the first full chapter of my book *L. S. Lowry: The Art and the Artist*, I include it because it is the article in my entire *œuvre* which best represents the personality and thought processes of a truly interesting and considerable painter.

The piece is a kind of palimpsest, composed of an article which appeared in *The Daily Telegraph*, conversations either tape-recorded or recollected in memory from private visits and encounters, and extracts from a long interview for the Third Programme produced by Anthony Thwaite and a

full-blown Third Progamme symposium. The solo interview attracted the
highest audience rating for a radio broadcast talk in the month it went out
on air. The symposium was produced by Philip French and was compiled
and presented by me with valuable collaboration from my wife, who drove
me around the country – thus having her first experience of life north of
Watford as we visited Herbert Read in Yorkshire and encountered Lowry
in his holiday hideaway in Northumberland. Other contributors included
Sir Ernst Gombrich, Sir John Rothenstein, Edwin Mullins and Michael
Ayrton.

Sidney Nolan

This, the longest essay in the book, has appeared, in edited form, in a
private press limited edition published in 2002 as part of the Benjamin
Britten centenary celebration. On the principle that in the land of the
blind the one-eyed man is king, I was, as author of the only full-length
and comprehensive study of the art of Sidney Nolan, invited to contribute
a short chapter on Britten and Nolan for a symposium, edited by Judith
LeGrove, on the Britten Pears Art Collection.

I had done some research at The Red House in Aldeburgh, where
Britten and Peter Pears lived, when writing the Nolan book twelve years
ago but had only, for reasons of space, written briefly on the Britten/Nolan
relationship, which had resulted in some notable artistic collaborations and
the acquisition by the Britten Pears Foundation of a lot of Nolan paintings.

Clearly much research in the Britten archive was necessary and my
wife and I arranged to stay for a weekend at The Red House, having got
the Librarian to look out all the relevant material. My professional life,
as publisher and art historian, has given me plenty of encounters with
both fame and genius, but while, alas, I never met Britten, the experience
of living, no matter how briefly, in his house can only be described as
numinous. Furthermore, to have the run of the archive and the chance to
read and handle original Britten material and correspondence was a rare
and extremely valuable experience. Valuable because a certain event, of
which I already knew a little and which I had briefly noted in my Nolan
book, turned into a major cultural event, or, rather non-event whose
collapse before it could get off the ground was probably one of the greatest
arts, or cultural, failures of the 20th century.

To state the obvious, Britten is the greatest British twentieth-century
composer and, together with Janáček, Britten was one of the two operatic
geniuses of the last century. For me, the worst of all operatic *lacunae* is the
failure of Verdi to write, as he so often talked of doing, an operatic version

of *King Lear*. To this, although I haven't the temerity to bracket Britten with Verdi, I would now add the non-existence of an opera destined to open the new, and iconic, Sydney Opera House. It was to be based on Patrick White's novel *A Fringe of Leaves*, with libretto by White, music by Britten, and sets and costumes by Nolan. I have read White's synopsis for the libretto and that's all there is. For further information on this, to me, agonizing non-event you must read my essay.

Paula Rego

This is made up of two catalogue essays for Rego's exhibitions at Marlborough Fine Art in 2011 and 2012.

August Strindberg

This, written in English but originally printed in both English and Swedish, is the 'British Contribution' to the definitive monograph on Strindberg's paintings, published, of course, in Sweden. It was written a long time ago and I still stand by what I have written about Strindberg and Turner. However, I have recently read Sue Prideaux's authoritative biography, which throws a shadow of doubt on whether, when Strindberg went to London, he actually saw any Turner paintings.

Jack B. Yeats

When the publisher Marshall Cavendish was preparing a series of monthly fascicles meant eventually to be a complete painter-by-painter history of world art, their advisory editor was Sir John Rothenstein. He had no particular feeling about Yeats, so approached the dealer who had revolutionised the world's perception of Yeats in search of a useful name. The dealer, Victor Waddington, had noticed that my love affair with Yeats was just beginning and recommended me. In matters Yeatsian I was still a tyro and it was at least two decades later, having published Hilary Pyle's definitive *catalogue raisonné* of Yeats's oil paintings in three massive volumes, that I dared to publish a modest, full-length monograph of my own – which to my quite surprised delight is now in its third edition and still in print. The indefatigable Pyle has meanwhile also published *catalogues raisonnés* of Yeat's watercolours and drawings. I have also included in this volume three essays which have given me great pleasure to write and are, perhaps, useful background material for those who might have some personal curiosity.

The Neuraths

Walter and Eva Neurath created and developed art book publishing to the highest international standing. They were my first employers; I stayed with them for twelve years, and owe entirely to them any publishing skills I may have developed. In the building of Thames & Hudson they have had a profound effect on art and artists and, above all, on enabling the art lover of moderate means to learn from more than a thousand reasonably priced art books. I salute them and their memory.

On Anti-Semitism

This appeared in *The Daily Telegraph*, a newspaper whose treatment of Jews and Judaism smacks strongly of philo-Semitism, a position I have long respected.

I am a secular Jew of atheist persuasion, but as the child of German Jewish refugees I have, via actions and words, had a long experience of anti-Semitism, so that being a Jew is a very important part of my life and one that has, I suspect, coloured much of my behaviour and my character.

The reader might be interested to know that of all the thousand articles I have published this is the one that attracted the most mail in response. Roughly half was favourable and added individual episodes and experiences. The other half was abusive, written in green ink on lined paper with no address, and followed a more or less similar line: 'If you don't like it here after all we've done for people like you why don't you leave the country?'

Matthew Hodgart

So much of one's character is formed, next after one's parents, by one's teachers. Had I been a professional writer while at school – obviously a nonsensical construction – I would have written about two of my teachers, John Tanfield and Douglas Brown, who so brilliantly eased my passage to Cambridge University. The obituary of Matthew Hodgart is here because I am vain enough to believe that it is, *qua* writing, a decent piece of work. It is also here as an act of homage to the university teacher who did the most to stimulate my mind and to do what dons are supposed to do, which is to *stretch* your mind. My knowledge of, and passion for, literature were stimulated by him quite unforgettably. I *salute* him.

MICHAEL AYRTON
– A Memoir

'Why', said the Editor of this journal, 'was he so eclectic?' 'Because', said the writer of this article, faced over a dinner table a few days after Michael Ayrton's death with the need to produce an instant answer, 'he was not educated.' A typical dinner-table exchange? Glib, superficial? Yes, possibly, even probably, but not, I think, certainly. As Ayrton's fellow member of the Brains Trust, Professor Joad, might have put it, it depends what you mean by eclectic and in particular whether that word is used pejoratively; and if eclecticism in the pursuit of originality is no vice, education in the pursuit of learned conventionality is no virtue.

Had Michael Ayrton, the son of a fiercely feminist socialist mother, Barbara Ayrton, and the mildly ineffectual but amiable socialist literary critic Gerald Gould, been fully educated within even the most enlightened sectors of the English system, he would assuredly have been a duller, less original and far less talented man. Fortunately, at the age of 14, he incurred the unfavourable notice of the headmaster of his boarding school who summoned Gerald Gould in a phraseology which caused that worthy man to fear the worst and prepare for yet another pale, rather shameful little episode of the kind of which countless autobiographical sketches and, God help us, whole English novels have been made. When told that young Ayrton had indulged in neither mutual masturbation nor buggery, but had actually slept with a girl, his father was so relieved, not to say delighted, that he removed his son with pleased alacrity. Thus from the age of 14 onwards Michael wandered abroad and became first a teenage autodidact, and then a youthful prodigy, and then a mature and brilliant artist.

Painter – sculptor – draughtsman – engraver – portraitist – stage designer – book illustrator – novelist – short-story writer – essayist — critic – art historian – broadcaster – film-maker. There were probably other artistic functions, but, in the fifteen or so years that I knew him, those were the facets of his work I came to know and admire. As a person he also had prodigious gifts as a clubman, a wit, a conversationalist and a friend. He hated cricket and scorned any *organised* conviviality. But put him at one of the large tables at the Savile Club, or at the head of his own table in that glorious, totally Ayrton-stamped, 13th-century house in Essex where his wife Elisabeth, a notable expert on English cooking, kept their guests in a state of permanent gluttony, and you had a magnetic and irresistible personality.

If ever a man needed a Boswell, it was Ayrton (and if ever a man would have loathed the very idea, it was he). He was a supreme raconteur and anecdotalist, each story honed and polished for maximum suspense,

This memoir appeared in the June 1976 issue of Encounter.

joy, and amusement, but the stories were impoverished without that
mellifluous, ironic voice. Like most substantial artists, he was an egotist;
and he liked to converse because he liked to argue, and to learn, and was
in fact omnivorous for knowledge, craving the didacticism of his peers in
other fields. He loved to shine in company, and could shine anywhere;
but, as any student of English society and culture knows, the greatest
crime is to be too clever by half. It's all part of a British aberration,
fostered perhaps by the dottier followers of the wretched Dr Arnold, that
you must never be seen to be *trying*: if you really are brighter than the
other fellow you'd better not show it and if you want to get ahead, keep
your talent under your hat for as long as you possibly can.

The wit and wisdom of Michael Ayrton were, I think, among the
chief reasons for his lack of true recognition. They were too public, too
flamboyant. A man who can perform in front of a television camera with
greater skill and professionalism than those who are supposed to sit in
judgment over him is not likely to be popular. A man who writes better
about aesthetic matters than those whose principal livelihood it is to do
just that tends to garner not wholly favourable notices. One of my bonds
with Michael was the distrust of most critics, particularly those who wrote
exclusively about art, and his undisguised scorn did him little good with
opinion-makers. For Michael, criticism, like patriotism, was not enough.
As an art critic, I survived with him because the act of criticism occupied
a proper place in my scheme of things. For several years I was a regular
reviewer and, apart from looking at pictures, which was what one did
anyway, the copy was written between lunch and dinner on Sunday and
dropped into the editor's office on Monday morning. It never interfered
with being a director of a large publishing-house which Michael, having
been art critic of the *Spectator*, perfectly appreciated. He would never
accept that a few hundred words a week was a sufficient task for a man; he
knew how it was done, and it was too easy by half.

There is a clue in Michael's relationship to criticism to the relationship
of critics to him. He thought their work essentially simple if not actually
nugatory, and he rarely bothered to hide this. At the same time, because
his mind moved fast and he always wanted to find something new to do,
he rarely gave critics any carefully programmed development to latch on
to; so that even if he had not alienated them with his scorn, he offended
them with, in their terms, an ever-increasing inconsistency.

Thus one had the spectacle of a boy-wonder becoming a prophet without
honour, all in the space of one generation. The obvious explanation is, of
course, the excessive versatility. But if versatility is normally a virtue,

why, in Ayrton's case, should it be a misdemeanour, as it evidently was? (The old English tag, about cobblers and lasts?) Versatility in the visual arts alone would probably have been quite acceptable, indeed encouraged; it was all those other activities that got a bit much. The young Ayrton, having parlayed his expulsion from school into a precocious European grand tour, began his artistic career with a show at the Leicester Galleries in 1942 when he was only 21; and in the same year he collaborated with John Minton in the stage designs for John Gielgud's *Macbeth*. This wasn't a bad start for someone with no formal art training. In the late 40s he painted in Wales with Graham Sutherland, to whom a splendid Ayrton landscape once belonged. Critics like Bryan Robertson regarded Ayrton, together with near-contemporaries like Minton and Sutherland, as among the great white hopes of English painting in the 40s and early 50s. Robertson bestowed on Ayrton what used to be one of the accolades of the English art scene, a Whitechapel retrospective, as early as 1955.

It was an auspicious beginning, but one from which, critically speaking, he never looked forward. Gradually, as he changed dealers (and then, for some years, did without dealers at all), as his work grew and varied and metamorphosed, so his reputation among his friends and admirers expanded and consolidated and his reputation in the world of the visual arts, the world that most mattered to him, dwindled.

He had the temerity to become a man of many media and always with that consummate verbal fluency, that total articulateness which so often left not less intelligent but simply less verbally gifted people floundering. There are still those who prefer their artist types to be incoherent unless they have a brush in their hand.

When I first met Michael Ayrton – we were fellow judges of an appalling painting competition in a small provincial town – we spent our modest fee, a fiver apiece in cash, in the nearest pub on substantial quantities of whisky and, within the hour, were fighting each other for the truest stranglehold on the great Hector Berlioz. Later he was to give me a copy of his book *Berlioz: A Singular Obsession* inscribed simply: 'For Tom, a fellow obsessionist, from Michael, 1969.' The year was the centenary of the composer's death. I brought that arch-Berliozian, David Cairns, the superlative translator of the *Memoirs*, and Ayrton together at my dinner table and watched them trade ever more recondite and arcane minutiae. Michael introduced me to *La Mort de Cléopâtre* and that seductive noise reverberated repeatedly through the Ayrton household at Bradfields (you can't play Berlioz *pianissimo*, even at three in the morning). On the wall was an oil of Hector which Michael had painted with those gimmicky eyes

that appear to follow you around the room. I once told him of a rare full-scale staging of *The Damnation of Faust* in which the set was substantially inspired by Piranesi's *Carceri*, for Michael one of the greatest sequences of engravings in the Western world, and it was a perfect 'Ayrtonian' consummation. In a dazzling short story he created (or, as he would have put it, recreated) in 'An Episode in the Life of a Gambler', an encounter between Berlioz and the condemned poet, gambler, and murderer Pierre Lacenaire, a brief work of considerable deductive scholarship and macabre wit. The Berlioz theme is, in fact, central to any understanding of Michael because it crystallised so many facets of his life and work; the informed passion for music; the great appeal of the Romantic Movement in which his admiration for Piranesi and his influence on the Romantic imagination figured so largely; the worship of the underrated Ingres, whose drawings Michael saw as one of the high points of 19th-century art – in fact, a plural obsession with the giants of that century. His homage took the form of drawings, paintings, bronzes, and also a remarkable BBC Television programme to celebrate the centenary of Berlioz's death. As Ayrton himself wrote, it was 'the realisation of the private dream of a far from fashionable sculptor and painter about the personality and the music of a composer and writer who is only now becoming fashionable a century after his death...'

I suspect that Michael in his later years, if one can speak of the later years of a man wantonly removed at 54, identified more and more with Berlioz, not with the habitual paranoia of the artist (he knows he's a genius, but the world's against him) but with the sense of being so unrecognised and under-rewarded as to feel himself to be an outsider. Berlioz was indeed a Protean outsider, and Ayrton felt himself to be much the same. In a way the association was beneficial because intellectually stimulating; in another, it induced in him a blind spot about the painted results of his singular obsession which, at a crucial stage in his career, adversely affected a major commercial opportunity.

One of his earlier idols was Wyndham Lewis. When the National Book League launched an enterprising series of exhibitions entitled *Word and Image* devoted to the more interesting British writer/painters of our time, it was appropriate not only that they should start with Lewis and Ayrton but also that they should be shown jointly. I wrote the catalogue introduction, and I was struck by one passage from Ayrton's brief memoir of Lewis, 'The Enemy as Friend' (it can be found in Ayrton's last and best collection of essays, *The Rudiments of Paradise*):

in the Redfern Gallery, during his 1949 show... I wandered in to find two silent figures contemplating the exhibits. One of these was Mr T. S. Eliot, dressed with quiet elegance in a blue business suit, stooped like a benevolent osprey and gazing intently at Lewis's early self-portrait. This imposing picture shows the artist gazing stonily out from the canvas and wearing a large, fierce hat. The sole other occupant of the room was Mr Lewis himself, wearing a large, fierce hat and gazing stonily at his own portrait of Mr Eliot, a picture in which the poet is dressed with quiet elegance in a blue business suit...

Ayrton always had a high sense of the absurd; but he also was an exceptionally kind man and went on to record how, when Lewis was blind and luxuries rare, Eliot used to send him champagne (which, together with caviare and walnut cake, evidently comprised his chief solace in his declining years). Wyndham Lewis had once had, to say the least, unfortunate right-wing and anti-Semitic tendencies which he shared with other pillars of the Modern Movement as part of the strange English cultural heritage which believed in the rightness of the Right and the wrongness of the Jews. To Michael, with Zangwill blood in his veins, and with a passionate commitment to a non-Communist, neo-Orwellian Left, nothing could have been more anathematic.

Yet, as is well known, Lewis had recanted, and the friendship between them was such that, for a time, Ayrton was Lewis's visual amanuensis, designing Lewis's book jackets, and letting the great *blind* man choose and, where necessary, describe the alterations he wanted made. In retrospect, Lewis and Ayrton were soul-mates, both hating 'the Enemy', with a violent iconoclasm, switching with ease from pen to brush. Both had superb critical gifts; both saw draughtsmanship as the true beginning of painting; both, by their differing physical afflictions, were hampered in the realisation of a prolific output (although both left, nonetheless, a prodigious amount of material). Both wielded a dreadful scourge when faced with cant, pretension, pomposity or hypocrisy. Both, more than anyone else this century, tried to record faces for our intellectual posterity, Lewis usually with large-scale oils, Ayrton usually with drawings. Significantly, one of Ayrton's relatively few oil portraits, and perhaps the best formal portrait he painted, was of Wyndham Lewis in 1955 shortly before his death. Ayrton and his wife came to offer condolences to Mrs Lewis, and found that workmen had already arrived to tear down the building. In a frenzy they managed to rescue, from a laundry basket, the contents of the disused studio. As Ayrton wrote, 'Among those we rescued was a large pencil drawing of Ezra Pound, with half the head torn away. This half head, in due time, I replaced. It was my last act as a sort of substitute for

the eyes of Wyndham Lewis…' With much of Lewis's angularity, but with his own, spiky, idiosyncratic draughtsmanship, he gave us, with an occasional virtuoso oil such as that of Constant Lambert, superb drawings of Dylan Thomas, Henry Moore, William Golding, Norman Douglas, William Walton, Christopher Isherwood, and many more. Michael was not a formal portraitist in the sense that people paid him; he simply painted or drew those whose personalities or faces particularly interested him (and, preferably, who were friends). As with Lewis, a considerable section of English cultural life, and a characteristically eclectic one at that, will be known, where the camera is not considered enough, by his portraits.

Ayrton combined, to an unusual degree in an artist, generosity for others and an inability to hide his sense of injustice at the lack of recognition of himself and the excess of it, in his view, received by others. For those, such as Moore or Giacometti, whom he idolised and loved, his praise could not be too great. About those of his contemporaries and near-contemporaries with their Tate and Hayward retrospectives and their decorations, he was, often with justice, scathing. Was he jealous of their greater recognition? He simply felt that he had been neglected. An honorary doctorate from Exeter University was slim pickings for three full decades in the public eye. This is not to suggest that he felt superior to his contemporaries; he just knew enough to know what they had done, and how yet, typically, in his own collection he had a not inconsiderable selection of works by his contemporaries.

He stimulated, when I was at Thames & Hudson, the definitive book on Wyndham Lewis's art, and caused me to rescue from oblivion, at Secker & Warburg, Lewis's savage satire of the world of Arnold Bennett and Desmond McCarthy, *The Roaring Queen*. His political passions prompted the publication of the first solid and full-length book on the Colonels and why they were doomed to fail, *Greece under Military Rule*.

As a critic Ayrton was primarily constructive, and revelled in the opportunity of sharing a discovery; and here, again, his eclecticism, springing from his lack of formal education, was valuable. Had he progressed from, say, Cambridge to the Courtauld he would doubtless have published learned articles in scholarly journals which would, inevitably, have been read only by other scholars. As it was, he wrote his articles, gave his lectures, made his broadcasts on a great variety of topics to as wide an audience as possible. In his essay 'The Terrible Survivor'in which there is a learned account of Barna di Siena he wrote: 'I am not a scholar but rather a celebrant', and it's a fine distinction. For a total

understanding of Piero della Francesca one has recourse to the work of the
art historians. But if one wants an insight into the effect upon the viewer
of a key work by that Umbrian genius and of his exact *placing* in that still
timeless world, one must read Ayrton's short, intense, utterly personal
and convincing essay on his own discovery of Piero's *La Madonna del
Parto* in the tiny little hill-town of Monterchi. It was in that spirit also
that he made his one full-scale art-historical effort, a monograph, the
first and most comprehensive (including a *catalogue raisonné*) in English
on Giovanni Pisano. Aided by the enthusiasm of Henry Moore, out of
whom he conjured an introduction, Ayrton brought this relatively little-
known genius to the attention of a far wider public in a subtly written and
comprehensive work. It is a loss to art history that he never had time to
write his projected monumental survey of the art and practice of bronze
sculpture.

But he could also be non-celebratory. He could also, bravely, change
his mind, and it is illuminating to read, in rapid succession, his essays on
Picasso (all available in *The Rudiments of Paradise*, that most eclectic of all
collections) entitled 'The Master of Pastiche', 'A Reply to Myself' and
'The Midas Minotaur'.

The three essays span the three decades of Ayrton's perceptions and
preoccupations. In the first, dated 1944, Ayrton questioned Picasso's at
that time unquestioned eminence and concluded that: 'The whole body
of Picasso's work amounts in my opinion to a vast series of brilliant
paraphrases based on the history of art.' Ayrton in 1956 mildly retracted
some of his strictures but re-emphasised others ; drew a parallel, in terms
of repute, between Picasso and Liszt; and emphasised the talent but drew
the line at the genius. 'The Midas Minotaur', published in 1970, refers
in detail, and with some sympathy but by no means uncritically, to John
Berger's Penguin study, *The Success and Failure of Picasso*, a book which
Ayrton had himself been asked to write. In declining, he had suggested
Berger as a substitute, and Berger, in the first serious, long analysis of
Picasso as less than a titanic and universal genius, inscribed the copy he
sent Ayrton to that effect and wrote to Ayrton that he believed Michael to
be 'a prophetic exception' to the worldwide chorus of adulation.

'The Midas Minotaur' is almost a paradigm of the relationship of
Ayrton to Picasso, of Picasso to the Minotaur, of the Minotaur to Ayrton,
and of Picasso to King Midas. Ayrton's analysis probes the themes of
vigour and weakness, impotence and old age, fame and its curses, asses'
ears and irony, and it looks forward to his last prose work, his novel, *The
Midas Consequence*. The hero of *The Midas Consequence*, a novel published

in 1974 to a strange mixture of derision, hatred, puzzled respect and wary admiration, is a very old and fabulously wealthy artist called Capisco. The anagramatically inclined inevitably identified him with Picasso, but this was facile. Capisco did, of course, have much of Picasso; but, with a nice mixture of eclecticism and egotism, Ayrton had in fact created an artist-hero who contained fragments of Matisse, de Chirico, Henry Moore and himself. He was also, since the author was not exactly a man short of inventive powers, a character in *fiction*, who performs properly invented acts in a book of great ingenuity, using a number of cinematic techniques and devices in a novel whose very framework is the making of a documentary about the artist hero. (The book, incidentally, is dedicated as an act of both friendship and homage to that great documentary film-maker Basil Wright, with whom the ever versatile Ayrton made a film on Leonardo drawings and another on Greek sculpture.)

If, in retrospect, *The Midas Consequence* is a less satisfactory novel than its predecessor, *The Maze Maker,* I suspect the reason is to be found in Ayrton's preoccupation with myth. In *The Midas Consequence* he dealt with modern myth which is no more than fame (and fame in the end, like Capisco's fabulous wealth, is transitory) while ancient myth is, perhaps by definition, sufficiently everlasting and permanent and could bear more readily the full weight of Ayrton's erudite inventiveness. To a contemporary artist like Ayrton the modern titans like Picasso or Moore appeared not so much Minotaurs as minatory. They dare not be imitated, and one runs mortal risks if one comes too close. The genuine mythology of the Classical past is safer and, because more complex, more rewarding. Both Picasso and Ayrton made modern Minotaurs, and I cannot help thinking that is why *The Maze Maker*, which deals, among other things, with the origin of the legendary Minotaur, is a more powerful book, and the identification of author and protagonist/narrator is total:

> My name is Daedalus and I am a technician. This I chose to be. I have made many things in many places and done so cunningly, for that is the meaning of my name. I have constructed buildings and planned fortifications. I am proficient in stone-carving and I can make the forms of Gods in wood, competently joined. I have made many tools to do these things and invented others to make the work simpler and have it better done. Also I can paint images and I am adept at mechanical contrivance. All these things I can do as well as any other, be he who he may…

'The archetypal Maker', in William Golding's phrase, threads the nautilus, constructs the artificial cow in which Pasiphae and the Bull conceive the Minotaur, builds the labyrinth at Knossos, and creates the

wings with which his son Icarus commits his fatal act of hubris. The parallels between life and art are intertwined: like his heroic Daedalus, Ayrton incessantly sought new ways of making and doing things.

If his erudition made him culturally eclectic, his dexterity and his acute feeling for both natural objects and effective materials gave him a magpie-like physical eclecticism. He used the skeletons of birds in paintings and collages, the skulls and bones of animals in sculpture.

All his fiction, the two novels, the prose and verse fragment *The Testament of Daedalus* (the precursor of *The Maze Maker* and, arguably, the best thing he ever wrote) and his collection of illustrated short stories, *Fabrications*, a kind of visual counterpart and homage to Borges's *Ficciones*, dealt largely with artists and their relationship to mythology. Ultimately Ayrton was a mythopoeic figure. Once he had done the conventionally talented work on which his early reputation was built, everything that followed was deeply rooted in mythology and antiquity. A Cretan landscape would contain the shape of a female Cycladic figure; his female drawings became Oracles or the Cumaean Sybil; sculpted figures of bathers or acrobats gave way to the Minotaur or Talos. When he tired of mere figures he turned to mazes, and his most celebrated, and certainly his largest, work is a colossal maze built for an eccentric but enlightened American millionaire; and there it is, at Arkville, superbly impenetrable, and with a life-size Minotaur at its almost unattainable centre. And who's to say who made the grander gesture, Armand Erp in paying for it or Michael Ayrton in constructing it with true Daedalian cunning? Even in his most technically complex sculptures, with their bisected heads, reflecting surfaces, Perspex dividing screens, the emotions were always as powerful as the intellect. His various versions of the Minotaur convey pity and terror and pain. How typical that he should himself describe his creation more succinctly and movingly than a critic could:

> What is a man that I am not a man
> Sitting cramped pupate in this chrysalis?
> My tongue is gagged with cud and lolls round words
> To speak impeded of my legend death.
> My horns lack weapons' purpose, cannot kill
> And cannot stab the curtain of the dark.

Ayrton was clearly fascinated with the nature and ambiguity of man and animal. The Minotaur was the figure that most clearly expressed his pain, while Daedalus and Icarus most deeply expressed his obsession with not merely flight but a quest for a mastery of stress, a desire to

transcend disability and literally take wing. Think for a moment of what
it meant from young manhood onwards to be attacked by a distressing
and crippling form of arthritis that rarely left him free of pain, made
it impossible for him to walk any distance, and, if he wanted to look at
his interlocutor, forced him to turn his entire body to face you, since he
could not turn his neck. No wonder so many of his human figures are
shown in postures of stress: oracles trying to utter, or man trying to take
off. Perhaps also that is why, quite often, and strangely for a man who
loved women (and, particularly, well-rounded women), his female figures
were sometimes oddly ungainly. Curves became angular in the way that
arthritically-attacked bones metamorphose. The standing male figures in
his later period did not always give the impression of being able to run,
or even to walk; they seemed to be rooted in the earth, or trying to escape
from it.

Like any other artist, he took himself seriously but, unlike some others,
he had a capacity for laughing at himself, even for self-mockery, as in that
thoroughly ingenious bespectacled, large warts-and-all self-portrait in his
jacket design for *Fabrications*. He had the wit to attach as an epigraph to
The Testament of Daedalus these lines (from *Henry VI*, Part III):

> Why, what a peevish fool was that of Crete,
> That taught his son the office of a fowl!

Michael had a habit of doing one a good turn now and again while
simultaneously heaving a substantial burden, in the nicest possible way,
on to one's shoulders. Many years ago the co-editor of *Encounter*, in an
earlier life, asked me to become art critic of *The Listener*. The burden
for someone not yet 30, to fill the post once held by Herbert Read and
Wyndham Lewis, was slight compared with Ayrton arranging with
the BBC that I should fill in for him on *Round Britain Quiz* while he
went abroad. Not only did I have to partner Denis Brogan but, said
Michael, 'by God you'd better win!' Well, perhaps because they fed us
easy questions, or because Sir Denis and I had a madly complementary
knowledge of things American, we just managed it by a point or two.
But it was, win or lose, quite impossible to match Ayrton's urbanity and
fearsome erudition, backed as it was by an alarming total recall. (And how
odd, or perhaps how very English, that Brogan's standing as an academic
was never harmed by his quiz supremacy, but for Ayrton the artist to
do the same thing represented a distinct diminution of reputation.) One
last, and poignant, memory. Some time ago he suffered a painful and

undiagnosed illness and very nearly died. He was so ill and drugged that even his closest friends could not see him. During that time the RAF Museum at Hendon was opened and, having two small sons, I became a regular visitor. When, at the very last moment, an intuitive neurologist finally made the right diagnosis, and a particularly vicious diabetes was controlled, I described these visits to Michael and, as the wasted flesh slowly returned and the skeletal man once again became robust, we planned a first excursion together to that splendid memorial to the brave young men and their flying machines. Michael, who despite his immobile neck was (with the aid of a few extra mirrors) an impeccable driver, drove to the great Hendon hangar which, during his recovery, had very sensibly bought one of his best Icarus statues. On the way there and back, and during our rapturous inspection of Sopwith Camels and other aeronautica (about which, inevitably, he discoursed to the Curator who had greeted us, with knowledge and authority), he expounded to me his last, tangential venture.

He had been reflecting on the nature of mirrors and the mirror image. It was his final obsession, and over the next 18 months he explored every conceivable aspect of mirror images: science, philosophy, psychology, literature, music, mathematics, physiology, architecture and art tumbled about in his brain. What first emerged was the script for a 13–part BBC TV series, and the basis of a quite revolutionary book. Michael was the onlie begetter, the scriptwriter, the producer's right hand, and was, with that wonderful, bearded, leonine head and that seductive voice, to be the presenter and interpreter in what was clearly going to be something new in the communication of complex visual ideas to a mass audience. It was the obsessive topic of all our conversations for months as this formidably erudite man, who had not been formally educated, unfolded the *ne plus ultra* of enlightened, intuitive and deductive eclecticism.

On Sunday 16 November 1975, after lunch at Bradfields with Professors Moses I. Finley and G. S. Kirk, with whom he had discussed the minutiae of a translation of Archilocus which he was illustrating (a first proof of one of the etchings, his last more or less finished work, is reproduced here), he drove to his London flat. That evening he had a massive coronary and, mercifully, since he could never have put up with an inactive life, was dead within minutes.

ARTHUR BOYD

'Immature poets imitate; mature poets steal.' – T. S. Eliot

If, after a quarter of a century's knowledge and friendship, I was suddenly faced with the name Arthur Boyd and asked to free-associate, my response would be simultaneously easy and far-ranging. Painter, sculptor, engraver, potter, draughtsman, Australian, thematic, obsessed, obsessive, prolific, versatile, compulsive, innovator, borrower, converter, student of the Bible, cunning observer of Old Masters, profligate of talent, voyeur, erotic, polymorphous and so on – ending, perhaps, with universal genius.

None of the above is wrong or even inappropriate, yet he is at once all of these and more. Boyd is both a prodigy and prodigious. He seems to have endless time to travel – and needs it because he will not fly. He is devoted to a large, sprawling family and, with justice, indulges in a fair amount of ancestor worship, (see the family tree on page 34). Yet, of all the artists I have known and studied, his *œuvre* is the most massive and varied, though still consistent, in the history of twentieth-century painting – with the obvious exception of Picasso, with whom there are indeed one or two parallels. A future art historian, charged with doing a *catalogue raisonné*, including the drawings, will have to work for more than a decade.

That some of Arthur Boyd's work is facile is inevitable; so was much of Picasso's. But if one discounts the doodles, some of the sketches, the occasional redundant, repetitive reworking of a theme or an idea, there is still an *oeuvre* incomparable in post-1945 art in its richness and vitality, in the sheer abundance of square metres, in all media, covered with glowing paint and imagery.

If this introduction is both allusive and anecdotal, although these characteristics have no literary virtue they are at least appropriate to the subject.

Like many visual artists, Boyd is a diffident, indeed occasionally faintly inarticulate speaker, but let the patronizing beware. Behind that shy and gentle surface is what used to be called in academic circles an 'alpha plus mind'. Set a group of Sydney intellectuals or Hampstead literati in a roar at a crowded dinner table, let the pontifical pontificate for an hour or so until there is an accidental pause and, hitherto silent, Boyd will hesitantly utter a few sentences which reveal that he has seen through everyone else's pretensions and will come out with a handful of devastating truths that utterly silence the rest of the company.

And, as his brain is manifestly much quicker than most, so is his brush. We have all been pestered in European cafés by artists who, for

This is the introduction to The Art of Arthur Boyd *by Ursula Hoff published by André Deutsch 1986.*

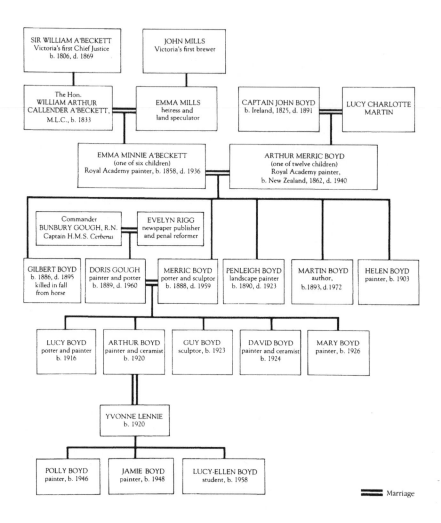

the price of a meal, will execute an instant sketch of a child or a mistress and very bad they are. Arthur Boyd is that amazing creature, the one who can do an instant sketch with a person, mythological figure or landscape and, in a matter of hours, produce a large canvas, fully worked out and meticulously painted with all the intensity and attention to detail that another obsessive like, say, Francis Bacon, would spend weeks or even months on.

I have never been surprised by Boyd's interest in mythology; he works, despite the travel and the family and the veritable collection of houses in which he lives, as if the Furies themselves were driving him. He once asked me to sit for a portrait. I protested about lack of time, but was told an afternoon would suffice. Inevitably, a mixture of curiosity, vanity and

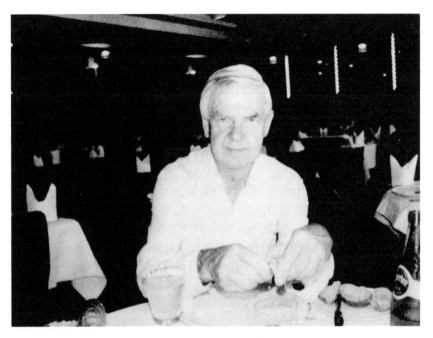

Arthur Boyd in 1982 (photograph by T. G. Rosenthal)

friendship prevailed and, in his house in Hampstead, between lunch and dinner, a full-scale oil on board portrait emerged. Like, I suspect, most sitters, when I first saw it I was not pleased. That was some twenty years or so ago and I have not seen it since, but I have not forgotten either the experience or the picture itself. It told me things about myself I did not know and perhaps did not want to know.[1] Frankly, it terrified me. But it was a unique insight for me into the frenzied, concentrated energy of Arthur's intellect, vision and almost daemonic technical virtuosity; he had done in a few hours what even the two acknowledged giants of twentieth-century portraiture, Oskar Kokoschka and Graham Sutherland, would have spent weeks on – and on which half their not inconsiderable reputations rests. Yet Arthur is relatively unknown as a portraitist. Portraiture is for him merely one of those things he finds it occasionally interesting to do. But let him loose for a year, with the sitters going to him at reasonable intervals, and he could achieve a one-man Australian national portrait gallery. As a portraitist he has that uncanny gift of painting, as it were, for the future.

Looking at his *Self-Portrait in Red Shirt* of 1937 (done when he was seventeen) and a photograph I took of him at the beginning of 1982, one sees the same face, weathered and tempered by the aging process, but the teenager's vision of the artist is acute, self-aware and prophetic. It

explains why I was able to go up to a complete stranger at a party and say, to a fully grown eighteen-year-old, that he was Matthew Perceval, simply because I had long admired a painting of the son of John Perceval and Arthur's sister Mary, done when the boy was about two years old. But in any assessment of Boyd's work his portraiture would probably be seen as only a minor diversion, so strong and varied is the rest of his career.

Eclecticism in the pursuit of art is no vice, and imitation, or, better still, theft in Eliot's sense, is in Boyd's case at least a cardinal virtue. Like many an artist growing up far away from the great galleries of Europe and America, much of his 'environmental' imagery as opposed to his 'inherited' talent must therefore have come from reproductions, mostly in monochrome, in art books. As far as his European influences are concerned, he had to be largely content with Malraux's 'museum without walls'. For his Australian heritage there were galleries enough and, for artistic training, there was his legendary family. While the National Gallery of Victoria has an impressive collection of European works, there was no London National Gallery a bus ride away, no Louvre, no Vienna until long after World War II and adulthood.

Thus, as he began to find his own authentic style after he had come to terms with the countryside around Melbourne and the legacy of Bunny, Conder, Roberts *et al.*, the already fully formed Australian landscape technique gradually became filled with foreign icons, icons which are all familiar images. They are familiar from the Bible, from mythology and from their most potent past manifestations, the pictures that always get reproduced in art books and in slides at school.

I think that the potency of these images derives not only from their obvious aesthetic merit but also from their constant repetition during a human being's most impressive years. Franz Philipp in his pioneering monograph on Boyd (the standard work, even now, on the *œuvre* up to 1966) has an acute analysis of *The Mockers*, clearly placing its genesis in Bruegel's great work in Vienna. While Philipp is surely right, it seems to me that this extraordinary painting done in 1945, when the artist was only twenty-five, is the great pointer to Boyd's future. Bruegel and the bush unite in a unique vision which is wholly Boyd's own.

Already the technical virtuosity is there in the handling of a literally crowded painting. The terrain is unmistakably native Australian. The theme and the imagery chosen may be borrowed or stolen from Bruegel, but they have been converted by Boyd's genius into something wholly his own. When considering the origins of this picture, it is interesting to know about Bruegel and to be able to appreciate the biblical reference;

but such knowledge is academic, in that it is Boyd's vision, and that alone, which drives this first major thematic work. It derives naturally from those wartime images such as *The Kite* (1943) and *The Gargoyles* (1944) in which the elements of horrific fantasy are engendered by war – with demons and crutches and stringed humans flying through the air. It also looks forward to the equally Bruegelesque *The Mining Town* of 1946– 7, the subtitle of which is *Casting the Moneylenders from the Temple*. A further blend of ancient and modern, naturalistic and grotesque, it pulses with life; though at first glance almost a naive painting, it is primitive only in its vitality and energy.

Significantly a slightly later work, *The Expulsion* (1947–8), is, as they would say in Hollywood, based on a treatment by Masaccio, in turn inspired by an idea from Genesis. The expulsion is, of course, that of Adam and Eve, and while Masaccio's angel is a sword-wielding avenger, Boyd's brandishes a whip and is seen more as a voyeur – outraged but, like all the breed, secretly enjoying the experience. Adam and Eve are terrified and, in a curious way, almost asexual, as if perfect fear has driven out desire. Many of Boyd's paintings show hidden watchers, particularly where sex or love is a vital part of the picture. Angels and other ministers of potential harm are seen as cruel, lovers as victims. Often an overtly erotic theme is shown with a touching innocence. There is nothing sexy about Eve. Her breasts are only sketchily present and the hair on her *mons* merges with a convenient tree branch. Adam's genitalia are almost hidden by his pubic hair. Yet when the painting first went on show, an outraged elderly Melbourne bourgeoise took out her hatpin and furiously scratched Adam's vital equipment away – and Boyd had to practise some *pentimento* to restore what was there.

One has to remember that Melbourne in the forties was a provincial city and Boyd's eroticism – later, particularly in his graphic works, to become so prominent – was in these early works very restrained. Even, later, at its most blatant, it has never been created merely to titillate.

Indeed in an age when the study of Freud has often produced all sorts of half-baked nonsense that would have made the founder of psychoanalysis snort with derision, Boyd has interpreted sexuality in a wonderfully matter-of-fact way.

Who but Arthur Boyd would do set and costume designs for Robert Helpmann's ballet of *Electra* at Covent Garden and garnish the dancers with snakeheads over the female pudenda and, in one case, a menacing *vagina dentata*? After the major religious paintings of the forties, Boyd did, by his own standards at least, his most conventional Australian

paintings, very much in the traditional progression of the great nineteenth-century Australians. These Wimmera and Berwick landscapes are less frenetic than the earlier work but, with their ubiquitous black birds, are unmistakably from his brush. They form a kind of peaceful interlude before and between the extraordinary ceramic paintings of 1949–52 which, together with his second series in the same medium in England in 1962–3, represent a precise fusion between his vision as a painter and his craftsmanship as a potter. In a sense, these compositions – sometimes individual tiles, sometimes composites of six or nine tiles or more – are his equivalent of Italian frescoes. The whole is often overwhelming because of the accretion of the parts, as in, say, the St Augustine frescoes of Benozzo Gozzoli at San Gimignano. They are the most 'primitive', the most openly emotional of his works, in which the strong vein of fantasy is at its most apparent. Like some of Chagall's work, they have great charm; but happily they lack the Russian's sometimes cloying whimsy. There is something endearing about a *Temptation of St Anthony* in which the saint, at once tempted and understandably perplexed, stands in a rockpool filling up with bright blue water gushing from his own navel, with his arms raised and caught in a tree from whose branches swings, upside down, a naked and unambiguously tempting blonde. Technically these paintings are immensely striking because of the intense colour effects achieved by firing metallic oxides such as chrome, cobalt or manganese to a temperature of a thousand degrees centigrade. The depth and intensity of the colours, aided by the 'crazing' that takes place in the kiln, give this part of his *oeuvre* a unique, heightened quality not seen elsewhere. If they survive for a few centuries, it is perhaps not too fanciful to imagine them being related to the polychrome sculptures of the della Robbias, although they are without the della Robbias' oleaginous sentimentality.

Above all, it is the fantastic imagery of the first series of ceramic paintings which seems to me to form the bridge between what preceded them – which was far from conventional – and the *Bride* series begun in 1957, first shown in Australia in 1958 and continued and shown in London from 1960 to 1961. The full name of the series is *Love, Marriage and Death of a Half-Caste* and I believe it to be catalytic within Boyd's *oeuvre* and his career, since it manifestly led to his most important exhibition up to that time, a retrospective show at the Whitechapel Art Gallery in London in 1962. This gallery was then in its heyday under the inspired guidance of Bryan Robertson and a show there was for a living artist an accolade second only to a retrospective at the Tate. The series brought Boyd instant recognition beyond the borders of Australia, much as the Burke and Wills

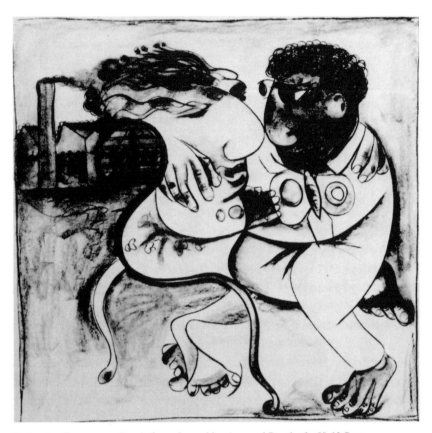

Embracing Figures on a Bench, from *Love, Marriage and Death of a Half-Caste*

and Ned Kelly paintings did for Sidney Nolan – who later became Boyd's brother-in-law when he married Mary Boyd Perceval. Significantly, they were the most obviously 'Australian' of Boyd's paintings; dealing with Aborigines, they had to be. Ironically, while a painter like Russell Drysdale had painted the Aborigines to considerable effect in an entirely conventional manner, which had brought him great fame and fortune in Australia but little outside it, the far more exotic, striking, yet utterly indigenous images depicted by Boyd had an almost instantly universal appeal in the Anglo-Saxon world.

Boyd had been profoundly affected by his observation of the Aborigines and attendant half-castes of Central Australia. Entirely eschewing any 'noble savage' nonsense, for all the elements of fantasy he brought to the paintings he saw them plain. We don't see here the sturdy figures of great physical strength painted and drawn by Drysdale, or the jolly painted chaps holding a corroboree and playing didgeridoos. Instead we see the

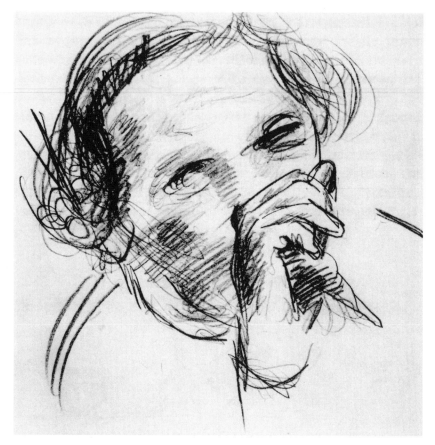

Doris Boyd, with hand over mouth

sad hunted and haunted figures we could visualize from Randolph Stow's remarkable novel *To The Islands*. The characters inhabit a world of tin shacks, ragged clothes, desperate love, haunted by death and fear. They are oppressed and their relationships are doomed because the outside world gives them only hostility at worst and, at best, apathy. If all this sounds like a social commentary, it is not meant to. Boyd is too subtle and sophisticated an artist to sermonize.

He simply shows the predicament of, say, the bride in *Mourning Bride I* as she tries to join her lover/husband in the coffin, his jet-black skin white in death, as his blue-skinned friend (or is it his formerly living self?) watches both impassively and sadly. Guns are pointed, bridegrooms are frightened, a pale-faced half-caste child clings to a rock-solid Aborigine whose blackness illuminates the painting as much as her scarlet dress. Thus in the *Bride* series Boyd's brand of fantasy becomes more firmly

Yvonne Boyd (Yvonne Lennie) lying on a couch with book and clarinet case

grounded in reality, paradoxically in a group of paintings peopled not by figures from the Bible but by unnamed, half-observed, half-invented Aborigines and half-castes. In other words, Boyd has created his quasi-mythical figures not out of the known, European religious models of the Renaissance but out of the native Australians whom he could himself observe in the flesh. Not, of course, that there is any attempt in Boyd's Aborigines at anything approaching conventional realism. Inevitably Boyd has tried to dig beneath the conventional surface. If the black-skinned Aborigines were Negroes, one would say he was expressing their Negritude. There is a kind of racial understanding in these pictures, a wholly unpatronizing, unsentimental comprehension of their plight. In Drysdale's paintings one is made brilliantly aware of their physique and their external appearance. In Boyd's one becomes aware of their minds and spirits. Although the trees, the scrub and, particularly, the birds which so frequently recur in Boyd's work are all redolent of Australia, it is the Aborigines in the *Bride* series which constitute the most strongly Australian element in his *œuvre*. In a painting like *Half-Caste Child* (1957) we find an almost archetypal Boydian situation and setting. The trees spring from rocky land, the sky contains a hundred subtle colours, the ubiquitous black bird looks on and the human figures are clothed in reds and blues of a startling vividness. The child clings, seeking protection, to a truly primitive figure: his massive, neckless head is attached to a huge, stiff, strong but curiously vulnerable body and the great staring, startled

eyes are at once fierce and haunted, cruel and pitiful. In other paintings in this series the element of fantasy is very strong, but it is a fantasy founded on terror, filled with images of hidden watchers and hostile pursuit, of death and mourning.

These are tragic images, painted with both passion and compassion, but they do not simply make one angry in a knee-jerk-reflexive liberal, intellectual way, for they are not a crass political 'message'. The imagery is too exotic for that. The gun-pointer has a white beetle on his black cheek, the persecuted lover a gorgeous bouquet of flowers stuck in his ear. The paintings themselves burst with sumptuous colour. They pulse with painterly life. Each one is a glowing icon, not of social anthropology but of high art. The *Bride* series constitutes, together with Nolan's two series on Burke and Wills and Ned Kelly, the most powerful visual images to emerge from Australian painting, as opposed to painting in Australia, in the twentieth century. Boyd ceases to be precocious and achieves both absolute originality and complete maturity; these paintings are, I believe, the watershed of his art and without them he could not have done some of the notable later series.

Boyd's arrival in London in 1960 (he moved to England with his family in 1959) is also a turning point in his work. The accessibility of Europe's vast collections made a profound impression on him and his eclectism became more extreme, as the sometimes wild imagery of the *Bride* series spilled over into his first London work.

In the paintings Boyd did in London in the early sixties there are several noticeable developments. In many pictures the fantasy has a basis in metamorphosis, as in *Nude Turning into Dragonfly* or *Bride Turning into a Windmill*. In others Boyd displays his endearing habit of eclectic borrowing – for example, the fruitful left breast from Tintoretto's *Origin of the Milky Way* or the mournful, seated dog from Piero di Cosimo's picture of a satyr mourning a dead girl. But in all the paintings of this period Boyd shows a much more sophisticated handling of paint than previously. The relative flatness gives way to a heavier, more impasto style, with fairly thick streaks of paint carefully worked with knife or brush-handle. This technique is much in evidence in the series of portraits he did at about this time and is exploited to enhance the physical immediacy of these works in that most difficult of genres.

Perhaps the most singular paintings that Boyd has done so far are those on the theme of Nebuchadnezzar and Daniel's prophecy of his fate: 'Thou shalt be driven from men, and thy dwelling shall be with the beast of the field; thou shalt be made to eat grass as oxen.' Boyd shows

us Nebuchadnezzar 'wet with the dew of heaven, till his hair was grown like eagles' feathers, and his nails like birds' claws.' He shows us the king afflicted, like Job, with boils; above all, he shows him consumed by a terrifying madness. Boyd's imagery here is highly complex, mingling that of the Bible with that of his own imagination and simultaneously toying with Freudian ideas. (In one picture Nebuchadnezzar is on fire, squatting simultaneously on gold and his own excreta.)

The most exciting of these pictures is probably *Red Nebuchadnezzar with Crows* in which a terrified, crouching king, covered in boils, stretches out huge, splayed, suppliant hands set on fire and outlined in yellow flames, and cowers before the attack of two black, red-eyed dive-bombing crows. (One is reminded of Van Gogh's crows in a cornfield, and, since one of the crows is going beak-first into Nebuchadnezzar's mouth, of Freud's interpretation of Leonardo's dream. But the menacing bird in Leonardo's dream was a kite and it was its tail that entered the dreamer's mouth, so that perhaps Freudian interpreters of Boyd's work should not be over-zealous, particularly as the Nebuchadnezzar paintings present them with an all too easy field-day.) The whole painting, in its colouring, in the fierceness of the working of the paint surfaces, in its feeling of whirlwind and simultaneously of shackled (because fruitless) motion, is filled with a kind of cathartic terror. The force of both its imagery and its execution makes it linger in the mind long after one has seen it.

This peculiar force is found also in *Nebuchadnezzar and the Crying Lion*, where the thick yellow impasto of the lion, with its paint surface worked up almost into a facsimile of the lion's curly mane, utterly dominates the haunted shadowy figure of the king. Boyd's representation of the lion is a *tour de force* in communicating the essence of the beast, with its startling forward projection and the power of that great, muscular, tapering torso.

In this series of paintings there are many other memorable images: the king walking, multi-legged, like a Muybridge photographic sequence; the king tufted with eagles' feathers, walking blindly through a purple, starry night or striding through the fields like Van Gogh on the way to Tarascon. In one very moving work he is on his hands and knees, naked, eating grass, the knobs of his backbone standing up and echoed by the peaks of the hills behind him, the beloved Boyd dog perched on his back.

Boyd is sometimes open to the inevitable criticism that his work is illustrative and over-thematic. That it is illustrative is, since he has deliberately eschewed abstraction and any specific 'school' or move-ment, perfectly natural. Until what we call 'modern art' began, all painting was illustrative and it is only in a world and at a time when a pile

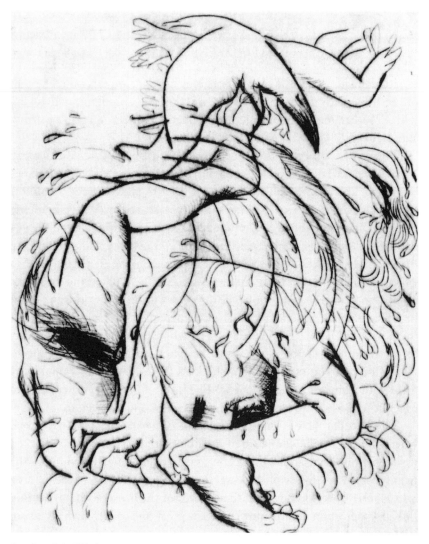

Jonah and the Whale

of bricks can be bought with public money and displayed in a national museum that 'illustrative' could be thought a pejorative word. Leonardo was, after all, illustrative. As for the thematic nature of Boyd's work, as so dazzlingly demonstrated by the Nebuchadnezzar series, this seems to me the natural concomitant of his amazing energy. If the Renaissance and classical painters were happy with one version of an allegorical subject or if one patron requested a St Jerome, then that was fine; but let Boyd once get an idea for a subject, be it biblical, allegorical or mythological, and

he's away. In 1972 I thought it would be interesting to put Arthur Boyd and Peter Porter together to see if there was a theme that would stimulate them both. When Jonah emerged from our joint talks, Peter Porter wrote a substantial volume of verse and prose at what seemed to me remarkable speed. Arthur Boyd, however, almost rendered the publication of a mere book impossible. So far as Porter's words were concerned, I remember suggesting a possible change of order here and there and an omission or two; but Boyd simply flooded my office with hundreds of drawings in line and wash. We came close to drowning in this cornucopia and it took months to fine down to the selection that eventually appeared in the book.

Since there is a certain solemnity about both art and literature and particularly in writing about them, it is worth quoting and illustrating from Jonah as both Porter and Boyd have a lively sense of humour.

> Saturday I have this day experienced the wonder of the whale's farting. Such turbulence of digestive juices, so many deplorable vapours, I have encountered, but considered later that it must prevail with whales as it does with men, that it is better such gasses be out than in, and that no man, nor whale either, is ever embarrassed by the smell of his own farts.

JONAH'S CONTRACT WITH THE WHALE

> ... that the party of the first part, hereinafter known as *The Whale*, shall undertake to deliver the party of the second part, hereinafter known as *Jonah*, by means of vomiting, expelling or otherwise voiding the said *Jonah* on to a beach, promontory or any secluded part of the adjacent coast at the earliest opportunity before the New Moon, always allowing for local impediments and hindrances offered by tide, weather or any other natural hazard.

> ... that the said *Jonah* will, if required, assist *The Whale* in carrying out this undertaking by journeying to the screen of membranes at its throat and tickling or titillating these parts to hasten the epiglottal reflex: *Jonah* also agreeing to follow *The Whale's* instructions at all times and, while remaining in its belly, to abjure fire and trenching implements, and also to undertake not to gather material such as ambergris or sea-kale which might be offered for sale on his return to the outside world.

Boyd's collaboration with Porter has been a fruitful one. *Jonah* was followed by *The Lady and the Unicorn* in 1975 and *Narcissus* in 1984. These two later books each contain a series of black and white prints of considerable virtuosity. No conventional book can do justice to the deep velvety black that surrounds the prints, which are, as one might expect, inventive, full of fantasy, highly charged with eroticism and at the same time lyrical in tone. The Unicorn may be a fabulous beast but it is

The Lady and the Unicorn, XV

Narcissus, XX

also often a sad one; while Narcissus doubtless loved himself too much, he had no one else he *could* love. As always, Boyd's fantastic, at times phantasmagoric, vision is a compassionate one. The central characters of his major graphic series, including the often delicious and hilariously sexy *Lysistrata*, are more sinned against than sinning.

The visual games that Boyd plays in his graphic work as a whole, full of sly innuendo, erotic charm and sheer *joie de vivre*, are equalled in terms of technical skill by very few twentieth-century artists. For comparable virtuosity and single-minded exploration of a theme, one really has to go back to Picasso's *Minotauromaquia*, an appropriate parallel not least because Boyd has always shown, throughout his graphic work, an absolute genius for metamorphosis. It is particularly visible in the *St Francis* pastels and engravings, where the saint becomes inseparable from his beloved animals.

This passion for changing forms, while accentuated in the graphic works because of their subject-matter, is of course highly visible also in the paintings. Given the fluidity of paint as a medium, as opposed to the necessary rigour and rigidity of copperplate, the metamorphoses are, if not more inventive, more like a magician's tricks when carried out with brush rather than needle. Sometimes they are almost breathtaking in their boldness, as in *Bride with Lover* (1960), which Boyd subtitles as *Bride Turning into a Windmill*, or *Nude Turning into a Dragonfly* (1961). The *Bride Turning into a Windmill* is a *tour de force* of the imagination as, against a sumptuous background of vegetation, sky and inevitable black bird, the Bride is a mere head. Instead of a body, there is just an elongated pillar of white wedding-dress, while her bridal veil stands on end and becomes the windmill's sails, as she serenely levitates in a horizontal position. It is a breathtaking image, once seen never to be forgotten.

Much has been made of Boyd's 'Australianness', as if he were a Johnsonian woman preacher. As a critical label it is about as valuable as Hardy's being a Wessex novelist or D. H. Lawrence's intimate knowledge of Nottinghamshire life. Yet without Wessex there would have been no Hardy, and Boyd's Australian heritage is inseparable from, and highly relevant to, his art in that it is the foundation upon which he has built the pillars of his artistic talent. Indeed in the early and the most recent work Boyd's native country is indispensable to his art and our understanding of it. What one must be aware of is the use of the national adjective as a limiting factor. This is easy enough to avoid if one takes into account the decades of the sixties and seventies, which owe relatively little to his Antipodean roots. During that period he experienced the influence of

English and European topography and aesthetics, and also engaged upon the many themes and iconographies mentioned above, none of which is in any sense local. Indeed, they are universal.

Boyd has a house in Tuscany and it is therefore hardly surprising that he so wholeheartedly entered the world of St Francis and the Wolf of Gubbio. He spent a lot of time in Portugal creating and supervising a series of sumptuous tapestries and thus joins a tiny handful of modern European artists who have mastered this difficult medium.

He also has a house in Suffolk, only a few miles from Constable's Flatford Mill, and, in that rural seclusion, has done some of his finest graphic work as well as becoming a highly accomplished painter of landscapes which are truly English in spirit and not some kind of reverse transportation from Botany Bay.

But in the last few years, without in any way severing his ties with England and Europe, he has made a deeply committed return to Australia – not to his native Victoria but to New South Wales, where a formidable family estate has been established on the banks of the Shoalhaven river.

Not all art books genuinely illuminate their subject-matter, so it is a rare pleasure to recommend as an essential tool in the understanding of Boyd's recent life and work an extraordinary and obsessively detailed study by Sandra McGrath entitled *The Artist and the River: Arthur Boyd and the Shoalhaven*. The study of Boyd's relationship to the area is so exhaustive that it even includes some of his instructions to his architect, as well as some useful, sharp comments on individual works.

Boyd's output over the last few years, beginning in 1975 and still going strong in 1985, provides a sample of his *œuvre* in both microcosm and macrocosm. The relationship with nature is there in the endless and successful attempts to come to terms with a landscape so dramatic that one finds it hard to credit until one sees the accompanying photographs. There are the usual animals, the live ones flying, running or watching, the dead ones as clean-picked carcasses or bloated corpses floating down the river in flood, all done with the extreme tenderness that fills so much of his art. Nude female figures, not a million miles from his wife Yvonne, are set in an unmistakable Australian bush and are charged with the same intense love Rembrandt devoted to his Saskia. There is also the genuine grand design of his topographical sense. He has always, in large-scale landscape paintings, been able to show the earth's skeleton beneath the skin and flesh surface of the most elaborate and tangled Boydian vegetation. There is, too, the inescapable mythology. Narcissus is himself observed on the banks of the river. There is the freely admitted eroticism, even in the

landscapes. As Boyd himself said of his *Broken Cliff-face* and *Moon* of 1974–6, 'the cleft shape has obvious sexual connotations, but any division in a rock face – even a waterfall – can be seen that way.'

But any idea that Boyd, now in his sixties and very much rooted in his relatively new Australian renaissance, might have 'settled down' is happily dispelled by the continuing, even burgeoning, vividness of his imagination.

The prodigal son is welcomed back into a cave in a bank of the Shoalhaven, a slightly sly passing angel rubbing its hands in smug satisfaction. A man on a sandbank drives a jinker, drawn by black swans. In what is to me the most striking work of the period, *Shoalhaven River with Rose, Burning Book and Aeroplane* of 1976, we get a conventional but daring view of the river as seen from a high rock, with the water curving and meandering for miles into the distance. On the rock rests a fragile, toy-like aeroplane next to a fiercely burning book. The burning book is surely one of the most horrific images of the twentieth century. In this essentially peaceful landscape the plane is an image of war, the book a potent reminder of prudish and repressed women with hatpins for excising genitalia and of Nazis eradicating uncomfortable free ideas by burning books in Frankfurt.

As if that were not enough, above it all, against the lightly clouded blue sky, like a descending parachute, there is a huge, gorgeously painted rose. If this all sounds symbolic, then Boyd clearly means it to be; he has himself commented that 'The rose represents the desperate attempts of the Europeans to impose their civilization and culture on an essentially primitive landscape. It always floats because it cannot take root. If it does, it destroys like Lantana.'

The above analysis of book and plane is of course my own, based on my instinctively European stance towards Boyd's work and my understanding of his own absorption of the horrors of the history of the twentieth century. It is cautionary, therefore, to go back to his own stated interpretation of this canvas:

> The burning book represents Aboriginal wisdom, which has also suffered from the encroachment of white civilization. If the white settlers had taken a page out of the Aboriginal 'book' they might not have ruined the landscape. The aeroplane is a reminder of the harshness of the land – they were used that year to rescue people when the Shoalhaven flooded. They actually used helicopters but I felt a bi-plane had close connections – grasshoppers and dragonflies for instance.

Well, it is Boyd's painting and he is entitled to know what he put into it and what he means. But I do not think my own view of it is entirely fanciful. As always, once a painter has finished a work its content becomes common property. Unless it's downright dull and empty, its ideas are transformed by the eye of the beholder. Nevertheless, this undoubtedly major work is a perfect fusion of Boyd's 'Australianism' and the solid leavening of his European experience.

That Boyd is, in his versatility, a kind of Renaissance man is a truism. I began this essay with a crude piece of free association, but as one creates a retrospective of his work in that other museum without walls, one's own head, with its crowded, unerasable memories of everything one has seen and recorded there, the mind's eye must select, as inevitably Ursula Hoff's study of the artist, so scrupulously does.

One remembers the unique vision of the terrain, recalling Randolph Stow's lines from 'Landscapes' in his collection *Outrider*:

A crow cries: and the world unrolls like a blanket;
like a warm bush blanket, charred at the horizons.
But the butcherbird draws all in; that voice is a builder
of roofless cathedrals and claustrophobic forests
– and one need not notice walls, so huge is the sky.

One recalls the poignant images of Adam and Eve, the Aborigine and his elusive bride, of tormented Nebuchadnezzar and lovelorn Narcissus, the gentleness of St Francis, of the Unicorn trapped by hunters, of humans metamorphosing into animals and phantasmogorical creatures, all depicted with brush or needle or palette knife or even fingers, in an ever richer, yet ever more controlled and defined blaze of original colour.

From the smooth 'Old Masterish' texture of the early work to the later heavy impasto, from the early sparse drypoints to the full-blown heavy black plates, Boyd's art is a majestic progression from teenage precosity to a mature grandeur of conception and execution. He is, I am convinced, a twentieth-century artist who will live for and in posterity. And, for that other kind of posterity, students of the family tree might wish to know that Arthur Boyd's son Jamie is already an independent and successful painter, so that the fourth generation of artistic Boyds is beginning to flourish...

The Lady and the Unicorn, IV

[1] After the sitting, Arthur offered me the painting as a gift. I declined, ostensibly because it was too generous but in reality my fear overcame my cupidity. I did, in fact, see it again in 2002, long after Arthur had died. He had included my portrait in his munificent gift to the Australian National Gallery in Canberra and, while I was researching my book on Sidney Nolan in the National Gallery's subterranean reserve collection, a kindly curator sought out the portrait for me. I looked at it for a long time, got permission to photograph and realized that I had been right to decline it. It's a magnificent painting but it still scares me.

52

IVON HITCHENS

Ivon Hitchens is one of the strangest and most paradoxical figures in the history of modern painting in England. Strange because he has had little of the intellectual recognition of his near contemporaries, such as Henry Moore or Ben Nicholson; paradoxical because he has practised that great English virtue – consistency – and has been blamed for it as if it were, in fact, a vice. For over three decades now, at a time in modern painting when artists are encouraged to change their styles with a rapidity more appropriate to the rag-trade than to art, he has resolutely painted in the same way, in the same place, and more or less in the same size. His constancy has, to many who influence the ways of the art world, actually become a drawback. There have been no long voyages to distant countries to bring back some tastefully run up exotica; there have been no quick flirtations with a convenient work of literature or music to create an instant new series; above all there have been no self-conscious breaks with the past in order to create the instant new future so beloved by the art admass who need a new image to excite them, or by professional art reviewers faced with cruel lack of space, inconvenient deadlines and a basically philistine public, who yet have to find something tolerably dramatic to write about.

Thus Hitchens' virtuous consistency is a bit of a bore and a bit of a nuisance. Yet, devotedly cared for by his admirable wife and supported loyally by a few discerning collectors, Hitchens has managed, privately, to thrive. Perhaps the privacy as much as the consistency is the key to his artistic *persona*. Driven out of London by bombs at the beginning of the war, Hitchens, to quote Patrick Heron's pioneering monograph, 'retired to a caravan he had lately purchased for £20 and driven into a thicket on Lavington Common composed of rhododendrons and silver birch, with oaks above and bracken below. Here, with more turpentine than water, he remained, with his wife and infant son for company, to paint the war out.' When one visits him today, the caravan is still there as the guest-room for those who stay overnight, but it now adjoins a remarkably deceptive-looking, one-storey dwelling. Deceptive because it looks small and simple, but is actually simple and very large, sprawling from modest living quarters to studios and store-rooms, of apparent chaos, which contain, immaculately recorded in the artist's head, hundreds of finished canvases and works in progress. Here Hitchens has acquired and achieved total privacy. He rarely visits London and his few excursions from the house are usually to other places where he might find something interesting to paint but, almost invariably, they are only a few miles from his home.

Note: All quotations from Hitchens are from conversations and correspondence with the writer. 53

His home is far from being, in any conventional sense, his castle; equally unconventionally it is his estate. Only the initiated can locate it, and once inside it one cannot be overlooked. It consists of just a few acres but they are so enclosed, so richly vegetated, and so volatile in their ever-changing response to climate, that the house and grounds are a world in themselves and are, indeed, the heart of Hitchens' artistic world. The landscape of Hitchens' domesticity is also incontrovertibly and irredeemably English. Any seasoned world traveller dropped there without warning could not but instantly know himself to be inside the very core of England. This rambling, random, overgrown, and undisciplined patch of Downland is to Hitchens what Walden Pond was to Thoreau, and in its intellectual and sensual richness the analogy is not idle.

But Hitchens did not spring fully armed into and out of his rural richness. Before Sussex dominated his artistic life he might easily have gone in other directions. He was born in London eighty years ago, like Ben Nicholson the son of a painter, and he had, after an unconventional schooling at Bedales, a conventional art education at St John's Wood School of Art and the Royal Academy where his instructors included Clausen and Sargent.

In the 1920s he was sufficiently unconventional to have joined, with, among others, Nicholson, Moore, David Jones, John Piper, and Barbara Hepworth, the Seven and Five Society and by 1931 was sufficiently part of the non-academic mainstream to join the London Group. Yet, already, the essential privacy was manifesting itself and Hitchens was far from being one of nature's joiners. Exposed, as everyone of his generation had to be, to the pervasive influence of Cézanne, there is little else one can say of art-historical interest. Yet that early passion for Cézanne was fruitful in both a superficial and a deep way. Superficially it is obvious in the early landscapes like the elegant watercolour sketch *Farm Buildings, Study of Essential Form* of 1922 or the oil painting *Curved Barn* done the same year and already, half a century ago, in Sussex. At a deeper level it is an integral part of Hitchens' whole approach to, and practice of, landscape painting – a point which I shall explain later in this essay. Also superficially, because it is such an obvious point to make, yet surely significantly, as Cézanne found himself as a painter and fed his genius in Provence, identifying himself almost mystically with a particular landscape, so Hitchens has done the same with his corner of Sussex. Naturally this is not something to over-emphasize, and only a fool would thereby overrate Hitchens; Terwick Mill is not the Mont Sainte Victoire, but it is at least interesting that whenever in the last hundred years or so one looks at the great and

obsessional landscape painters, such as Cézanne, Van Gogh, Gauguin and Bonnard, one finds for each a place or two which have wholly seduced them to the point that obsession becomes genius. In a very English, understated way Hitchens met his Arles, his Tahiti, in West Sussex, and if there are those who consider that his obsession became so exclusive and all-pervasive as to be boring, then one must let them think that; although there are others who would trace the obsession with more patience and care, seeing through the apparent opacity of sameness to a subtlety and depth of development of rare intellectual excitement and much beauty.

One of the hallmarks, perhaps the most vital one, of any good painter is that any work, from any period of his life, no matter how many times he may have changed his style, should unmistakably be his own; that under no circumstances could it have been painted by anyone else. The perfect example, when one has the benefit of hindsight (as one surely must with a dead artist or one who is an exceptionally well documented octogenarian), is Mondrian. When one had the chance to see the extraordinary retrospective in 1966, one could see within a few feet of each other rather dingy Dutch landscapes, complete with windmills, and the relentless, compulsive final energies of the Broadway Boogie-Woogies. Yet, with that exquisite hindsight possessed by the fortunate surviving critic, one could see at a glance the imprimatur of the same hands, and, if one gave more than a glance and steadily surveyed the progression from windmill to Boogie-Woogie, one saw that the progression was perfectly disciplined and marched, step by logical step, like a great game of chess spread over half a century.

So it is when one sees, as one could at the Tate Gallery retrospective of 1963, the whole pattern of Hitchens' work. Even the Nicholson-influenced abstractions, like *Control* of 1935 or the sumptuous colour symphony of the 1937 *Coronation*, show inescapably the same, almost architectural, bone structure as the early landscapes and those of the last ten years. The cynic may argue that where nothing really changes, then all is the same and that the charge of monotony does, after all, stick. Yet anyone who can find monotony in the contemplation seriatim of *Control*, *Coronation*, *Waterfall*, *Terwick Mill* of 1945, the *Warnford Water* Series of 1959, and the great mural of 1954 in Cecil Sharp House would, I suspect, find it also in listening in sequence to all the Mozart symphonies.

This is perhaps a convenient moment to deal with this charge, often levelled at Hitchens and hence needing, particularly in this book, to be refuted. The charge of monotony is, in an artist of such consistency, inevitable when the consistency is backed by such an enormous output

and when there are so many wholly arbitrary considerations which tend to make it convincing. The vast bulk of Hitchens' work is painted on canvases of three basic sizes. They are all, under his own direction, meticulously framed in largely similar styles and materials. They are all a basic 'Cinemascope' shape. They tend to have very similar and hence mildly confusing titles. The majority are, of course, Sussex landscapes. There is an inescapable aura of 'you've seen one, you've seen them all'. The selection, largely by the artist himself, of the Tate retrospective in my view seriously over-emphasized the landscapes and paid insufficient attention to the flower and figure paintings.

All this, no matter how arbitrary, appears telling in any attempt to convert the unconverted, who rarely have either the time or the inclination to take the trouble to look more closely, to go below the superficialities and to see the infinite variety and subtlety of Hitchens' art.

As I write this essay I sense the distinct entry of a defensive note, of a need to justify the validity of a lifetime's work which has not yet had its proper due. I write as the partisan convert trying to prove that those who admire Hitchens are right and those who do not are wrong. Hitchens, unusually, evokes strong passions only in his admirers. There are few people of any sensibility who hate his work, but there are many who, perhaps for the arbitrary reasons noted above, largely ignore him. The perennial elongated landscape has become too repetitious and the critical eye becomes glazed.

Perhaps in order to unglaze it a little one should consider the artist not, as is customary, in a chronological sense, but thematically, and, since the obsession with landscape is a truism, one should accept that fact and deal with the landscape last, after one has had a chance to consider his other faces.

One can, for example, be forgiven for knowing little or nothing of his public works. They are indeed little known because there are only three, one at Nuffield College, Oxford, one at Sussex University, and one in London. Yet the one in London is, by any standards, one of the major public works of art of twentieth-century England. It is, however, a relatively inaccessible piece of work. For almost ten years I have lived within walking distance of it yet I, Hitchens devotee that I am, only go to see it about every two years. In what was surely one of the most enlightened acts of patronage since the war, the admirable English Folk Song and Dance Society commissioned a huge mural for their headquarters at Cecil Sharp House in Regent's Park Road. The painting was 'opened' in June 1954, having taken four years to complete

and measuring 69 feet wide by 16 and in part 20 feet high. Unlike, say, Sutherland's *Christ in Majesty* tapestry at Coventry Cathedral, it is a true and colossal conception. The Sutherland, by virtue of its location and its siting within that hyper-glamorous building, dominates with insouciant ease; its huge chief image a focal point for all who enter the Cathedral. By its sheer size it cannot fail to impress; yet, when one considers it carefully, one realises that it is, in fact, simply a 'blown-up' version of a small painting. Particularly when one observes, as one could in London a few years ago, the gouache sketches Sutherland made, one sees that the greatest virtue of the Coventry tapestry is not its real intellectual or artistic size, but merely its scale. If one wants true size one need only see the Christian mosaics of Ravenna. This apparent digression is not to denigrate Sutherland, a supremely conscientious and dedicated painter, but merely to point out that the creation of huge works of art is a huge labour both physical and conceptual, and that, at Cecil Sharp House, is what Hitchens has wrought.

His mural is not a sketch writ large but a grand (never grandiose) design in paint, conceived for its site and executed with almost breathtaking daring. One must, of course, always preserve one's sense of proportion; it is not the ceiling of the Sistine Chapel nor is it the Goya of the church of San Antonio de la Florida in Madrid. But it is fit to keep company with the large panels of Miró or Matisse and it is not disgraced by comparison with *Guernica*. As the perceptive Heron pointed out:

> There is not, one should note, a single vertical or horizontal line or form in the entire scheme. It may thus be described as a venture in a sort of modern baroque: the presence of the rectilinear, in any form, would of course have given it a swift passport into the world of internationally approved art.

Hitchens has himself indicated that the absence of verticals and horizontals is a deliberate device chosen because 'the dancing figures on the wall were intended to be part of the dancing in the arena. I argued that a lot of tall gloomy figures staring down at the actual human performers could have a depressing effect.' The original proposal was that the mural be behind the orchestral platform so that audiences at concerts would be able to look at it while listening. Unfortunately the plan was reversed so that the musicians can look at, or be distracted by, the painting while the audience looks at the windows.

To describe the mural in detail would take a whole chapter in any book. Like any work of such size it must, therefore, be studied both in photographs, so that one can see within a manageable compass the

intricacy of the design, and *in situ* to see the full interplay of the various parts and experience the great audacity of the conception and the subtle vibrancy of the colouring. Each individual viewer must, I think, work out the contents for himself. In brief, the mural is a multi-faceted woodland scene, in archetypal Hitchens proportions, full of people and animals, bursting with energy and vitality, and at the same time intensely rural and peaceful. The explosions of movement within the sylvan backgrounds are what one would expect from the commission and its site, namely, the traditional English dances: Morris, Ring, Horn, Padstow Hobby Horse, etc. But probably to analyse too much is to destroy. All one can do is grasp at the essence and marvel that a commissioned work should be so appropriate for its patron without being, as is so common on such occasions, stultified. Just as one can identify and rationalize every separate component of *Guernica*, so one can with the Hitchens mural. But Picasso's masterpiece is more than a fierce cry of outrage at the wanton destruction by Nazi bombers of a Basque town: it is in fact a definitive statement about the horrors of modern warfare. So the Hitchens, full of the components and associations of rural England and everything that the indefatigable Cecil Sharp championed and collected, is a paean of praise for rustic society, for unabashed pagan enjoyment, for the joys of the seasons; not a definitive but an all-embracing statement of the energetic richness of rural England as it once was and has almost totally ceased to be.

Yet the mural, like the rest of Hitchens' rural work, is far from being a mere tranquil recollection of a passing arcadia. In its structural complexity it is just as demanding of the viewer as *Guernica*, perhaps more so. The way in which each individual section, each human or animal form, every tree or pool is worked out both in terms of colour and form with the whole grand design is one of the major intellectual achievements of English art. For those who consider intellectual qualities in painting as bad form, it should also be said that it is a remarkably beautiful picture in which the richness and counterpoint of the colour perfectly set off the essential *joie de vivre* of its contents. If one were to pursue a musical analogy, which, since the keynote of the work is its highly complex and wholly achieved orchestration, is perhaps legitimate, then one would compare the mural with the programme music of Berlioz, particularly, say, the *Symphonie Fantastique*.

Music is one of Hitchens' great loves and the gramophone is rarely silent when he is working in his studio, yet music is mostly much more an accompaniment to his work than an integral part of it, as it is with a painter like Klee. Only in the mural is the musical element strong and plain and

in the handful of abstract paintings which form another, intensely worked out, example of the true variety in his *œuvre*. The casual observer would of course maintain that virtually all of Hitchens' work is abstract, and his landscapes do undoubtedly contain an element of abstraction which varies from the slight to the consuming. Being painted out of doors, *in situ*, they do, naturally, reflect the surrounding scenery. They are, therefore, not abstract paintings as we think of them in terms of Mondrian or Malevich or Albers or late Barnett Newman. Yet Hitchens has done a handful of pictures which belong to a different tradition of painting from that of his usual preoccupations.

The most notable of them are *Control* of 1935, *Coronation* of 1937, and *First Easter Morning* of 1958. The first and last of these are, according to the artist, linked in theme and style and are both religious and symbolic. In both one can find aspects of the resurrection. Yet the gap of twenty-three years between the two pictures is inevitably a large one. *Control* is an immensely elegant, meticulously worked, and highly satisfying intellectual and artistic exercise. It is very much a child of its time; one sees Nicholson and the Pevsner–Gabo Constructivist axis as much as one sees the experimenting Hitchens. *First Easter Morning*, on the other hand, seems much closer to the mainstream of the artist's work, and although it repeats some of the forms of the earlier picture it is much less austere, warmer, more sensual, a symphonic work as opposed to a piece of chamber music. But it is *Coronation*, now happily, thanks to the Chantrey Bequest, in the Tate Gallery, which in my view represents Hitchens' major excursion into pure abstraction. When he painted it in 1937 Hitchens was much interested in Kandinsky's ideas linking painting and music, and Hitchens himself has used the phrase 'the "visual sound" that one tries to put on the canvas'. *Coronation*, as perhaps it should be if one considers its title, is a sumptuous work of blazing colour and hard rectangular panels of blue, crimson, and ochre softened by curvilinear areas of the canvas left, as in so many of his landscapes, in their original, untouched white. It is an absorbing and majestic painting which at least partially illustrates one of Kandinsky's dicta of 1910--11:

> Cold calculation, random spots of colour, mathematically exact construction (clearly shown or concealed), drawing that is now silent and now strident, painstaking thoroughness, colours like a flourish of trumpets or a pianissimo on the violin, great, calm, oscillating, splintered surfaces.

In fact the Kandinsky passage applies to so much of Hitchens' work that it might almost stand as an epigraph.

Hitchens' abstract pictures (in the sense of *Coronation*, or the superb *Triangle to Beyond* of 1936) are few but they are masterly and quite indispensable to the totality of his work and any understanding of his protracted engagement with landscape form. Perhaps the only occasions when his abstract disciplines are not brought wholly into play are the two genres for which he is, compared to his landscapes, relatively unknown and yet of which he is, as with abstraction pure and simple, an absolute master, namely, flower pieces and figures.

Flower painting, oddly, is one of the casualties of the twentieth-century artistic revolution. In the nineteenth century some of the most revolutionary painters applied their revolution to some of the classic subjects, but in this century, with the noble exception of Matthew Smith and, surprisingly, Epstein in his watercolours, flower painting in England has become a refuge for the incompetent and the academic who continue to churn out indifferent canvases for people who do not appreciate painting but feel that they ought to buy a picture as furniture, much as they might buy a few feet of fine leather bindings.

Hitchens is a splendid painter of flowers. Indeed, surrounded as he is by some of the largest and most spectacular rhododendrons in England, it would be odd if he were not. Hitchens' flower pieces are rarely conventional; they often seem to be temporary excursions from the permanently obsessing landscapes. It is as if they represented a self-administered Rorschach test in reverse: the pictures represent the associations, and the associations with one microcosmic aspect of nature turn the painting into another landscape. A perfect example of this is *Flower Composition, Violet and Orange* of 1958 where one could be forgiven for assuming at first, and indeed second, glance that this is yet another landscape, and not merely because he has extended the picture over his habitual wide-screen canvas.

In a conversation with me Hitchens once said:

> I love flowers. I love flowers for painting. It's only that life's too short – one can't always do flower paintings – not a carefully arranged bunch such as people ought not to do – but doing a mixed bunch in a natural way. One can read into a good flower picture the same problems that one faces with a landscape, near and far, meanings and movements of shapes and brush strokes. You keep playing with the object.

Of course Hitchens' insistence on a 'natural way' is typical. No nonsense about three roses tastefully arranged in a vase – instead the scattered but disciplined profusion of, for instance, *Flowers Against Blue*

Patchwork of 1952, a rare vertical painting which, in explosive tones, juxtaposes the man-made colours of the cloth with the glowing subtleties of the petals and centres of at least seven different blooms in totally natural profusion. No doubt the naturalness was created by the artist in the first place; variegated flowers in full bloom do not just happen upon exactly the right squares of the covering of the marital bed. But the effect, in composition, in colour, in brushwork, is not 'carefully arranged' but is the effect, the dazzling effect, of the 'natural way'.

If natural is the key word for his flower painting it is even more applicable to Hitchens' figures. While figure painting in twentieth-century England has not fallen into the disrepute of the flower piece it has certainly declined; declined, it must be admitted, from a not particularly high peak. For doubtless infinitely complex reasons the greatest glories of English art have not included the nude. Constable, Gainsborough, Turner, Stubbs – giants all – have not concentrated on the human figure which seems, in its highest form, to have remained European property. We have no Delacroix or Ingres, no Goya or Velázquez, no Rubens or Renoir, and when an English figure painter has attracted a large following he has tended to the photographic vulgarity of an Etty or the mildly titillating, pseudo-erotic output of a William Russell Flint. In our own time it must surely be significant that the most powerful painter of the human figure, more often male than female, is Francis Bacon who has invested the human body not with sensual delight or beauty, but with a kind of putrescent horror and corruption, as if each subject were the real portrait of Dorian Gray.

Nor of course can one omit the nudes of Lucian Freud which, rather like Bacon, emphasize the unappealing aspects of the human body, both male and female. For my taste, Freud's rendering of the human body is almost the reverse of erotic. Particularly when he paints women there is something brutal and intrusive which subjugates rather than celebrates them, not a criticism one can lay at Hitchens' door. For him, his naked women are a form of enhancement and celebration; painted not with cold, clinical detachment but with warmth and love.

These are sad reflections because our century has seen two superb English figure painters – Matthew Smith, who has almost been given his due for the genre, and Hitchens, who has not, doubtless because his few people have been drowned in his flood of landscapes. The artist himself is wry and amusing about the paucity of nudes in his work. He always explains how difficult it is to get models down from London; how infinitely more difficult to keep them amused and awake while he paints

them; and how impossible it is to explain to them why he has to desert
them in a probably under-heated studio, because he has just seen a new
conjunction of hitherto familiar landscape through the window and must
abandon the girl, at least temporarily, in order to record it before the
memory fades.

The argument is persuasive and almost credible. Yet Hitchens,
even more than Smith, adores beautiful women. But the adoration is a
rational, human, aesthetic and artistic one. There is no Stanley Spencer-
like obsession, producing brilliantly painted female studies which simply
worked out the artist's own erotic fantasies. Hitchens' nudes, like all the
best nude pictures, are celebrations of the female body, and within his
huge output there is, despite all his disavowals concerning logistics, a
substantial *corpus* of figure paintings which, in quantity, must come close
to that of Matthew Smith and, in quality, is surely his equal; which is to
say that at his best he is as good as the best Europeans of the 20th century
– with the exception, inevitably, of Bonnard, who remains on his lonely,
inviolable peak, with Matisse in hot pursuit.

I once asked Hitchens if he saw even the human body in terms of
landscape, not least because virtually all his figures are reclining nudes
and thus the pictures are the same size and have almost exactly the same
proportions as the landscapes. His answer was characteristically assured,
for Hitchens has analysed and dissected his own work with far more care
than any mere critic could ever achieve

> I expect so. Yes, it is the same. It's the same problem, but much more complex
> really because in a landscape you can run your brush strokes upwards but of
> course a nude isn't a tree where it doesn't matter if it's going up. You have
> to organize a nude more subtly so that you've got to extend the bounds of its
> possibility… You are much more disciplined because of its known shape. All
> the instinctive background knowledge is there to bawl you out and stop you
> from doing what you want to do if it is wrong.

There are three things that make up a classic Hitchens nude, apart
from the habitual reclining form. (Hitchens rationalizes the almost
invariable posture as the one which is most relaxing for the model and
hence involves him in the least obligation to keep her busy or interested –
a typical courtesy from this infinitely gentle yet strong-willed man.) They
are the innate sensuality of the figure itself (not so obvious a component
as all that – think of the controlled distance and almost clinical coldness
of a nude by someone like William Coldstream), the vibrant distinction
of the colour (more adventurous and exotic even than that of Smith), and
the painstakingly built up, brilliantly contrapuntal effects of the various

sections of each picture. Two perfect examples, one fairly early, one more
recent, are the *Algerian Woman No. 3* of 1949 and *Figure, Blue Sky* of
1967. The former, although there are many valid comparisons to be made
between Hitchens' nudes and those of Matisse, in fact owes nothing to
the latter's monumental *Femmes d'Alger* nor to its eponymous progenitor
by Delacroix. If one needs to find a modern parallel or antecedent it is, if
anything, related by its sheer turbulence to Kokoschka's *Windsbraut*, but
Algerian Woman No. 3 is really *sui generis*. The pose, seen more or less
from aloft, is striking in that it is sinuously relaxed yet simultaneously
tensely erotic. Like so many of Hitchens' nudes the curvaceousness of the
body seems endless, partly because he eschews all angularity and partly
because the ankles and feet are missing so that, as the legs float off the
edge of the canvas, so the body seems to go on for ever. The definition of
shape is absolute, yet every outline, from the oriental planes of the face
to the languorous pose of left hand on left thigh, is soft and fluid. But
above all this great painting is a masterpiece of glowing and meticulously
balanced patches of colour, each individual, yet each reciprocated and
echoed by its counterpart. The dark patches of the *mons* and below the
breasts echo the top panel; the purple areas in the lower left-hand corner
coincide with the girl's upper hand and right leg; three separate yellow
patches set off the deeper, almost ochre tone of the trunk and thighs. In
composition, it is as subtle and complex as any of his landscapes, but in its
initial, physical impact it is direct, almost fierce, in its effect.

Figure, Blue Sky is altogether simpler. It would be tempting to say that
it represents a refinement of the techniques so dazzlingly displayed in the
earlier work but this is not really so. It is in fact much closer to Matisse in
spirit, or the American Milton Avery, in that the shapes and planes have
been fined down to an extreme simplicity and economy. The colours are
purer, simpler and fewer and the areas of paint less in number. The girl's
body is almost colourless and she is bordered by some virtually unpainted
canvas. She is supported on an area of purple which runs the whole width
of the picture and is answered by a large panel of blue for the sky, which
in its left-hand corner leads the eye straight to the partly stylized, slightly
twisted body of the figure. Her face is only rudimentarily sketched in and
her hair is spread out into two great wings of brown which not only frame
the face but also act as its background and constitute the third largest area
of colour in the picture other than the body. The whole composition is
daring in its simplicity and entirely successful.

These two paintings represent, as it were, the two extremes of
Hitchens' nude technique but each, with many of the pictures that come

in between, both stylistically and chronologically, shows him off as one of the finest painters of the female figure in the 20th century. They are erotic, sensual, joyous, and above all, supremely beautiful to look at, and in their apparent abandon and simultaneous total intellectual control show the artist at his very best.

The other genre which, of course, shows Hitchens at his best or, to his detractors, at his most monotonous worst, is the landscape. What self-portraiture was to Rembrandt, or the varieties of religious experience to El Greco, the landscape is to Ivon Hitchens. It is his obsession and it is his fulfilment. Even the few square miles of West Sussex are too much for him ever to record completely, and if some severe incapacity were to confine him to his own house then even the acres that he owns himself would prove inexhaustible. On his estate – one cannot call anything so magnificently uncultivated a garden – there is a pond which houses, among other things, a boat. Recently the boat was hauled out of the water and turned upside down to have its bottom scraped, and have done to it all the things that boats' bottoms periodically require. Whatever this may have done for the boat, the effect upon Hitchens was galvanic. The strong, clean outline and the beached-whale-like shape inspired a series of landscapes on which, as this is written, he is still working.

The simple solidity of the boat acts as the focal but by no means central point against which are balanced the fluidity of the water and the strong, upright shapes and movements of the trees. The structure of each painting and the interrelationships of boat, water, and foliage change constantly, as do their colours, the boat veering from purple to brown to black, in accordance with the vantage point, the season, the weather, even the time of day. The boat itself has had to remain stranded, out of the water, to become unfunctional except to serve paintings and painter, like the bowl of succulent fruit in a mordant short story by Osbert Sitwell called *Pompey and some Peaches* where the fruit could, and should, have given sustenance to a long-suffering wife, but instead had to remain uneaten and gradually rotting because the painter protagonist had to go on relentlessly pursuing the perfection of still-life after still-life.

This is not to say that Hitchens is a heartless or ruthless man like Sitwell's hero. As a man Hitchens has a rare sweetness and generosity of nature but he is, in his art, fiercely and appropriately, intellectually ruthless and no where more so than in his landscapes. I have mentioned earlier the inescapable heritage of Cézanne. One must not make too much of this or damage Hitchens by making hyperbolic comparisons in terms of quality. But it is clear that Cézanne's analytical quality and his use

of the skeletal structure of a landscape, so that one could almost see the bones of a mountain or a forest sticking out of the earth, was such an extraordinary development in landscape painting that the ripples thus sent out had massive and infinitely varied effects. It is hard to imagine, say, the roofscapes of Horta del Ebro by Picasso without the looming shadow of the Mont Sainte Victoire. Equally, that deep and, in all senses, elemental lesson has penetrated far into Hitchens' consciousness and his own lansdcape *œuvre* is unimaginable without the lesson of Cézanne. In those very early works of the twenties when the affair with Sussex was just beginning to develop, the 'Cézanne effect' was plain but superficial, rather as if in a picture like *Curved Barn* of 1922 he had drunk too deeply and too often at the well of Roger Fry. Yet as Hitchens matured and his art became more and more personal, so the lesson of Cézanne became more of a backbone to his work and less some kind of almost theatrical make-up. The elemental structural quality was absorbed in depth, and something very different and individual emerged. Just as Terwick Mill or Warnford Water took on the microcosmic aspects first of the English countryside and then of nature itself, so Hitchens miniaturized Cézanne's approach. Where Cézanne reorganized planes and created a new order out of his own upheaval of an entire countryside, so that one looked at scenery which had been painted much the same way for five hundred years with totally fresh eyes and the true shock of recognition which is the hallmark of great art in any medium, Hitchens transposed the larger upheaval and made an endless series of small reconstructions. One looks vainly in Hitchens for a panoramic landscape dominated by a great mountain. But what one does see, with a clarity which brings its own frisson, its own repeated small shocks of recognition, is Hitchens' extraordinary rapport with the individual components that make up the wholeness of a large landscape. One sees trees, foliage, water, earth, and sky with a unique closeness. In his best landscapes Hitchens can make one see the essence of a tree so that it becomes almost a philosophical concept of a tree, and if that sounds pretentious then consider what one may learn of apples from the still-lifes of Cézanne, or look at *Divided Oak Tree No. 2* of 1958 and then try to respond to any stricken tree encountered later on in quite the same way as before. The two major aspects of any good Hitchens landscape are its selectivity and its compositional structure. Naturally the two are inextricably linked and mutually interdependent, but while each selection probably admits of only one composition, a given view can, and for Hitchens often does, produce a variety of selections. The artist himself is eloquent on the subject:

In my own case I think that after that first impact, which is very vital because you have got to strike your contact with life, I've got to think to myself how is it going to be best to represent that on canvas – this complex subject that I see in nature. Nature contains everything really – it is only limited by our own consciousness looking at it, and a degree of my own consciousness, the shaping of my thoughts at this time, filters out the ideas that are in my head; filters out, really, what my eye is capable of seeing. And so, given this particular landscape, which is trees and houses and hills behind, a stream of water... the good old traditional way sorts them out into some means of converting them on to canvas and you stick them down on canvas and they make some sort of sense... I find myself faced with a different problem. I tend to like not one but two views because it becomes much more interesting. One says A and the other says B, and I have to decide in my mind which is the more interesting, A or B, of these two component parts. Both have got to be united to make the whole but at the same time A is more intricate, sharply crystalline, detailed. B is softer in a way, perhaps, full of rounded shapes. Yet both are the same landscape. What am I going to do about that? Then I have got to think that out. The nearest part is the sharp crystal one and the soft one is far away B, but the fact is that I am going to be hit in the eye by A, and B is going to be far away and I shall be so occupied looking at A that my attention doesn't really go through to B. And that's probably not really what I want because, finally, the interest perhaps of the subject is something else that happens a bit nearer B; but I really want it to be the right relationship.

Of course, Hitchens being Hitchens one can be reasonably sure that he will paint A and then B and then the elusive middle, and will then see yet another aspect demanding to be recorded. His selectivity for each canvas is circumspect, sparse and carefully thought out, yet, in the end, he remains an artist for whom selectivity means, instead of weeding out, being all-embracing so that he can satisfy his omnivorous attitude to the scenery which truly, in all meanings, supports him. With approval he quotes Matisse as saying that the artist's chief object is to spread the artist's interest all over the canvas surface. Hitchens does the same, to please himself and, eventually, to please the viewer. His selections, however copious, are not random; his ruthless eye filters out the dull, the inessential, the distracting, and places before us only those forms which interest and please him. Yet he is, while doubtless arbitrary (as he is entitled to be), always truthful. He selects, as any test of picture and scenery *in situ* will prove, only what is there. He paints what he sees at the time and then makes us see, with newly opened eyes, that lake, that waterfall, that patch of sky as framed by two adjacent trees, that ride arched over by tumultuous linking clusters of foliage.

If Hitchens' processes of selection are peculiarly his own the structure of his landscapes is also unique. The reason for their 'Cinemascope'

shape is simply that the traditional square or near square rectangle are inadequate for the needs of his lateral designs. He has to have the extra horizontal space which his wide canvases afford him, because nearly all his landscapes are composed of several sections. Very many of them are in fact triptychs; some are even divided into four or five sections. The classic Hitchens landscape has to be 'read', rather like a Chinese or Japanese scroll.

Hitchens is fascinating on the design of these paintings :

> I'm really only interested in the structure of the three-dimensional canvas – the visual structure... It's really converting the current distances of reality, near and far and half-way back, into two dimensions so that only as your eye travels around the passage, the two-dimensional passage, dark to light and light to dark, warm to cool, cool to warm or broad up to narrow – as it travels along these things – so it suddenly subconsciously finds it's doing something in depth as well.

This is of course a marvellously lucid exposition of an individual 'section' of a landscape, and in any typical work the three or more sections not only exhibit these characteristics (look for example at *A Boat and Foliage in Five Chords* of 1969) but they complement each other, and relate to each other, by an external logic described above by Hitchens. He often sees the individual sections as self-contained parts, rather like the movements of a symphony, and often, although far from invariably, he sets a horizontal section against, rather than merely next to, a vertical one. Thus a left-hand section (Hitchens usually wants his pictures to be 'read' from left to right) might well be composed of the vertical strokes of tree trunks, and the next one along of broad horizontals for the central path of a woodland ride or the placid surface of a pond.

As Hitchens himself points out, occidentals all tend to 'read' more easily, and hence more readily, from left to right. But in recent years he has found

> a tendency to select subjects that will 'move' from right to left. On all occasions a too violent horizontal movement needs an 'opposition' to stop it. This, of course, is specially applicable when the action is approaching an abrupt halt at the frame edge. Before then some transition is desirable either in a convenient tree or building form – or in the direction of a brush stroke.'

The analogy of the symphony which is one much loved by Hitchens himself is an apt one in that, like the movements, each section is a work in its own right, because it is self-contained, yet it is not complete in itself.

Just as one has to hear the whole symphony to understand it, no matter how affecting and seductive one might find a *scherzo* or an *andante*, so one has to read the whole of a Hitchens landscape, all the way from left to right, before one can really stand back and comprehend the whole.

Not all his paintings are thus constructed, or require that effort from the viewer. Some, like the wonderful *Waterfall, Terwick Mill* of 1945, while still composed of juxtaposed vertical and horizontal planes and panels of colour, are not so rigidly divided into separate sections. Some of the later works, particularly those with water as their principal theme, are much more unified in structure.

Since Hitchens acquired a cottage on the seashore at Selsey Bill (still of course in Sussex!) he has painted some almost miraculous seascapes. They are totally unconventional, owing nothing to any predecessor who has tackled that most difficult of subjects, and belonging firmly in the tradition of his own work. Yet a picture like *Red Shore* of 1967 has a wholly different fluidity of movement from, say, the Warnford Water series of 1960. The simple limitations of sky, water, and flat shore have paradoxically produced what is almost an uncharacteristic wildness of technique and the result is a sumptuous explosion of colour.

Landscape then, carefully plotted, analysed and structured, but always lovingly painted with a marvellous richness and variety of colour, is Hitchens' main preoccupation and hence his trademark in the art world. Yet he is also a consummate painter of murals on a grand scale, of flowers, and above all of the female nude. A fair proportion of his enormous output does not work and he undoubtedly lacks, as so many artists do, a sufficient capacity for self-censorship. He is in no way an easy artist to approach. All his work is intensely subjective and there is no convenient objective correlative. Everything is in the eye of the artist-beholder and *sauve qui peut* for the viewer-beholder. Like all true artists he works primarily to please himself. Those who look at his paintings can rarely get away with doing so casually. But if the viewer goes only a little way to meet the artist, to enjoy the sheer sensual delight and compelling intellectual daring of his work, he will, I think, see in the art of Ivon Hitchens some of the finest English and indeed European painting of the 20th century.

THELMA HULBERT

1913 – 1995 – A MEMOIR AND AN APPRECIATION

Thelma Hulbert, while never fashionable, and more or less totally without either fame or fortune, was a most interesting and gifted English painter and, through her friendships, an artist of considerable, if discrete influence. Born in Bath in 1913, she studied at the Bath School of Art and came to London in 1934.

Soon afterwards, she joined the School of Drawing and Painting, founded by William Coldstream, Claude Rogers and Victor Pasmore. She joined as a pupil and fellow students included Graham Bell and Colin MacInnes. Older mentors included Duncan Grant, Augustus John and Paul Nash. MacInnes has memorably described what is now simply known as The Euston Road School and Thelma's role there:

> The first person I saw when I climbed the autumnal stairs up into the school, was Thelma Hulbert. She was then acting as part secretary, part painter, and she sat at a table radiating shy, contained, uncensorious affability. I must instantly confess that I then had no inkling that Miss Hulbert would become the admirable painter that she is today. This was partly because I was too preoccupied with myself to be much interested in anyone else, and partly, I fear, because of masculine vanity. It now seems to me that of all the painters working at Euston Road, her development has been the most remarkable; and also that she is the artist who has most fully transcended the limitations of the Euston Road manner, and created a visual world of power, beauty and originality.

Inevitably someone of Thelma's disposition made many friends and, for a time, she shared a house with Merlyn Evans (another unjustly neglected artist and the father of the distinguished architect Eldred Evans) and his wife, the pianist Margery Few, and Penelope Sims the cellist.

During the war she worked in a canteen for refugees and, in the fifties, was a much loved art teacher at Camden School for Girls. After the recognition she received because of her Whitechapel retrospective in 1962, she was given teaching posts first at St. Albans School of Art and then at the Central, which wisely kept her on until her retirement, after which she moved to Honiton in Devon, where she painted and drew until shortly before her death in February in 1995.

I first met her in the early sixties, shortly after her great Whitechapel show at the end of 1962. At the time I was a tyro publisher working at Thames & Hudson and my considerably less tyro-ish colleague Pat Lowman, later to become Pat Mueller, and eventually one of Thelma Hulbert's executors, introduced me to her. I was, I suppose, in the first

This piece appeared in the London Magazine *issue of December/January* 1997.

flush of art: beginning to publish art books on my own initiative, to write for some of the minor art journals, and to acquire a few drawings and paintings (collecting is far too grand a word for my exiguous budget). Pat took me round to Thelma's studio for a drink and to look at the pictures. She led me confidently through the mazy tunnel that debouched into Thelma's fairy grotto, a huge Victorian room whose original function no one appeared to know. Impossible to find unless one was, as it were, in its confidence, it combined a lavishness of scale with an almost paranoid discretion.

Was it the hideaway of a rich man's mistress, or an oubliette for either a bastard or an imbecile child? We shall never know, but all those who saw it, transformed by Thelma into a perfect studio and home, will never forget it. In the profusion of its ill-matched but entirely complementary furniture and the wealth of painterly equipment and the veritable jungle of vegetation one should have found chaos and disorder but instead found orderly design and calm.

At its heart stood its chatelaine, quite as impressive and as beautiful as any chatelaine in the Loire Valley. Since I was as much a tyro with women as I was with publishing at that time, even though, ungallant as the thought is, Thelma was old enough to be my mother, she was, in her late forties, overwhelmingly beautiful, and even today I find it painful to remember how tongue-tied and clumsy I felt.

This was of course a product of my callowness, not of the hauteur or *étonne-moi* quality that many beautiful and gifted women exude. Thelma, for all the steel inside her, which made her such a formidable painter, in fact exuded sweetness, gentleness and – that word we now all find so difficult to use – goodness. Her Victorian habitat was not inappropriate and Dickens would have been entirely at home with her and she would have fitted in perfectly with the Cheeryble brothers.

Because Thelma was indeed good and kind, she managed to melt my clumsiness away and I managed to express my admiration for her work and express my regret that I couldn't buy even the most modest of her pictures since about six month's salary would have been necessary even at the relatively low prices she charged. I left Holland Park entirely bewitched. Thus, when a few months later, Pat Lowman wandered into my basement office to ask whether I could try and help Thelma out of a fearsome mess, I immediately buckled on my armour determined to ride to the rescue.

Thelma, particularly for the Whitechapel show, with nearly two hundred exhibits, had had all her paintings and drawings sumptuously

framed by the best framer in London of those days, Robert Sielle. Sielle, who was, at the very least, an artist *manqué*, had done a wonderful job but Thelma, whose business sense was non-existent, had not asked for an estimate first and had no idea what a top framer charged, particularly to top artists, which in his eyes Thelma, with a Whitechapel retrospective, indubitably was.

When the bill came Thelma, whose prices were very low by the standards of contemporaries such as Victor Pasmore and who had no regular dealer to look after her in these matters, was shattered and desperately worried. Would I, asked Pat, use all my negotiating skills to get Thelma out of this mess? To please Thelma was of course a joy for me, but how to cope with Sielle, with whom I had no standing whatsoever, was altogether a horse of another colour than any white charger I fancied myself upon.

I phoned him, explained who I was and went to see him. The pre-inflation figures involved would be meaningless today. Suffice to say that they represented something like three times my junior publishing executive annual salary and came to somewhat more than Thelma had earned from sales of her pictures in a lifetime.

Sielle was as charming as he was talented and gracefully accepted me as Thelma's representative, and battle commenced. After two courteous but tenacious hours an honourable draw was declared. Thelma's debt mountain became a smallish hill and she was given time to pay.

I took back this modest victory to Holland Park, and a grateful Thelma, the shades of imminent bankruptcy, homelessness and worse instantly banished, insisted on presenting me with an exquisite small painting of a fish under water that has now lived in my study for more than thirty years.

A few years later I did some minor piece of publishing business with our then Ambassador to Teheran, Sir Denis Wright, who generously, since he had no children himself, invited me to stay, complete with wife and nine-months-old son, at the Embassy. Relationships with Lady Wright were as impeccable as you would expect between a perfect Foreign Office wife and complete strangers passing through and unlikely to be seen again. But once inside the private sitting-room I said, with all the pomposity of the self-styled expert on alien ground, 'Good heavens! That's a Thelma Hulbert!' as indeed it was and all ice was immediately broken, not on the grounds of my recognition, but because Lady Wright, as Iona Craig, had shared a flat between the wars with Thelma in a house in Charlotte Street, once owned by Constable, when they were fellow art

students and very lively girls about town. They had, despite the rigours
of the diplomatic life, remained the closest of friends. -I have said that
Thelma was beautiful and when I think what she was like at nearly fifty,
with a thick mane of dark hair and voluptuous figure, how wonderful
she must have looked when young and acting as Secretary of the Euston
Road School, and how lucky were those male members of the School to
whom she was attached. I have already invoked in a Dickensian sense
her goodness which was not the wishy washy, goody-goody wetness of a
Dora or an Agnes in *David Copperfield*, but a real goodness and generosity
of the spirit which perhaps only Dickens was capable of setting down in
print – one thinks of Mr. Brownlow in *Oliver Twist*...

Despite her wonderful feminine qualities and several love affairs with
genuinely distinguished men, Thelma was surely wise not to marry at a
time when marriage still meant subservience and the sacrifice of a career,
or in this case vocation, to inevitable housekeeping. Her inner core of
steel as a painter was too important thus to be wasted.

Many of the Euston Road School artists strike one as being if not
cold, at least a bit chilly. Claude Rodgers alone among the men brought a
sensual warmth to his landscapes in particular. But Victor Pasmore's path
to abstraction seemed inevitable and his brilliance there clinical rather
than sensual. Coldstream and Gowing both carried coolness to the point
of frigidity.

Thelma, in art as in life, was always warm and sensual. Her
Mediterranean landscapes, eschewing the clichés of blazing sun,
nonetheless resonate with heat and light, as in the exquisite *The Roof, Ischia*
of 1959. Her domestic interiors, as redolent of her studio surroundings as
Hitchens' landscapes were of the few hundred square yards of Sussex
where he lived, have a quiet and luminous intensity which lives in the
memory.

Her sense of the domestic, of the movement of a curtain in a breeze,
of the placing of a bloom in a vase are as sure-footed as anything we find
in Vuillard. And while obviously she lacked a bath-obsessed wife, (or was
it his obsession?), she shares with Bonnard, and is entirely worthy of the
comparison, that glowing sense of joyous sensuality to be found in the
most apparently mundane interior.

Look at *The Gauze Screens*, two of her most important paintings, one
of which happily, if belatedly, has just been acquired by the Tate Gallery.
These intimate and delicate works are in fact monumental and if the
words had not been so tarnished in this century one would describe them
as full of strength through joy. For me, Thelma has one extraordinary

talent which, as I write this on a Mediterranean terrace, overlooking a rocky beach, has me searching quite vainly for any parallel in twentieth-century painting. As I know from the fish she gave me all those years ago and from *Lobster and Crayfish* which I bought more than three decades later from her estate, she could recreate water and the live and inanimate creatures and things beneath it like no one else. The shifting shapes, the evanescent, always changing colours, the multiplicity of shades, the swift, instantaneous sensual appeal – all these things are an astonishing act of virtuosity. If that makes it sound like a technical trick, then I have expressed it badly. This is no trick. It is an artistic act of total skill and total integrity.

Among British art critics, not for the first time, Bryan Robertson was wonderfully perceptive and, via his patronage at the Whitechapel Gallery in its heyday in the sixties, her great champion. Colin MacInnes was also acute in his reading of her work.

Man himself appears in her pictures only obliquely: we do not see him much, but we constantly feel his presence. There are views of rooms and of windows opening onto the natural world, and even in those paintings where the direct evidence of man is absent, we feel he is there because Miss Hulbert has the rare gift (found also among Chinese artists and some of the English watercolour painters) of implying, in her landscapes and still-lifes, that man is involved with these – is inevitably a part of, and at one with, nature. In much European landscape, even the very finest, the artist looks at the natural world as if, however superb, it is an alien element. Miss Hulbert recognises no essential distinction between all nature's living creations.

As I contemplate the posthumous retrospective at Central Saint Martins, I cannot help thinking that here is a great British artist who, perhaps because of that personal integrity which caused her to avoid the world of dealers and hustle and hype, has never won the recognition and honour she so abundantly deserves, but who will indubitably live on wherever those who truly love the art of what was some years ago described rather contemptuously as 'easel painting' still survive.

WYNDHAM LEWIS'S RATIONBOOK
Reminiscences of a Lewis aficionado

Like many people of my generation, although conventionally and thoroughly taught – Perse School and Pembroke, Cambridge – most of my extra-curricular education came from the heyday of the BBC Third Programme, not to be confused with its pale successor Radio 3, now little more than an up-market Classic FM without the advertisements.

In my teens I listened to a radio drama adaptation of Wyndham Lewis's *Tarr* starring one of the BBC's finest radio actors, Stephen Murray. For me it was not just Murray's distinctive voice that beguiled me through a long evening. Instead I was mesmerised by the authorial voice of Wyndham Lewis, which needs no gloss here. All that fuss about a frac; all that coruscating warfare between singularly unlovable characters. Nothing could have been more remote from my then literary interests, which were essentially dramatic and admirably fed by the Third Programme's cornucopia of Ibsen, Strindberg, Chekhov *et al.* to supplement the school diet of Shakespeare and the Restoration dramatists. So *Tarr* was tucked away in my mind and was to remain un–read in its original form until, some time in the 1970s when, it being already clear that I suffered from advanced bibliomania, I became a serious Lewis collector and acquired a first edition.

It was not, of course, the first interesting Lewis book that I bought. That was *The Apes of God* in its second, 1955, edition with the wonderful jacket, of a sinister ape holding a whip, by Michael Ayrton. One of a thousand signed by Lewis it was copy number 35, had been priced at three guineas when published, and cost me thirty shillings in the tiny second-hand bookshop in Perrins Court in Hampstead, invariably visited on my way to the Everyman Cinema round the corner. Looking back, I can see clearly that, within a library that now consists of about 7,000 volumes, this simple, single purchase proved to be the most intellectually stimulating of my long bookish life. First of all it's a preposterously engaging book. Secondly the Ayrton jacket is dazzling as an image of the book, as a piece of design and as a very typical work by Ayrton. Of course I had no knowledge at the time of the link between Lewis and Ayrton and while, alas, I never met Lewis I had not at that stage met Ayrton either. The closest I had got to Ayrton was my purchase, as an undergraduate, from the Cambridge University Contemporary Art Society, of a small oil painting called *Gethsemane* which Ayrton had painted in 1947 while he and Graham Sutherland were working together in Wales. (If the reader should think this an irrelevant digression by an elderly literary gent he should be assured that from this Ayrton connection flows virtually all

This essay appeared in the Wyndham Lewis Annual, Volume IX and X of 2002–3.

of the Lewisiana that follows.) It cost me ten pounds. I met Ayrton a few years later when we were the judges for a painting competition in Cambridge (we were each paid five pounds in cash for our labours). It had been a dull competition and, by silent common consent, we left the gallery to find the nearest pub where we drank our fee and began a friendship that lasted until Ayrton's untimely death in 1976. It was then that I, with much sadness because of the actual necessity, became his literary executor.

The friendship grew as I published books by Ayrton and his wife Elizabeth, and Michael and I, fuelled by the fact that our wives were both cooks of superlative quality, spent many evenings together in a relationship of much intellectual depth. It was through these discussions that I learned of Ayrton's role as Lewis's amanuensis in his declining years; while Lewis grew blinder and blinder, Ayrton did his book jackets and even finished off some of his half-completed drawings.

As I learned more and more about Lewis and Ayrton so, inexorably, I became a collector of both, albeit on a modest scale. The true collector will of course forgive and understand the insanity that means that my Lewis shelves contain all his first editions which are wrapped in Ayrton jackets, and my Ayrton shelves contain all the Ayrton jackets that are wrapped round Lewis books. (To me this is entirely logical. After all, one of my sons might inherit the Lewis collection, the other might get the Ayrton.)

Inevitably, since I was always an art critic as well as a publisher, I wrote frequently about Ayrton, as reviewer or as author of a catalogue introduction for one or two of his exhibitions. But I wrote only once about Lewis's art and that was when the National Book League mounted, in 1971, a major pair of simultaneous exhibitions devoted to Lewis and Ayrton and I was invited to write the joint catalogue essay which, as examiners used to put it, compared and contrasted their visual and literary *œuvres*.

It would be both immodest and tedious to quote my own work of thirty-odd years ago but I shall reproduce some of the key quotations I used to illustrate the subjects of my essay. Surely there is nothing more apt or more moving about Lewis than Ayrton's words from his essay 'The Enemy as Friend' reprinted in Ayrton's collection *The Rudiments of Paradise* (Secker & Warburg 1971):

> [I]n the Redfern Gallery, during his 1949 show … I wandered in to find two silent figures contemplating the exhibits. One of these was Mr T. S. Eliot, dressed with quiet elegance in a blue business suit, stooped like a benevolent

osprey and gazing intently at Lewis's early self-portrait. This imposing picture shows the artist gazing stonily out from the canvas and wearing a large, fierce hat. The sole other occupant of the room was Mr Lewis himself, wearing a large, fierce hat and gazing stonily at his own portrait of Mr Eliot, a picture in which the poet is dressed with quiet elegance in a blue business suit.

I also quoted Lewis on Ayrton:

> When interested by the work of one of 'the young', I like if possible to check up on personality and physique. For I know that this poor devil has to pass through two or more wars, a revolution, and a number of depressions. Most, I feel, will fall by the wayside – their talents will die, if they don't. But about Michael Ayrton I entertain no anxiety; his stamina is unmistakable, since it is of a piece with the air of stability possessed by his work. At the Redfern Gallery, where he is holding an exhibition, is the classic serenity he so much prizes—even to a touch of coldness. When the women are symbolically distressed, or distracted, by the first signs of a great storm, it is but in a rhythmic trance of distraction. With Michael Ayrton, unlike the other 'young', we have emphasis on subject-matter. It was in Italy he found this specific material, and found himself too, I believe. He may be the bridge by means of which the British 'young' move over into a more literary world again. Michael Ayrton is one of the two or three young artists destined to shape the future of British art.

The resonance of that quotation both then and now was enormous. In part it was because one of my idols was praising one of my friends. In part it was its source, one of Lewis's reviews of 1949 as art critic of *The Listener*.

In part also it was because in the 1960s I had accepted an invitation to become art critic of *The Listener* myself. At the time it seemed an awesome responsibility to sit in the chair once occupied by Herbert Read and Wyndham Lewis. I had only minor qualms about Read since he was an author whom I published and was also a friend and we often discussed contemporary exhibitions. But Lewis was, for me, a long-dead God-like and fiercely irascible figure and I did not want to be haunted by him and subjected by his ghost to the sort of indignities he had visited upon Bloomsbury.

The other quotation in my essay to be re-quoted here reinforced that last point. I had by that time acquired the first edition of *The Apes of God*, the one done in 750 signed copies, with the jacket by Lewis himself, and I had dipped into it again to savour his mordant attacks on the Sitwells.

How then could I not quote Auden's lines:

The Sitwells were giving a private dance
But Wyndham Lewis disguised as the maid
Was putting cascara in the still lemonade.

*

To me there are few nicer serendipities than that one of the powerhouses
of posthumous Lewis activity should be a rambling, medieval house, partly
built in the eleventh century, and once owned by that hyper-elegant and
fastidious man of letters Sir Francis Meynell, creator of the Nonesuch
Press, that great monument to scrupulous editing of definitve texts and
flawless design and book production standards. His house, Bradfields, on

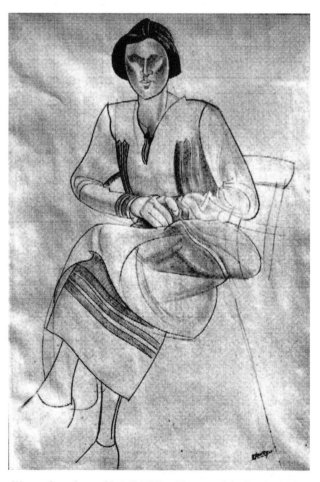

Woman Seated on a Chair (M498) – Photograph by Raphael Munton

the Essex–Suffolk border, was, until Michael died, the ever-hospitable home of Michael and Elizabeth Ayrton.

It was at one of the many weekends my wife and I spent there that I met the American scientist and Lewis expert Walter Michel and learned that his life work was the *catalogue raisonné* of Lewis's art. Apart from the fact that Michel was a thoroughly delightful man, it was also a personal pleasure to be able to tell him that I was the new owner of *Woman Seated on a Chair*, the portrait sketch of Iris Barry (who had borne Lewis a son), which I had just bought for £200 from the Piccadilly Gallery and whose new provenance Michel duly noted. (Barry's son Peter was, until his death, a member of the Wyndham Lewis Society.) The rest was boring, technical publishing talk which resulted in the eventual successful publication of *Wyndham Lewis: Paintings and Drawings* by Michel under the Thames & Hudson imprint in 1971. Apart from providing the picture known as Michel number 498, I had made my first significant contribution to Lewis publishing.

At about the same period my wife and I were just packing our bags one Saturday morning to drive to Bradfields for the weekend when Michael Ayrton phoned to ask whether we could give a lift to Hugh Kenner who was to be a fellow guest. To which I responded rather ungraciously that that depended on how big Kenner was. 'Same height as me but thinner', said Michael. 'Why does it matter?' 'Because', I said, 'he has to fit into the back of our Mini.' So we crammed this great academic figure into our Mini and another Lewis link was forged, and I persuaded him to write the luminous introductory essay that prefaced Michel's study and gave it the academic clout that I needed to sell a substantial American co-production to the University of California Press. (Incidentally Michel is, of course, long out of print and the most recent copy I have seen in a specialist second-hand art bookshop was priced at £400.)

My other contribution to Lewis studies in that same year was the invaluable collection *Wyndham Lewis on Art*, edited by Michel and the indefatigable C. J. Fox, one of the few Canadians to have rated his fellow citizen as he deserved.

Hugh Kenner was also responsible for another, to me even more interesting, piece of Lewis publishing. To my shame, lessened to some extent by the fact that Ayrton had not heard of it either, I knew nothing of *The Roaring Queen*, largely on the grounds that it had never been published. Hugh maintained that the only extant copy was a proof of the Jonathan Cape edition in the University Library at Cornell. So I phoned my friend Roger Howley, the director of the Cornell University

Press, and persuaded him to have a photocopy made and sent to me at my office in Secker & Warburg to which publishing house I had by then moved. I read it with immense joy and saw at once why, no matter how outraged Lewis had been at the time, Cape could not have published it in the 1930s. All my publishing life I had been plagued, as were my colleagues and competitors, by libel writs, and as *The Roaring Queen* had virtually undisguised scabrous portraits of, among others, Arnold Bennett (Samuel Shodbutt), Walter Sickert (Richard Dritter), Virginia Woolf (Rhoda Hyman) and Brian Howard (Donald Butterboy), I could entirely sympathise with Cape's inability to go ahead. The only character who would not have sued was Nancy Cunard (turned by Lewis into Baby Bucktrout) since she had originally wanted to publish the book herself, but felt unable to pay the needy Lewis an advance.

Interestingly, although Jonathan Cape, Secker & Warburg and virtually every other London literary publisher had been put on notice that they would have been sued for libel if they were to publish *Heritage*, the autobiographical novel by Anthony West containing a fairly cruel attack on his mother Rebecca West and a portrait of his father H. G. Wells, thus effectively suppressing the book in England until after West's death, she was not thought to be a threat to *The Roaring Queen* in the thirties. Victoria Glendinning has however stated in her biography, *Rebecca West: A Life*, that Rebecca believed herself at the time to have been the origin of Stella Salton.[1]

Ironically, there is one other significant character in *The Roaring Queen*, a thoroughly venal book reviewer (other than Arnold Bennett), called Geoffrey Bell. He was none other than Gerald Gould, father of Michael Ayrton. Michael only discovered this, at the same time as me, when he read the photocopy I made for him.

I was myself ready to publish, with an introduction by Walter Allen to set the book against its 1930s literary and political background and a jacket design of course by Michael Ayrton – it was a fine caricature of Arnold Bennett in his prime – when I experienced that moment of dread which so many publishers occasionally feel, when they know something might go wrong.

Publishing in my time had become increasingly bureaucratic but in the twenties and thirties it was much simpler. I suddenly thought – the Secker edition was by that time in page proof form and had been announced in our catalogue – that it was more than likely that in those carefree, unbureaucratic days no one would have bothered to cancel the contract for a book withdrawn for fear of a libel action, and that there was

[1] *Heritage* was in fact then published by me at Secker & Warburg. The book had been published without difficulty in the United States, where the libel laws are much more relaxed.

a strong probability that the house of Cape still held a valid contract, with an exclusive licence to publish, for *The Roaring Queen*. Happily Graham C. Greene, nephew of the novelist and managing director of Cape, was a good, if competitive, friend and I went to see him in his Bedford Square office and explained the circumstances. Good fellow that he was, and is, he checked the Cape contract files, confirmed that my suspicion was correct, but stated that he would not interfere with our arrangements with the Lewis estate.

I celebrated this happy escape by publishing a special deluxe limited edition of the book, of which only 100 copies were for sale, signed by Mrs Wyndham Lewis, Walter Allen and Michael Ayrton, whom I had commissioned to do an etching for the edition. Michael produced a marvellous portrait of Lewis in hatted, Tyro mode, with the title 'Mr Wyndham Lewis regarding, with distaste and rancour, the literary establishment of the 1930s'. When the limited edition had been properly bound and boxed, I asked Graham Greene to come to my office for a drink and presented him with one of the out-of-series copies to demonstrate that it isn't always true that no good deed ever goes unpunished.

The relative success, no matter how belated, of the first publication of *The Roaring Queen* prompted me to do a new edition of *The Revenge for Love* which I felt had been out of print for far too long. I had become friendly with Julian Symons and I persuaded him to adopt the Walter Allen role and write the long background literary essay to set the book in its context for 1982. So it was only natural that, in our discussions over lunch one day, after I moved on to run André Deutsch, our shared enthusiasm for Lewis should lead to Julian's admirable anthology *The Essential Wyndham Lewis*, edited and introduced by him with his habitual incisive authority, and published in 1989.

Among my more treasured volumes is Julian's first book, the collection of poems entitled *Confusions About X*, undated but published by the Fortune Press in the late thirties. As Lewisites will know it contains as a frontispiece Lewis's superb ink-drawing portrait of Symons. Having discovered the book for a modest sum in the Charing Cross Road I got Julian to inscribe it to me, and he wrote me a note in December 1990 which, to me at least, sums up the essential integrity and humanity of one of Lewis's staunchest supporters:

A note for Tom Rosenthal, December 1990: 'X is the kiss of the unknown' – I am not sure whether I derived a title from that line of Roy Fuller's or whether Roy took his line from my title. Anyway, that was the idea – to

express confusion about the unknown, about what was going to happen. I only wish the poems, some jejune, others barely comprehensible, lived up to the title. Are just two or three less than shameful? I hope so. What's certain is that none of them are deserving of the splendid Lewis drawing, done in less than half an hour, which seems to me one of his finest pieces of the late thirties.

Inevitably, in a lifetime of compulsive collecting, one is going to pick up quite a few oddities, ranging from the Chatto & Windus 1919 illustrated monograph on Harold Gilman by Louis F. Fergusson with an introduction by Lewis, to a copy of the not very interesting *Madness in Shakespearian Tragedy* by H. Somerville, which also carries an introduction by Lewis.

I also own copy number one of the 79-copy signed limited edition of *The Wild Body*. Among other treasures is *The Ideal Giant*, signed in 1917 by Lewis 'With the author's kind regards', but there is alas no evidence of who was the recipient of those regards. I had spotted it, at

Two views of Lewis's 1918 ration book – Photographs by Raphael Munton

an exorbitant price, in a Modern Firsts catalogue issued by an academic and then provincial bookseller in Leamington Spa called R. A. Gekoski. I phoned him to say that the price was ludicrous and was there anything to be done about it. Rick was, and is, a very shrewd dealer and refused to discuss the price but said that when he was next in London he would visit me and show it to me. So he brought it to my office and, of course,

once I'd seen this bizarre artefact, one of a printing of 200, and that heavy, spiky black ink inscription I was done for, but at least I was able to bargain the price down from ludicrous to merely outrageous and Rick has become a friend for life to me (if not to my bank manager), as well as the leading London dealer in Modern Firsts. He has been designated in my will to be the man to sell my library (including all my Lewis books) if my family don't want to keep it when I pop my clogs. But nothing is quite so odd as a find in New York, namely Lewis's ration book. To someone with an impoverished wartime childhood in Manchester who remembers rationing all too clearly, this was an irresistible purchase which has given me particular pleasure. But it was only as I was looking more closely at my Lewisiana to prepare for the accuracy required of this article that I examined this fragile document with a magnifying glass and discovered that it is not a cousin of the ration books my mother struggled with at home while my father was doing his bit in Egypt. Nor is it, as I had carelessly assumed, from World War II when, as I knew via Ayrton, T. S. Eliot used to help out the Lewis household with the odd care package from Fortnum's and occasional bottles of champagne. The ration book in my possession is from World War I. It was issued at Paddington, has the serial number N27 NO.898373 and bears the rubber stamp of Whiteley's of Queen's Road W2, a 'Butter & Margarine retailer'. The 'signature of holder', repeated several times, reads P. Wyndham Lewis and the date is indubitably '29.11.1918'. The address is given as 38 Bark Place. Interestingly enough the bulk of the meat coupons are unused. Will this spawn a thesis that Lewis was a vegetarian, or does it mean merely that he was too broke to afford meat?

My relationship to Lewis is not a simple one. As the London-born child of German Jewish refugees who fled to England as early as 1933, and as one who was brought up as an orthodox Jew, Lewis's political attitudes as expressed in the early thirties, notably in his book *Hitler* of 1931, were not so much problematic as repugnant. When one is young, tolerance and maturity are not one's strongest suits. It was this attitude that made me refuse to speak German after September 3 1939 – I had been until then bilingual – and to refuse to learn the language at school until it was too late and I realised only in my twenties how foolish I had been.

But gradually I learned a little wisdom and began to understand that Lewis's anti-Semitism and espousal of Fascism was simply endemic among vast tracts of the intellectual classes in England and Europe, and he was just a part of a movement that included T. S. Eliot, Ezra Pound and others whose dislike of Jews was an unthinking knee-jerk tic based on

prejudice and lack of knowledge. After all, Michael Ayrton, himself a Jew (a member of the Zangwill family), and someone who could spot an anti-Semite at a hundred paces, worshipped him. And, most importantly for me, Lewis, unlike Eliot and Pound, changed his ways and even recanted. To the best of my knowledge Eliot never acknowledged error in that department. And Pound of course we all know about. Lewis published two entire books which, while hardly an apologia for Judaism, were at least a powerful setting-straight of the intellectual record of anti-Jewish race hatred.

His *The Hitler Cult* of 1939 was a powerful anti-Nazi polemic. 'A Sunday School of Sunburnt State paupers armed to the teeth' is a vintage Lewis condemnation. There is something very prescient in the J. M. Dent blurb – remember that this was written in 1939, before the war had begun:

> And finally it is predicted that this 'Marxist Cecil Rhodes' will be less lucky than was the famous Englishman, not having Mashonas and Matabeles to deal with; that this latter-day Rotarian Caesar will lose the Empire he has, rather than acquire a new one.

The comparison with Rhodes is absurd and the remarks about the Mashonas and Matabeles are offensive to modern ears, but he stated clearly the unfashionable view – assuming that, like most polemicists, Lewis wrote his own blurb – that Hitler was loser rather than saviour.

In the same year Lewis published *The Jews: Are They Human?* In his Foreword he wrote:

> 'Jews are news.' It is not an enviable light that beats upon the Chosen People … Germany, Hungary, Italy, Poland, Czechoslovakia and other countries, are freezing out their Jewish minorities by means of what has been described as 'cold pogroms' … The governments of those foreign counties regard their Jewish citizens as 'undesirables". It is the intention of the Hitler government, for instance, to have made Germany *Judenrein* [Jew-free] in two years' time. This would entail the migration of 600,000 Jews.

There is dreadful irony in any contemporary contemplation of Lewis's statistics but, I stress, he was writing in 1939 and this book is, as a whole, a thoughtful, thoroughly humane and decent work for its time, even if to our ears today it sometimes reads patronisingly.

I therefore had little difficulty in coping with Lewis as a whole. The early blind spot about the Jews faded against the powerful searchlight of Lewis's remorseless pursuit of the Enemy, of the scourge of Bloomsbury and the Sitwells, of the probing intelligence of this great iconoclast.

Looking again at my shelves and walls, I see other mementos of his genius. One of them gave me the only bad moment in over forty years of collecting. An antiquarian bookseller's elaborate catalogue reached me at home one morning and, spread over two pages, there was a fine set of the Ayrton-jacketed Methuen editions of *The Human Age*, plus some of Ayrton's sketches for the illustrations and the framed dust-jacket artwork for Volume One. Now it so happens that there hangs in my office the original jacket artwork for both volumes which I bought from an Ayrton dealer several years earlier. Within seconds all sorts of explanations and permutations passed through my mind. One, that the antiquarian was bent and was selling a forgery. Two, that the art dealer I bought from was likewise bent and a purveyor of fakes. Three, both merchants were honest and had been duped by a forger, and so on. None of these explanations was probable and none made sense, not least because the price quoted was not that high, Ayrton was not in the league of artists who attracted forgeries and, on the principle that in the land of the blind the one-eyed man is king, I knew Ayrton's Lewis-orientated work better than anyone else in England and was not likely to be taken in by such a fake.

So I counted to ten, drank a cup of strong coffee, put the catalogue into my briefcase and travelled to my office. There I made as careful a comparison as is possible between an actual painting and a photograph of another one, and was able to dispel all my brief, paranoid fantasies. Mine's OK and so was the one in the bookseller's catalogue. The two were very similar but looking at them and recalling four decades as a book publisher who used to drive most of his jacket artists crazy, I realised that Ayrton had in fact made two different versions of the same subject, either to satisfy himself, or the near-sightless Lewis, or at the whim of the publisher who wanted some changes to accommodate the lettering. Peace broke out again in my household.

On the same little Wyndham Lewis wall I also have one of Ayrton's pencil sketches of the great man, complete with eye-shade/visor, and the artwork for Ayrton's jacket of the Methuen edition of *Self-Condemned*. At home I have the only monotype I've ever seen by Ayrton. It depicts in stark black and grey the sinister figure with the Mr Punch-style stocking hat that appears on the spine of the jacket of the second volume of *The Human Age* containing *Monstre Gai* and *Malign Fiesta*. Collectors of Lewis arcana might care to know that this edition is dated 1955, whereas its companion, the *first* volume of *The Human Age* containing *Childermass*, is dated 1956. The last section of these reminiscences concerns Lewis's masterpiece the *Red Portrait*, which is reproduced on the front of the

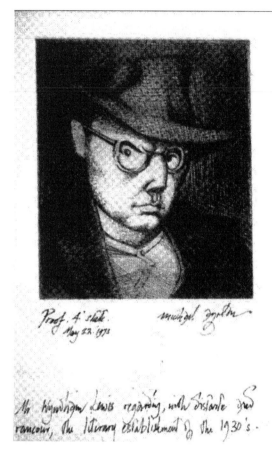

Michael Ayrton, *Mr Wyndham Lewis regarding, with
distaste and rancour, the literary establishment of the 1930's,*
1973 – Photograph by Raphael Munton

jacket of Michel's *catalogue raisonné*. I only saw the original once, about
twenty years ago in the Crane Kalman Gallery in Knightsbridge. I was
an unsuspecting lunchtime stroller, attracted to the gallery by a fine L.
S. Lowry in the window. Suddenly I was face to face with that wondrous
evocation of Froanna and I stood and stared at it for a least a quarter of an
hour. Andras Kalman asked me why I was so interested and I explained
my reasons. 'So why don't you buy it?' I asked the price and he replied
'£125,000'. I said that I thought it a perfectly fair price but that, with a
mortgage and two young children, I didn't even have 125,000 shillings,
and left; although I would check up on it occasionally until one day it was
gone. Kalman perfectly properly refused to tell me who had bought it.

In the meantime Elizabeth Ayrton, no longer happy to live at Bradfields after Michael had died, decided to move to the West Country and to dispose of some pictures. She knew how much I admired a wash and pen drawing, catalogued in Michel as number 883, 'Young Woman Seated 1936'. Michael had been particularly fond of it, not least because Lewis had given it to him, and it was the sketch for the *Red Portrait*. Elizabeth asked me if I wanted to buy it and I said yes at once, but because so many years of friendship were involved, I also said that she and I could not possibly talk about the price. I suggested that Michael's dealer be asked to put a fair market value on it and if I could afford that sum I would buy it. If not, she should sell it through the usual channels. Happily the price set by the dealer was affordable by me and *Young Woman Seated* has been on the wall of my study ever since.

Then, last year, I read in the *Lewisletter* of the Wyndham Lewis Society that the original of the *Red Portrait* was now the property of the Wyndham Lewis Trust and could be seen, by appointment, at the Courtauld Gallery. Apart from being able to see it again, of course I wanted to know how and why this had happened. I phoned the editor of the *Lewisletter* and explained why I wanted to know and could he please inform the donor of my interest and ask the donor whether he or she would be prepared to speak to me.

That same day I had a phone call from Graham Lane, a distinguished retired architect (a former partner in Sir Denys Lasdun's practice and a dyed-in-the-wool Lewisite). He told me that the buyer from Crane Kalman was a Swedish industrialist who had fallen on hard times and been forced to sell at least half of his collection at Christie's. Lane had noticed it in the sale catalogue, had hoped for a quiet day in the saleroom, been lucky, and had bought it for about a third of the Crane Kalman price. Lane then, in a remarkable act of generosity, had given it to the Wyndham Lewis Trust to be housed at the Courtauld.

Although infinitely less generous than Lane, I did feel passionately that, at least after my death, oil painting and sketch should be united and available for joint study. So, using the excuse of having to re-draft my will anyway because of the arrival of my first grandchild, I have bequeathed that beautiful sketch to the Trust, together with the Ayrton sketch of Lewis, and the original Ayrton artwork for the various Lewis jackets which I own. It seems a very reasonable recompense for the endless pleasure and fascination Lewis as writer and artist has given me over a lifetime.

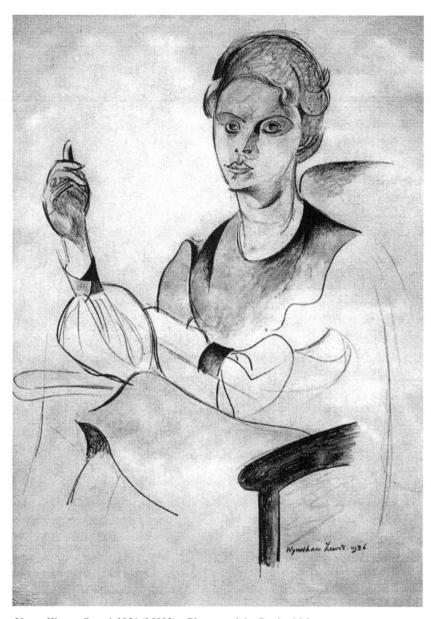

Young Woman Seated, 1936 (M883) – Photograph by Raphael Munton

LOWRY IN PERSON
'Solitude is the school of genius.' – Edward Gibbon

Just as those ignorant concerning Lowry's art use the phrase 'matchstick men' so those who know little of his life refer to him as a recluse on the grounds that he lived alone in a small house in a remote village. The recluse cliché is just as absurdly wide of the mark as the matchstick men label. Recluses don't on the whole travel all over Britain, take holidays by the seaside, carry on correspondences with punctilious correctness nor, above all, do several broadcasts and countless interviews. The several editions of Shelley Rohde's biography of Lowry and various reminiscences of him by people like his sometime dealers, Tilly Marshall or Andras Kalman, are full of non-reclusive information about him, some of it interesting, some of it, as in the case of Tilly Marshall's book, unpleasantly revealing about Lowry's personal habits as if the author were revenging herself on his frequent sponging off her and her husband's art gallery which had, admittedly, done so much for the artist in the North-East. In fact her husband, the guiding spirit of the Stone Gallery in Newcastle, Ronald Marshall, showed and promoted Lowry's work with great skill and enthusiasm. He managed, without denting the success of Lowry's London dealers, to enhance Lowry's country-wide reputation and acceptance.

Shelley Rohde was not really a biographer, although, as a working journalist, she was a dedicated truffle-hound, and her definitive identification of Lowry's mythical female *bel idéal* is quite compelling. Because the books are, ultimately, fascinating collections of anecdotes and the reminiscences and correspondence of Lowry's carefully maintained, but always separated, friends, they are, even if somewhat artlessly written, full of vital information; but Lowry still awaits a biographer who fully understands the nature of the subject's art and, the narrative skill to interweave the art with the life and thus makes, sense of it as Hilary Spurling has done with Matisse, David Cairns did with Berlioz, and as John Richardson (at time of writing at least) is so heroically doing with Picasso.

Nonetheless the most casual reading of Rohde makes it clear that Lowry was, although a lifelong bachelor, the least reclusive of men, who had long friendships with fellow artists, distinguished academics, a handful of key patrons and a succession of young women.

Lowry was not a recluse but a *solitary* and, in Gibbon's lapidary phrase, solitude is the school of genius. After a lifetime of work and friendship with living artists I have not known a single great painter or sculptor who was not totally ruthless about his work, which always came before everything else. The principal advantage of being a bachelor and

celibate artist is the obvious one of the lack of family ties and therefore a responsibility to no one except oneself in organising one's hours. Thus his single-mindedness about his art – which in other circumstances one could term artistic ruthlessness – was easy to satisfy while not being too obvious to alienate friends. Once his control-freak, bedfast mother died he was a free man at last; free to paint all night if he chose to; free to live where and how he liked; free to be, albeit gregarious, a solitary.

My first encounter with Lowry was in 1960 when I visited Manchester on business. I was the assistant sales manager of an art-book publisher and I was calling on the local booksellers to try to boost trade. Having spent my childhood in the city, it was a welcome return to old haunts, so I stayed over for the weekend and arranged to lunch with an old Cambridge friend. Lunch was at his parents' house in Mottram-in-Longdendale just over the Cheshire border. My friend's father was, among other things, the Treasurer for the annual Mottram Show and, as such, was a friend of the village's most celebrated citizen, L. S. Lowry. I persuaded my friend to take me round for a visit.

The door was opened slowly and reluctantly by the artist. He greeted David with just enough friendliness not to offend and regarded me with considerable and doubtless justified suspicion – a stranger arriving unannounced on a Sunday afternoon. At that time Lowry was 73, about six feet tall, heavily, solidly built but not overweight, with a lot of short grey hair, heavy spectacles, and oddly imposing in a paint-spattered, dark three-piece suit and one of those thickly textured striped shirts with neither collar nor tie.

Far from looking like an artist, he was every inch the retired rent collector that he was, the kind of man you'd see nursing a pint of mild, sitting by himself in the snug of a thousand pubs in the North West.

Lowry grumbled at us for not having warned him of our arrival, complained that we had caught him unawares in his painting clothes, and generally made us, me in particular, feel like unwelcome intruders. While Lowry made us some tea, I prowled around the front room of the modest two–up two–down stone house. It was a chilly day and the room, despite a small, two-bar electric fire, was cold and David and I kept our coats on while I scanned the walls for examples of the artist's work.

There were none; just some nondescript pieces of Victoriana: but there was one quite staggeringly beautiful drawing of a woman's head. I don't know where it is now, but I have still got a clear impression, after over fifty years, of a luminous, clear-eyed face, a mass of hair and the powerful blackness of the line. It was large, probably about 20 inches

high by 16 inches wide, and dominated the wall by the sheer force of a significant work of art surrounded by dross. When Lowry brought in the tea I ventured to say that I admired the drawing.

'Oh, do you like it?'

'Yes', I lamely replied.

'Do you really like it?' he persisted.

'Yes, really, it's magnificent.'

His somewhat closed and wary face relaxed a little and he offered the smallest hint of a smile.

'Do you know who did it?' he asked in the tones of a pedagogue who knew that his floundering pupil would *not* know the answer.

'Well, Mr Lowry, I can't be sure' – the drawing was unsigned – 'but it could be a Rossetti.'

'A Rossetti, eh?' and he looked wickedly in my friend's direction with the unspoken subject of 'how could you bring this idiot to spoil my Sunday afternoon when I'm busy painting?'

He then looked at me and said, 'Well, you're quite right. It *is* a Rossetti and I love it more than any other drawing I've ever seen,' and what the Sovietologists used to call a thaw began to set in.

After some desultory chat, about not very much, I dared to compliment him on a magnificent long-case clock in the corner, the only piece of furniture in the room that you wouldn't have to pay someone else to cart away. The inquisition proceeded on similar lines to the earlier one.

I swore that I *really* admired it, so Lowry, of course, asked me to identify its maker. Now, while I do know a little about art, antiques are, for me, mostly *terra incognita*. But I was extraordinarily lucky. The only great English clockmaker whose name had impinged on my brain was that of Tompion. So it was double or quits time and I named him as tentatively as I could.

'Right. Yes. It is. A Tompion, yes.' He looked wonderfully gleeful, which seemed a little excessive as a reaction to my mini-quiz. But the glee was not for me. It was for himself. 'Do you know where I got it? A Tompion. Yes?'

He paused to let me give the obvious negative response and then, marvellously animated and sounding like that old North-country radio comic, Al Read, he told us that he'd found it "in a junk shop in Rochdale. The owner didn't know what it was. It didn't work and it was all covered in dust and muck and he wanted ten bob for it. Ten shillings for a Tompion. He were blind. Blind and daft with it. So I offered seven and six and he took it. Of course it cost me a few bob to have it restored, but just you

listen to it when it strikes.' Which, ten minutes later, it did, and when the
sound had faded away he chuckled again. 'A Tompion, oh yes. He didn't
know, that fella in Rochdale. A Tompion.'

Al Read was born in Salford on 3 March, 1909. He began his career as
a comedian only in his 40s, having been appointed at 23 as a director of the
family meat packing business. This had been founded by his grandfather,
the first man to produce tinned meat. He did his first broadcast on 10
March, 1950 and was given his first 'Al Read Show' in September 1951,
but no matter how successful would not do more than one show a month.
Like Kenneth Horne of 'Much Binding in the Marsh' fame, who was
chairman of a paper manufacturing business, he would not give up the
day job. But, following a Christmas performance for the Royal Family at
Windsor, he recognised his talent and his ensuing celebrity and, in 1956,
sold his business and became a full-time performer with his perennial
catchphrases 'Right monkey' and 'You'll be lucky'. Physically he was the
antithesis of Lowry, conventionally good-looking, immaculately groomed
and smartly dressed, with a light, attractive voice, whereas Lowry was,
doubtless deliberately, scruffy, indeed shambolically turned out, with
a much deeper voice. But their accents were identical and they shared
a genuinely sardonic sense of humour, at once sly and dry, and, while
Lowry would have died rather than perform on a public stage, whenever
I was in his company and listening to him talk, complain or mock some
pretentious critic or would-be patron, I always heard the vocal tones
and spirit of Read. Read died, aged 78, in 1987 but some of his radio
programmes were still being repeated at the beginning of this century and
are still available on recordings.

By this time Lowry was beaming and his somewhat mournful
countenance was transformed so that I at last felt able to ask whether it
would be possible to see some of his work.

'Well you'd better come into the back room, then. It's very dirty,
mind. You'd better watch that fancy coat of yours. Don't want to get
paint on it.'

It was the invitation I had not dared to hope for – and yet finally I
was entering the studio of L. S. Lowry. It was indeed dirty, chaotic,
apparently disorganised. Paintings, both finished and unfinished, leaning
against the walls, facing outwards or with the backs of the canvases and
boards turned towards us. On the easel was a barely begun townscape. I
was, after years of schoolboy and undergraduate enthusiasm, in my own
private heaven. After another lengthy catechism, I was led in. It was,
particularly to someone who had played in the streets that he depicted

so vividly, had attended a primary school of the kind he painted, had seen the factory gates and the football crowds that so fascinated him – an overwhelming experience that many visits over the years to the old Salford City Art Gallery, with its great Lowry collection – since transferred to the Lowry arts centre, which opened in April 2000 – have never eradicated.

Against the serried and carefully curated ranks of a formal gallery, the higgledy-piggledy randomness of a messy artist's studio will always win in terms of both physical experience and aesthetic appreciation. Without glamorous framing and ultra-sophisticated spotlighting, and with only a couple of unshaded 100-watt bulbs for illumination, one's perceptions become both immediate and stark, with little opportunity for careful reflection, so that the magic of that exposure to his art was as deep as it was unforgettable.

At 24, and without the benefit of Shelley Rohde's 1979 biography, or the relentless cascade of confessional and gossip-ridden journalism since 1979, I did not dare ask him about the identity of the girl with huge eyes and centre-parted glossy black hair who stared at us from a particularly powerful canvas. Which is just as well, since she never existed, being an amalgam of several young women of a certain physical type whom he befriended but never touched.

What was so striking, apart from the obvious impact of the townscapes, teeming with what the ignorant call his 'matchstick men', was the extraordinary individuality and scrupulous differentiation of the hundreds of human beings then all within a few feet of my gaze.

I made what stumbling conversation I could, offering my jejune opinions on art in general and of his own work in particular and, by sheer luck, managed not to dispel his cheerful mood. Lowry, often wrongly described as a recluse and a loner, was in fact not only gregarious but an acute, drily witty talker. Just as his paintings, far from being naïve, are immensely sophisticated in both their composition and their humour, in private speech he himself was simple, direct, yet perceptive about his art – as I was to discover not only on that bleak winter afternoon but in later, more formal encounters when I was armed with a tape recorder.

As it got dark outside I felt that we should not outstay what had turned into a genuinely warm welcome, but the incipient collector in me would not be still, so I asked if it would be possible at least to consider acquiring one of his pictures. Another catechism about liking his work came and went and he then asked me which picture I fancied. Unerringly, having no idea as to his prices, apart from knowing that they would be far beyond my means, I pointed at the smallest one. Done in oil on board, it measured

only 6 ⅝ inches high by 5 ⅝ inches and contained a group of three people, a girl with her back to us, another, older, girl facing us, a small boy in a red sweater, and half a dog. In the classic Lowry white background there were some barely visible, vertical black streaks, indicating the possibility of some factory chimneys in the distance; at the bottom, a black strip that simultaneously represented the kerb and unified the structure of the picture.

'Oh, do you really like that one?'

'Very much, but of course I don't know if I can afford it.'

'Well, what do you *want* to pay for it?'

As a tyro publishing executive who had not yet paid off all his student debts and whose take-home pay was £11 and fifteen shillings a week, this seemed an insoluble problem. I knew nothing of prices and values.

So I told Lowry that I would happily give him all the money I had on me. This was in the days when 'unless prior arrangements have been made with the management' – hotels did not take cheques and there were, of course, no credit cards. I had therefore drawn from my employers a cash advance of £15 to cover the expenses of my trip.

I reckoned that I could borrow some cash from my friend who would take my cheque, so that I need not spend the next week washing dishes at the Midland Hotel, and extracted the three five-pound notes and nervously proferred them to the great man. Being an exceptionally kind man, he took them and said that that price was fine by him if it was fine by me, and how would I get home? I assured him of my return ticket and decided not to mention the hotel.

'But do you *really* like it?'

I again swore my undying love for the picture, whereupon the old devil, which, to some extent he really was, said: 'But it's not finished. I tell you what, I'll finish it and send it on to you. David will have your address.'

I offered some mild platitudes about being unable to bear being parted from this great treasure.

'All right then. I'll finish it for you now.'

I muttered my gratitude and wondered how so small a panel could perch on his easel. It didn't. He had vast hands and he held it comfortably in his left while spending the next thirty minutes with a series of small brushes in his right.

It was only many years later that I discovered that there were senior Royal Academicians who considered him an amateur, a 'Sunday painter'. They'd clearly never seen him at work. He was right. It wasn't finished

but at the end of that half hour it certainly was. A highlight here, a black line there, a deepening of the red, a thickening of his heavy, greyish white and it was an unmistakable finished Lowry work of art. I examined it more closely and saw that it had in fact already been signed: this picture, 'finished' in 1960, was actually dated 1957.

Then the old tease put it on the easel and proclaimed that while it was indeed now finished it was still wet and would have to remain with him for a few more days to dry and then he would dispatch it to me.

Somehow I managed not to gibber but persuaded him to let me pack it up in some silver foil he had in his kitchen and gave him an assurance that I would keep it upright and free of all harmful contact until I got it back to London.

After that there was occasional correspondence but I wasn't to meet Lowry again until the autumn of the following year, 1961. Again it was at his little stone house; now I was accompanied by the poet and, at that time, senior BBC Third Programme talks producer Anthony Thwaite. I interviewed Lowry for a radio arts programme called New Comment. It was not my skills as broadcaster but Lowry's spellbinding talk that made the transmission get the highest 'Appreciation Index' of any item broadcast on New Comment that year. We spent hours with the tape running because neither Anthony nor I could bear the thought of cutting off his flow of reminiscences, his views on art and on his own work.

Unfortunately no copy still exists of the sound tape but what follows is an edited transcript of the actual broadcast transmitted on the BBC Third Programme (now known as Radio 3) on Wednesday 8 November, 1961:

Rosenthal: I think one thing which most people would agree about, – Mr Lowry, is that your work is the most natural and, in a better sense of that word, uninhibited. Have you had a great deal of formal training in your painting?

Lowry: I went to the Manchester School of Art but did nothing but the antique, preparatory antique, and laughed for a long time but did no painting at all at the School of Art. I went to a private portrait painter – William Fitz, for painting lessons. He guided you also: you used your own colour: you did what you liked but he simply guided you.

Rosenthal: There is in fact absolutely nothing academic in your work. This is because presumably you picked up what you wanted to pick up and that was all. Is that a fair thing to say?

Lowry: Well, I did things in my own way, as I see them, without regard to anybody or anything else all my life really. I've seen these industrial scenes for a long time. Since 1919 to be quite exact. And I've just done them as I saw them without regard to anything else.

Rosenthal: Talking of those industrial scenes, an awful lot of people first of all, they don't understand your work. I think because they immediately say that your work is depressing. But those I think are the kind of people who would say that the scenery is depressing simply because they can't see it. I was brought up as a child in Manchester, I've seen the things you've painted, for many, many, years. I can see their beauty – I love them. A few others do too but not very many. Can you explain why it is that the beauty of those things is not immediately apparent, yet you yourself have managed to put over the beauty of this landscape with, I think, outstanding success?

Lowry: Well, I suppose it's the way I looked at it. We went to live in Pendlebury in 1909 on the other side of Manchester... At first I disliked the scenery very much indeed, and then I got used to it, and then I got interested in it, and then I got to like it somewhat, and then after quite a while I got obsessed by it.

Rosenthal: I'm glad you used the word 'obsessed' yourself because I wanted to use it, and often I think it is an impertinence to suggest the word. But I couldn't help feeling that, for example, in your last show, there were two paintings there which are not from this area as it were; there is a large painting of London's Piccadilly Circus and a very large one of Ebbw Vale. And yet it seems to me that the obsession which you mentioned with the landscape had carried you along, to Piccadilly and to Ebbw Vale.

Lowry: Yes.

Rosenthal: So that Piccadilly and Ebbw Vale in many ways look rather like... Mottram-in-Longdendale and the area round it. Do you think this is too far-fetched?

Lowry: No, I quite think it must be so, because I've painted industrial scenes for very, very many years – about thirty years I should think really – and I got it into my system and I go off to a place like Ebbw Vale and I

see Ebbw Vale something like this part. I don't think it is very different. Piccadilly to me looks, well, rather like any other place. It's not like parts of London which are very distinctive. I think Piccadilly Circus looking from the angle I took it from looks rather like anywhere else except for the statue of Eros in the middle.

Rosenthal: And this has come out in the painting of course.

Lowry: Yes.

Rosenthal: It's immediately recognisable as Piccadilly Circus; Eros is there; the red buses are there.

Lowry: Yes. But the figures.

Rosenthal: But the figures. And the whole atmosphere is in fact, for want of a better word, obsessive.

Lowry: Yes, I'm afraid so.

Rosenthal: But to sort of go away for a moment from these standard landscapes: you've painted I think a lot of very wonderful seascapes. Do you in fact cover very much of our coast? You've picked up the sea and the lakes which you do very well and yet which you don't show as much as the paintings for which you're rather better known.

Lowry: Well, I travel about a lot. In fact you may almost say I spend my time now in just travelling in this country – I don't go abroad. I spend my time in painting and going round seeing my friends... my friends are all scattered in the places I paint and I'm very fond of these places and now... ah well, there's not much to memorise in a seascape – you just do a seascape. You see it as it's been a long time. I know the sea pretty well. I'm very fond of it. And the lakes the same angle. The lakes quite a lot. And the lakes not far from here you know, the reservoirs; woodland reservoirs, Manchester Corporation Waterworks. Now they're very fine, pictorially, you know.

Rosenthal: Which aspect of the Lake District fascinates you more? The water or the mountains?

Lowry: Oh the lake, the blackish sort of lake, like Buttermere, I'd say. It's the lake really which... I would never think of painting the mountains without the lake.

Rosenthal: You seem, Mr Lowry, to be an artist who is very self-aware. Henry Moore once said when he was asked if he for example read all the Jungian psychoanalytical studies of his work and whether he thought it was a good thing to do so. He said 'No', he thought this was a very bad thing because if you become too much self-aware, too much aware of the mental processes which go into your art, eventually you will kill the spark which creates the art. Do you agree with this?

Lowry: Well, I don't know really. I never have. I just work on my own, apart from what's said about it. I don't think I could go in any other way if I wanted to really now. At my time of life I just work as I work. Put it this way: That you start a picture and it takes its own course and you follow like a man in a dream – I don't really know – yes, you start the picture without knowing where it will end... It always does finish up all right you know... but you don't know.

Rosenthal: I see that around the studio where we're sitting now there must be forty or fifty paintings the majority of which are not complete. Do you like to start on one thing and see it all the way through or do you prefer to hop from one canvas to another as the mood takes you?

Lowry: I have to hop from one canvas 'cos I can't finish them right off. I've tried to finish them right off and can't. They all take a long time. And the strange thing about it is when I think I've almost done one right away in the end that takes the longest time to finish. It's queer that, I've often wondered about it.

Rosenthal: In other words you don't like your work to come easily to you.

Lowry: It doesn't. It won't because I want it to. It certainly won't. It's very perverse – it won't do it.

Rosenthal: Actually I used the word canvas. This in fact is rather a misnomer because I suppose, looking round, there's only one in twenty on canvas. Do you prefer boards?

Lowry: Well, I use canvases for fair sized pictures but for little pictures I like wood. I like wood very much. Or there's good... excellent substitute for wood now which – these are what we call beaver...

Rosenthal: Hardboard?

Lowry: Hardboard.

Rosenthal: ... board and hardboard and things like that.

Lowry: Very good. For small pictures only. I wouldn't start a 24 x 20 on a board like that: I'd do it on a canvas—all my larger pictures.

Rosenthal: There's also an enormous predominance of white on your paintings. Why is that?

Lowry: Can't help it, it just is.

Rosenthal: It does enable you though to show I think very remarkable skill which is basically an economical one I think. You know you can by means of one or two lines suggest an entire atmosphere, almost an entire human scene. I have a small painting of yours which consists of three small child figures on a dead white background and there's just one very tiny black line which is just pavement and another smaller shadowy one, vertical one, which gives the effect of a lamp-post, and there you have a complete thing. Can you explain this economy at all?

Lowry: Well, I can tell you how it started. At first when I first did these industrial scenes I did them rather low tone, low key, and they got very low after a short time. And I spent a lot of time on these pictures and I didn't like it, you see. And so I went lighter. I was advised once to go... paint them very light indeed and I did and I find after a few years they've become just right.

Rosenthal: Yes.

Lowry: You see the white drops away... it's bound to drop. I was advised to do that many, many years ago. 'That's no use' a man said. He was a very knowledgeable gentleman too. He said 'It's too dark, look at it, it's much too dark against the cream wall.' He said 'You'll have to paint that

lighter.' So I thought there's a lot in it you see but I was cross with him for a while naturally, but afterwards I thought, 'Well, he's quite right' and I painted them white. But I noticed the white was mellow you know. It drops to just right.

Rosenthal: Some people have said – and I can't help thinking they're right – that your work has an atmosphere of the 1920s – the figures seem to be twenties-ish – when you do go into paintings that are genuinely depressing in that they show the grim aspects of this depression in the period of the twenties and perhaps of the early thirties you seem somehow to have stuck with this: there's no sign in your work of what is usually called today 'the affluent society'; your industrial people still have the sombreness of the people of the twenties. Where in fact today in the industrial North the workers are showing almost as many signs of the affluent society as the workers in the Midlands or the South...

Lowry: Well of course you won't see a large number of people coming away from a factory... I don't think they look much better than they used to in the old days. Individually yes – perhaps – but not as a crowd... I think the crowds look just the same. But I just do them as I see them I suppose. I started doing these things in the 1920s ... well my mind still sticks in the 1920s because I do them nearly all from memory. I just do the figures as I saw them, and the houses as I see those too. Some people say they're less like houses, they're like little boxes.

Rosenthal: Some people like living in little boxes.

Lowry: That's right. That's what I told them but they don't agree.

Rosenthal: But one thing that struck me is that very rarely it seems that you paint people as people. You don't often try to show in any way detailed studies of individuals. Is this because you are not interested in people as individuals; you are much more interested in people in the mass, as a whole. Is this a reflection of the basic interest in humanity or what? How would you...

Lowry: Well, I don't care for portraits: I am not interested in painting a portrait at all. I've tried... I've only done one person in the last – oh – call it thirty years ago. I like to imagine people, build them up, create my own... well, individuals if you like.

Rosenthal: And yet despite this apparent lack of interest in individuals as such your people come extremely alive.

Lowry: ... Yes, I'm glad to hear you say that. I think they do sometimes, but what I think is nothing: it's what the other side thinks. Isn't it really? Do you think?

Rosenthal: Are you sensitive to the opinions of others and do they ever affect your own work?

Lowry: Oh I listen... you get a lot of advice from people, particularly people who don't paint. Oh very often. Indeed I've got a lot of help from young people mostly who don't paint but are interested. Oh I always listen to what anybody says. I... oh... a young lady, a friend of mine, came in one day and said 'Look here' she said 'this is all very well, you paint in two dimensions all the time.' So when she'd gone I put in... I altered it of course.

Rosenthal: But did you really alter the picture for the better?

Lowry: Oh yes. The party was quite right: it was flat. I hadn't noticed it. She was quite right... I told her so: 'I'll alter it completely' I said.

Rosenthal: How interested are you in fact in three-dimensional effect in your painting?

Lowry: Oh, not very much.

Rosenthal: You just find yourself an instinctive painter rather than an intellectual?

Lowry: I think so, yes. I think so, yes. Yes. Definitely.

Rosenthal: Are you very much occupied or preoccupied with the problem of loneliness?

Lowry: No, I am lonely, I live by myself, I've got good friends but I'm lonely when I'm by myself, as far as I know. I simply paint as I feel. I suppose I've painted a lot of pictures people say are lonely, such as the sea, an odd figure at the sea I paint, I never seem to paint anything on the

sea when I paint the sea. And... erh... I either put a lot of people on a landscape or none, people say.

Rosenthal: Do you feel that the figures that you put into your more crowded scenes have any relationship with each other?

Lowry: People say not and I'm inclined to agree with them. Isolated figures, yes.

Rosenthal: Well they are. But I think they're only isolated in the terribly crowded ones like for example the football match, where they have a very obvious cohesion simply because there are so many of them crammed together. But in fact looking round here your small wood panels there, for example when you have the children playing, the children seem very much together and belong to each other. Is this done deliberately?

Lowry: Oh no it just comes. I'm very glad that you say that. Just comes. Just paint the picture and it comes.

Rosenthal: Do you think that it's interesting that a painter should be so obsessed with this as you yourself are?

Lowry: I see no reason why a man shouldn't keep on painting the same thing all his life if he wants to. Because if when he doesn't want to he'll change and he probably won't be able to go back to it.

Rosenthal: A great number of painters, composers, writers, have achieved their greatest work in their seventies, even in their eighties, and sometimes, even in their late seventies they've completely changed to something new. Do you think there's any chance of you doing that?

Lowry: I've not noticed it. I... [laughter]... I'm leaving it rather late aren't I now because I'm in my seventy-fourth year. I've changed a little I think but not a lot. What I shall always feel I think is that the industrial scene is my best work.

Rosenthal: Yes. That's... that's very true.

Lowry: Is it true do you think?

Rosenthal: Oh completely true.

Lowry: Yes completely.

(end of broadcast transcription)

Lowry serious, as opposed to mischievous, could be wonderfully terse, all part, no doubt, of his quite elaborately constructed public persona. I'm sure that those who think his pictures simple would also characterise his personality in the same way.

That would be foolish. This was an endlessly patient and subtle man who always knew what he was doing, whether personally or in paint. He once (as is fully described by Edwin Mullins), famously applied seven coats of white paint to a piece of cardboard, put it away in a drawer without any light for seven years and, at the end of that time, gave another piece of card its multiple ration of white so that he could compare the effects of time on his favourite colour.

When I asked him about his feeling for the halt, the lame, the down-and-out who so fill his pictures, he said: 'I feel very interested in them. I have a sympathy for them even if I know there's nothing I can do for them. I listen to them.' One of the few discerning critics to admire him in his lifetime, Edwin Mullins, speculated that Lowry was intrigued by these outcasts because he felt himself to be an isolated person.

As for his passion for Rossetti, he said: 'I'm fascinated by the paintings of his ladies. Nothing else.'

Lowry was much more self-aware than most acquaintances realised, and once observed of those much admired pre-Raphaelite ladies, 'They are not real women, they are dreams.'

In response to the obvious question about his industrial landscapes, he was both frank and cagey. 'I see them. I'm interested in them. They're not beautiful, I know that. I just do them, that's all. I got obsessed by it, I can't say why. It just happened.'

His industrial scenes are, in fact, an almost uncannily accurate rendering of something that has no corporeal existence in that form, but is a paradigm of an almost vanished segment of North-West England. While they are wholly imaginary in both concept and composition, the individual components are real, based on his endless perambulations through the area as a rent collector and minor functionary in an estate agent's office, when he invariably made pencil sketches of buildings and characters who appealed to him.

The last time we met was in September 1966, when I made a long radio feature about him for the Third Programme. It was part re-interview of him and part symposium of the views of various art world dignitaries and fellow painters. My wife and I drove up to a seaside hotel near Sunderland where he was staying (and often used as his North-East base), for which the word modest would be a considerable overstatement.

We had lunch together – a vile meal, even by the standards of the time – and, not too seriously, Lowry maintained that he was a poor man and had been one for forty years. I would have used more than a pinch of salt had I known then what I know now; that via his dealers he had, in 1964, bought at a Christie's auction Rossetti's oil portrait of Jane Morris, known as *Proserpine*, for 5,000 guineas (probably a million pounds today). It became his favourite picture and he bought other pre-Raphaelites – sometimes exchanging them for his own paintings – as well as works by Daumier and the two near-contemporaries he most admired, Lucian Freud and Jacob Epstein. His simple living was no pose. It was part of his character and never conflicted with his massive generosity to others.

I set out below the BBC transcription from the actual broadcast of the symposium transmitted on Saturday 26 November, 1966. This 45-minute programme was compiled and introduced, with appropriate linking passages, by me and was broadcast under the title *Every Day in the Week*.

Rosenthal: L. S. Lowry is now nearly eighty years old, and while no one could ever have accused him of being an *enfant terrible*, he is now respectable enough to receive the accolade of an Arts Council retrospective exhibition. Yet he is, in his way, one of the most paradoxical artists England has ever produced. One can look at his paintings for a few seconds and instantly understand them while at the same time they are highly complex works of art. His painting technique also looks, at first glance, crude and unfinished yet is immensely subtle. His choice of subject-matter, the industrial North of England and the stunted factory workers and derelicts whom one still finds there, inspires instant gloom in those who feel that their cocooned home counties existence will be threatened, if not actually sullied, by a trip north of the Trent for anything other than grouse shooting, yet Lowry is in fact a lyrical and poetical recorder of a landscape which has as much intricate visual beauty as the Sussex Downs if one only opens one's eyes to it. To many who have only seen his occasional excursions onto the television screen and have not come to grips with his paintings, he is a comical old buffer from up

north, yet his reluctance to intellectualise about his own work conceals, as usual with the best visual artists, an acute and perceptive mind. In other words, Lowry isn't half so simple as he appears, and sometimes sounds. For instance, it takes a man of more than average perception to give up painting effective if conventional portraits and competent but derivative Barbizon-type landscapes. Why did Lowry suddenly change the subject-matter of his work?

Lowry: I lived up to 21 years of age on the residential side, and we went to live on the other side for business reasons – a very industrial town called Pendlebury, between Manchester and Bolton. And at first I disliked it intensely... then after quite a year or two I got used to it, and then interested in it and then, and then I got obsessed by it and practically did nothing else for 25 to 30 years.

Rosenthal: Before you moved, had you in fact been painting non-industrial subjects?

Lowry: Painting portraits and landscapes. Just the ordinary portraits and just ordinary landscapes. And that's all. Little sea pieces and just the ordinary things that most people do. And after going to Pendlebury I did nothing after getting used to the subject-matter in Pendlebury. I did nothing else for 25 or 30 years.

Rosenthal: What made you become obsessed with it?

Lowry: Can't say. Just happened. It just happened.

Rosenthal: Was it the visual appearance of the factory chimneys and of the factory crowds, or was it in fact what these things meant to you and to other people?

Lowry: No, it was purely pictorial. I looked upon the people as the main feature and the background to the whole thing – the setting.

I asked Lowry if he thought his landscapes were beautiful.

Lowry: Well, I wouldn't say beautiful. I'd use... I see them and I'm interested and I just do them. That's all. I don't... I just see them, do them there, the attraction – something, I can't quite see what. I do

them. It's really the same way as somebody driving outside and seeing a landscape as I would see, and he draws it and thinks it's interesting, and that's what it is.

Rosenthal: Interesting, yes. But, I think, something more than that, and also significant by the mere fact of its being done at all. *This is what Herbert Read had to say when I asked him to amplify what he had once said about Lowry's being a revolutionary.*

Read: Perhaps the word revolutionary was rather strong. But he is original in the sense that he has seen the possibilities for painting that exist in the industrial landscape in this country. It's really quite extraordinary that in an industrial country like this no one... no painter of any significance has ever taken the industrial landscape as a subject, and what you might call industrial art just does not exist. But Lowry had the... well, yes, it's revolutionary in the sense that he had the new vision of the artistic value of this subject. No one else had seen the industrial landscape as potentially an artistic subject... but naturally there may be behind it some preference of an ideological nature; some preference for the working class as such, for the life of the people as such. That may have guided him towards selection of this particular subject-matter. I don't know Lowry well enough to know whether that has been a determining influence in his life.

Rosenthal: But he paints, you know, what they call the dark Satanic mills; do you think that he sees them with the same sort of vision as, let us say, Blake?

Read: Well, I don't think the vision is Satanic in Blake's sense. Blake was romantic and opposed, I suppose, to the industrial development of England as such. Whereas Lowry, I think, accepts it. To Lowry it is a natural background to his life and thought. I think there is that difference. Therefore I would say that his vision is not Satanic. He accepts the Industrial Revolution and makes the most of it.

I think that sentence about accepting the Industrial Revolution is a key one, since in many ways it exemplifies the differences between North and South in this country, which in turn are reflected in the different attitudes to Lowry. There are those who, quite simply, find Lowry's paintings ugly; others find beauty in them. Beauty is still of course very much a matter of the eye of

the beholder, and this applies as much to the industrial North itself as to the paintings of it. This is how John Rothenstein reconciles the paradox.

Rothenstein: I think he's done one very important thing historically. I think the whole history of modern art… has been the history of expansion with the concept of beauty, that is to say in times of Classical Greece very few things were thought beautiful and in modern times artists have taken more and more things and beautified them, presented them to the world in terms of poetic beauty, and Lowry has taken, if the inhabitants will forgive my saying so, one of the dreariest regions, visually speaking, of the whole civilised world, and presented it in terms of an extremely moving poetry, and therefore by doing so he's expanded our whole conception of what is beautiful and what may be beautiful.

In its triumph over what ought, in theory, to be bleak and grim, the beauty that Lowry imposes is, almost literally, transcendental, although Herbert Read finds that the relative beauty of subject and treatment are somehow integral and intrinsic.

Read: Well, anyone who has had any experience of this industrial landscape does feel its poetry. I myself – in my youth – was familiar with the industrial landscape round Leeds, and very much moved by its subtleties of form and colour. The outlines of the West Yorkshire mills and their chimneys and so on often have very great formal beauty. And then there is this atmosphere which is created by the smoke and fog and so on, but can be a great beauty from an atmospheric point of view, from a colour point of view. If one learns to see things, as it were to disassociate the form and atmosphere from the function, then one sees that it has beauty and that this beauty can be conveyed in painting. That industrial landscape, as it were, becomes an equivalent to the romantic landscapes of, shall we say, Corot?

Rosenthal: You've also observed Lowry's fidelity to this Northern industrial landscape. Do you think that Lowry could in fact have been as good a painter as he is if he had not been born in this environment and if he had not in fact devoted the majority of his painting career to that environment?

Read: No, I doubt if he would have developed in the same way or become the same kind of artist in a different environment. I think that the

industrial landscape found its poet as it were, its artist, in Lowry, and that he had a particular kind of sensibility which saw the possibilities in that landscape. He has, of course, formal qualities which are universal. He has not only a sense of form and composition, but a personal colour sense, personal feeling for harmony of various kinds, which might have been transposed into other subject-matter. [My guess is that he would not have been inspired by different kinds of landscape.]

As a matter of fact Lowry has also done a large number of seascapes, some of which are entirely successful as paintings, but I can't help seeing some significance both in Herbert Read's last remark and in the fact that Lowry has turned more to the sea in the last few years when he has, at least partly, abandoned the industrial scene in order to paint a lot of seascapes recently.

Lowry: I like to do seascapes. I'm very fond, now and then, of doing beach scenes. But the fact is that after getting used to the industrial scene, I never painted... and a friend of mine thinks I might have started painting the sea later on in life and it probably would have happened, I should say.

Rosenthal: Well, you have in fact painted a lot of seascapes?

Lowry: Quite a number, but not what you'd call a lot. Every so often I like to do them, and what interests me here is of course the shipping on the sea and the rivers and the sea itself.

Rosenthal: What is it about the sea that attracts you as a painter?

Lowry: The vastness of it and the wonderful different conditions on it. It's changing all the time. Anything's possible... you can hear it strumming over the promenade. It was a wonderful sight, but it was very fearsome to my way of thinking, particularly the east coast far more than the west.

In a sense the sea has been an escape for Lowry from the industrialism that has haunted him, but it's not a very far-reaching escape; Lowry has now adopted the sea at Roker on the coast by Sunderland, a move which John Rothenstein saw as being eminently logical.

Rothenstein: Well, he happened to be lunching with me one day, and he was talking about the North-East coast and he said, I'm thinking of settling there, so I said to him, I suppose you think you've discovered

a place that's even more forbidding than Salford, and there was a long silence and he said, I think that's just about it.

Actually, however forbidding the town of Sunderland may be, the sea at Roker can be magnificent, and indeed was just that when I visited Lowry and recorded these conversations with him in his regular first-floor room in a hotel overlooking the water.

Lowry: The sea, well I like the sea for its own sake. I'm very fond of the sea... oh yes, I'm very fond of the sea.

But while he's fond of it, he also finds it terrible, and I asked him why.

Lowry: Well, it comes in, comes in and comes in. There it is, this vast expanse, and I often wonder and often say to friends, I wonder wouldn't it be dreadful... what would happen if the sea suddenly didn't... the tide didn't turn and the sea came on and on and on and on and on. What would it be like? Wouldn't it be wonderful just to see it? Just fancy... on and on and on... didn't stop at all. Went on forever. Awful, isn't it? And I often think too that these people reckon that the tide will come in and are waiting outside with the ships that are going to come in with the tide in Newcastle on the Tyne, and I often wonder what would happen if the tide didn't come in and went somewhere else. If the tide did come in I don't know what it is that keeps it so... but it's a dreadful thing, it can be dreadful... at times, you know. Have you been on the sea... do you feel the same thing? It's all around you...

I think that some of this obsessional attitude towards the sea is reflected in the paintings themselves. His seas are neither conventionally placid nor typically tempestuous. Instead they are simultaneously both the subject and the object of a quiet intensity which is reflected in the concentration on a virtually monochromatic scale of grey and white. In this they become more concentrated versions of his industrial skies, and I think it's worth looking at his handling of paint from the point of view of other painters... Josef Herman, who has a high regard for Lowry, has shared an exhibition with him. I asked him whether he didn't find Lowry's technique to a certain extent uninteresting and unsensual.

Herman: I don't agree that the technique is uninteresting, but what I do agree with is there are no sensual qualities to it. But this was to my mind a deliberate choice in technique. The paste-like quality of his whites, or the

blacks, they achieve a certain plasticity without going into the research of itself… Lowry does not explore but what he uses are colours which struck him as true to life, and because he lived in an industrial area and because the subject-matter is of this area, naturally the restricted palette is a truer expression of this.

Rosenthal: And what about when he moves away from the industrial area? When he does his seascapes, some of which are very beautiful indeed?

Herman: Yes, this is perfectly true, but in painting, if once you acquire a technique, and once you acquire a style, you use it in whatever subject you will tackle, you see, and therefore between his seascapes and his cityscapes there exists no difference either in technique or style.

Michael Ayrton also approves of Lowry's technique:

Ayrton: I think it was inspired in him to limit his range to the extent that he has done. As a technician I would have thought he was comparatively rudimentary, but needs to be nothing else.

Inevitably, I suppose, when you talk about Lowry's technique you come up against the question of whether or not he is a naïve or primitive painter. The borderline between a painter like Lowry and the obvious primitives like Bauchant or Bombois is probably just as clear as that between Lowry and the obviously bad Sunday painters like Grandma Moses. But having said that, it's far harder clearly to define where Lowry stands in relationship to them and primitive art in general. This is what Herbert Read says:

Read: I don't think he is naïve in the strict sense of the word. I mean, I've met Mr Lowry and talked to him. I've seen the film that my son made of him, where he spoke a great deal about his life and ideals. I don't think he is naïve in the proper sense of the word. But, well, I search for the right kind of word to describe him, I think he is a simple man in a certain sense of that word. He lives a simple life, and although that in itself might be a pose, I don't think it is. I think he has a genuine preference for the simple life, and that this is part of his character which determines the nature of his painting.

Professor E. H. Gombrich also fails to see anything of the primitive in Lowry:

Gombrich: From the point of view of his very subtle gradation of tone and his very great awareness of tonal values, he is certainly not a primitive painter in the same sense in which, let us say, Grandma Moses is a primitive painter.

And this is how Edwin Mullins, who did the catalogue for the retrospective exhibition, sees him:

Mullins: In terms of the way he paints, he is anything but naïve; a lot of people think of Lowry as a very simple, almost primitive painter I think it very important to stress that in the way he actually applies his paint, in the interest he has in the texture and colour of paint, he has an entirely professional approach. There's that story which he has often told of how be became interested in the colour white. How he painted one board, one piece of card, with several coats of white paint, and then locked this card away so that air couldn't get to it, just as though it were in fact under glass, for seven years, and then before he took it out he painted another card with exactly the same white, and then unlocked the other one, and compared the two, and as a result of comparing the two he realised what he wanted to obtain from the texture of white. Now, this is immensely scientific and sophisticated and very much the reverse of a naïve approach to painting. And Lowry to me is a master of his particular way of using paint, particularly, of course, monochrome painting. He's not, to my mind, a colourist as such. His colours emerge from colourlessness, from black, from grey, from white, from slight tints of white; he's a master at being able to produce eight or nine different colours out of white, another eight or nine out of black, and give the appearance of a multicoloured canvas, where in fact colour does not exist. This I think is an important contribution that he's made, even if it isn't a contribution which other painters may learn from. But don't get the impression – I hope no one does get the impression – that he is a simpleton. He's very far from that.

Rosenthal: Indeed he is. You only have to look at his human figures to see that. Next to factory chimneys and dark streets the images conjured up by the name Lowry are most often those of people, either eccentric individuals or crowds of rushing homunculi, faintly Chaplinesque, slightly pathetic, sometimes compassionately observed, sometimes seen and depicted with a slightly sardonic humour. Lowry is fascinated by society's rejects and accepts his fascination as a matter of course.

Lowry: I just do them for the same reason as some people paint a still-life or a landscape or anything else. But these last years, I've been doing quite a number of down-and-outs, you call them. I really feel very interested in them. And I feel a sort of, well, I have a sympathy for them. You can't do anything for them, you know. There they are, looking into space, you've done all this scene, they'll be standing there suffering, might be standing... as far as I know. And you can't do anything about it. It's too late. I might want to chat with some of them. Got a lot to say – you know, very nice people. And until you get on to their private life. One man I remember quite well – be was very, very nice, and he was in a park, and he said, 'Can you spare tuppence for me, guvnor, for a cup of tea? I haven't had anything to eat or drink for ooh, two days.' I said, I'll give you two pence with pleasure, but when you've told me you've had nothing for two days, I don't believe you... what the dickens you like. And he laughed heartily and we got talking, got in conversation. Well, and then I saw him by strange chance in another park about a fortnight after and we like... started chattering again, you know. And he talked a great deal about himself. So much so as to encourage me to ask him what had happened to him, of course – he said, and he dried up, and he didn't say a word. Ten minutes went by, and I said good afternoon to him and he didn't say a word. He closed up just like that.

One can see why these people fascinate him from a visual point of view, and Edwin Mullins has this explanation for their actual fascination:

Mullins: This contrast between extreme loneliness and a concern with a bustling, teeming human life, like an ant-hill, gives you I think the two opposite poles of his way of looking at the world, and they are very much part of his own particular feelings perhaps about the society in which he lives. I think it's very important that Lowry is a man who has never felt himself to belong in any way to the world around him. He has an entirely detached attitude to life as it is lived, and the way he paints is almost like someone looking at our world from another world. I think that the figures he draws, these caricatures that he's done increasingly with old age, have a frightening detachment which, at the same time, as he presents his figures, in a detached way, they manage to reflect his own personal mood, his own loneliness, his own feelings that life has rather passed him by. This is a very curious combination of subjectivity and feelings of really having no pity, no love, no hate, no concern at all for the wellbeing of other people; he looks upon people with a kind of fascinated

curiosity. He's interested in outcasts, partly because he himself feels himself to be an isolated person, but also because he thinks they're so very funny. Now only a man with this frightening degree of detachment could present the grotesque in other people with this almost coldness. I find this aspect of Lowry very frightening and very, very powerful. I can't imagine a committed human being, a human being who loved others, was involved in others, who had lived, one is tempted to say lived a normal married life, Lowry has never married, he has very few friends, one can't imagine a person, other than Lowry, being able to present people in quite this ruthless way.

Is Lowry detached and ruthless and lonely? Perhaps he's all these things, and they are reflected in his figures. Yet all these qualities are at variance with the gentleness of his personality, which, as Herbert Read said, isn't a pose. He is generous to other artists and buys their work, notably that of Sheila Fell, but I wonder whether it isn't significant that among earlier artists he really only likes the Victorians, whose painting, for all its sentimentality, remained curiously unemotional. Lowry has several Rossetti drawings in his house, and I asked him why he liked Rossetti:

Lowry: ... fascinated by the paintings of his ladies. Nothing else. Not his subject pictures. Do you ever... what it is that attracts me, I don't know. That's all it is. He's the only man who I've ever really seriously... I shall keep on collecting Rossettis. I like some of the others. I'm very fond, you know, very interested in Victorian art. I don't mean it's very great art, particularly nowadays, I think so... I like it more than ever. I like all of them. I like the place. I like the lot. In a sense. Rossetti is the only one I ever wanted to possess, and I've got some very good ones, I think, and I'd like to have some more some time.

Yet there could be few painters more different from Lowry than the precise, almost clinical Rossetti. Lowry's art is much more diffuse, much more the result of imagination given a forward push by a couple of pinches of reality. As Edwin Mullins says:

Mullins: Lowry, in fact, very rarely records literally what he has seen. A great number of his compositions, I should say probably the majority of his compositions, are made up from a host of different impressions that his memory has stored up. He will build up a canvas starting from, he doesn't know what. He's told me that he's often started with a seascape

and, in the course of working through the night very often, it has become a mill-scene, or a mill-scene has become a landscape, or an empty landscape with lakes has become a composition full of little bustling figures... the point of this is, I think, that he's to a very great extent a subjective painter. He's not an objective recorder of something seen. And to me the impact of a Lowry is very largely that one is made aware of the personal feelings of Lowry. He's recording as it were the scene from within him, not just what the eyes see.

I think that that in many ways is the key to Lowry's art. Neither wholly imaginative nor wholly recording, it's an interpretation of people and places around him, as seen through his highly personal, jaundice-coloured spectacles, and it is this that makes him so hard to classify or place in the history of English, let alone European, painting. Michael Ayrton has an interesting point of view:

Ayrton: I should have thought the English Utrillo is probably the place I should describe Lowry as fitting. I think the point about Utrillo is that his quality, which at the moment is rather out of fashion, is a sense of the ambience of Paris, the quality of the plaster walls, the quality of the rooftops, of the quality of the city itself. The figures in Utrillo's paintings, which were not as well drawn as those in Lowry's, always seem too haphazard, and not in fact to be the centre of the situation. Nevertheless, they inhabit the place, and Lowry, like Utrillo, paints inhabited places. He is to me a city painter; he's an English city painter, whereas Utrillo is essentially the city of Paris painter, of the early twenties – the early part of the twentieth century. I've always thought of them together, though when I first encountered Lowry's work, Utrillo was a kind of highly prized myth who drank himself to death and was drinking himself to death, and all sorts of glamorous things like that, while Lowry seemed infinitely more English, infinitely more down-to-earth, and infinitely less likely to indulge in any of the bohemian chi-chi which attaches to the legend of Utrillo. Nevertheless, there is, I think, a common chord there. A sense of place, and of urban place, in a specific kind of way, and both have the quality of the self-taught. It's not the same as primitiveness, but it is self-taught.

Self-taught but not primitive. I asked Professor Gombrich whether there were any links between Lowry and Europeans like Douanier Rousseau, at least in terms of imagery:

Gombrich: Yes, there may be some links in the way in which he isolates individual figures, in which he keeps his painting very legible, in that sense, perhaps like a children's drawing, but this is only the scaffolding as it were for a very subtle distribution of shapes and forms.

And this is how Herbert Read sees Lowry against the background of twentieth-century English painting:

Read: I think he's a lone wolf in the sense that he is not particularly interested in the main trends or movements of contemporary art, and doesn't fit very naturally into them. But there are always in any period lone wolves who stand out from the mainstream, who stand apart from the crowd. They have their place in the contemporary scene. They are, let us say, influenced by the same factors perhaps that influence and create the typical movements of a period. But for some reason, some sense of independence, or sense of isolation, they decide to go their own way and to paint in their own way. And they can be some of the most typical artists of their period. One only thinks back to examples like William Blake at the beginning of the nineteenth century. He occupied a similar kind of isolated position in English painting, and yet when we look back over 150 years or so, we see that he did belong to the period, was part of the romantic movement, and I think 150 years hence Lowry will be seen to be part of the general trend of modern art. But that is not the same thing as belonging to a specific movement.

That Lowry is a lone wolf is undeniable, but I wonder if Lowry has ever been influenced by any other painter or whether in turn he has himself exerted an influence? Michael Ayrton does trace some influences, but of an indirect kind:

Ayrton: I would be very hard put to it to know who has influenced Lowry. Oddly enough, I detect a faint influence of a long-forgotten artist, Ethel Walker. Particularly in his painting of the sea, but this may be pure fantasy on my part. I think Lowry belongs to an English tradition which is essentially a provincial tradition containing such artists as Joseph Wright of Derby, for instance, but I very much doubt if there's any direct connection. I strongly suspect that like many self-taught painters, though there is influence, it is unconscious, and though there is derivation, it is taken in as influence often is by self-taught painters in a complete unconscious and unaware fashion.[1] I don't see any direct derivation from Lowry. In terms of his influence, I would have thought that he had

influenced painters like George Chapman, I would have thought even, perhaps, Josef Herman owed something to Lowry. It's very much a specific English topographical tradition he belongs to. And this is by no means a very fashionable form of expression now. But I have a strong suspicion that it's quite a permanent one.

Lowry was certainly unfashionable, yet as for other unfashionable figures before him, the tide has turned, and few English artists are more popular today. Perhaps in this he is wholly English traditional, out on a limb and at the same time accepted in the end as part of the common body. Does he perhaps after all belong to the loosely knit English tradition? That's not quite the way Edwin Mullins sees it:

Mullins: I think he clearly doesn't. He doesn't belong to anybody, you can't place him alongside any other English painter, and say he owes this, that and the other to him. In the early paintings you can see something of the influence of Whistler, something of the influence of English Impressionism, but this is a very fleeting influence. The moment he acquires his own style of presenting figures all influences really vanish. But I do think at the same time that he belongs to a different kind of tradition, which is that of the English isolated eccentric who's gone his own way, and one would mention artists like Richard Dadd, Blake is an obvious example, Stanley Spencer a more recent example, who may have nothing in common between them, except that they are all isolated freaks. One hates to call Lowry a freak because no one as a human being is less of a freak, but what they contribute to art is nonetheless freakish by its being so totally isolated from its surroundings. This seems to be a particularly English contribution to art. I can't define it, I can't even pretend to explain why it should happen. There must be something about English life which is particularly conducive to this sort of art, and I think it's a very valuable part of the English artistic tradition.

And what does Lowry himself think about his work? I asked him if he thought it was naïve:

Lowry: Well, I don't think they are. I drew the life, but I – well, put it this way, when I started to try to create the industrial scene, I did a lot of little figures and little drawings, sketches, and they looked like they do look, you know what I mean. And I thought, well, it's got to be, so there we are. That's all. If I'd painted a portrait from life, well, I don't

know... as I don't do any paintings from life, I just don't know what's happened. I don't know. But if they all thought of things about me... well, and sometimes I laugh, and say just fancy that! I can't think whether they're naïve or not. I don't intend them – I do them as well as I can, to express what I want.

Rosenthal: How much formal training did you have, and how much did it stick with you?

Lowry: Well, the training lasted me all my life, really. I did the anatomy, and I did a very useful – I draw the figures as well as I need to draw them. As well as I can draw them in a way to suit my purpose. But an ordinary live figure... that would bore me to death. You see, I don't want to do it. You can't photograph these mill scenes. Can't do that. They're too – you've got to be personal about it. Of course, I thought everybody else would really see it redundant, I did one when I started doing them, now I said to myself, I don't think anybody's ever done this mill scene business – as far as I can see Stanley Houghton wrote about it a little, as writing it, the *Hindle Wakes* man, you know *Hindle Wakes* – he was very good, I was very interested in him. And I started idly to do them, and then I said to myself if I can just get these things established, probably I'd clear out. Because I didn't intend to paint all my life, you know. I only expected to get out about 1948, but by then I'd mixed up in it and couldn't stop. But the last five years I'd been very fed up with it. I'd wanted to stop.

Rosenthal: Do you find beauty in paint itself?

Lowry: Well, if I could press a button, and have it done, I'd like to do that, you know. No – it's all the job, an income sort of job – painting, but it's got to be done, and you do it as well as you can, always as well as you can. If I could press a button and have it done, of course, I'd like to do that. I'm not one for painting for painting's sake. But, as I say, if I could press a button I'd like to do it, you know. I'd save myself the trouble.

Lowry likes phrases like that. He told us over lunch that he was tired, and, after a suitable pause, that he'd been tired now for forty years. In fact, it's all too easy to see Lowry as an eccentric from both a human and an artistic point of view, easy since that basically is what he is. But it is in many ways a calculated eccentricity, which only partially hides the man underneath and hardly hides at all the very considerable painter that he is. Lowry stands apart

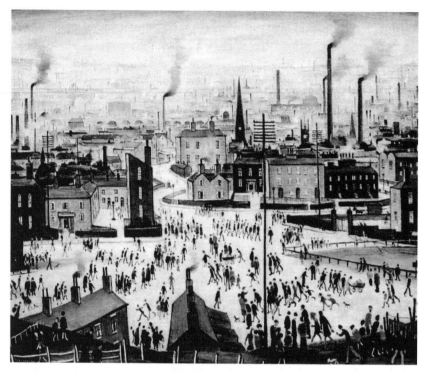

A Lancashire Town, 1945, oil on canvas, 54.6 x 64.8 cm.

in more than the lone wolf sense. He is, as Professor Gombrich says, wholly individual:

Gombrich: I feel very much that what distinguishes Lowry and makes his contribution particularly precious at this time is that he never tries to follow a fashion; he did not try to be original, he just was original. And he never tried, as far as I am aware, to be ahead of his time, or to follow a new trend, to jump on any bandwagon; he just was himself. And in this way he became an individual and great artist.

A great artist. In his way Lowry is that. He has made the harsh landscape of the industrial North take on the beauty which was its ravaged birthright. He has taken the scurrying crowds of the mill towns and turned them into individual streams of the life force and, when his sardonic eye has settled on some wretched derelict or down-and-out, he has extracted from him not only the obvious pathos, but also a kind of triumphant humour entirely lacking in self-pity. Modern art and its presentation always raises a great deal of dust, but Lowry's has for a number of reasons, mostly connected

with his relatively late discovery and the unfashionableness of his work, raised no dust at all, so that one can already see him with a fair amount of clarity and detachment. I think that in fifty years' time, when all the dust around him has settled, the work of L. S. Lowry will be seen as some of the most original and some of the finest English art of the 20th century.[2] But if that's too solemn a thought, perhaps we should let Lowry have the last word – provided that we remember that neither the work nor the man is nearly as simple as he'd have us believe.

Lowry: People call me a Sunday painter, well I suppose I'm a Sunday painter who paints every day in the week.

[1] It was assumed well into the 1960s and before the first appearance of Shelley Rohde's biography in 1979 that Lowry had had no formal art education. It is perhaps interesting to note that Michael Ayrton himself was a virtually self-taught painter and sculptor.

[2] At the time of publication of this book that fifty years will almost have elapsed. It is up to the reader to decide whether that prognostication by a then relatively youthful writer on art has proved valid.

This is the first chapter of my full-length book on Lowry published as L. S. Lowry: The Art and the Artist *in 2010 by Unicorn Press. A much abbreviated version of the essay appeared in* The Daily Telegraph *in the year 2000 when the Lowry arts centre was inaugurated in Salford.*

Facing page: *This essay first appeared in an edited form in* A Musical Eye: The Visual World of Britten and Pears, *edited by Judith LeGrove, published by Artists' Choice Editions (Church Hanborough, Oxon) in 2012.*

BENJAMIN BRITTEN, SIDNEY NOLAN AND PATRICK WHITE

The beautiful clavichord shown on the facing page is a paradigm and a symbol of one of the most interesting cultural friendships of the last century. It was given as a present to Britten by Peter Pears. After Britten's death there was an auction of some of his possessions. At that auction Sidney Nolan bought the clavichord.

Only recently – when I began my research for this article – I phoned Nolan's widow, Mary, a friend of mine for nearly fifty years, to check up on the veracity of an anecdote almost too good to be true.

> TGR: 'Mary, is this really true?'
> Lady Nolan: 'Oh yes. Very much so.'
> TGR: 'Where is it now?'
> Lady Nolan: 'I'm looking at it as we speak.'

Within a few hours the photograph printed here was e-mailed to me by Anthony Plant, the manager of the Nolan Estate in the Welsh Borders, and I immediately recognized and remembered my pleasure at seeing it on my various research trips to Mary's house where Nolan's *nachlass* was stored. It was a small but jewel-like memento of the Britten/Nolan friendship, just as the Nolan paintings in The Red House represented Nolan's admiration for and friendship with Britten and Pears as well as Pears' remarkable and perceptive 'eye' as an astute and deeply committed art collector. Nolan had been introduced to Britten by Sir Kenneth Clark, himself a collector and connoisseur of the highest skill, whose patronage of Nolan, first in Australia and then in England, had greatly enhanced Nolan's career in both countries. This ensured that he was propelled into the higher reaches of the British art establishment. Thus Nolan became a Senior Member of the Royal Academy, a C.B.E., a knight, and a member of the Order of Merit, as Britten had also been an O.M., a decoration in the personal gift of the Queen and therefore the highest decoration in England. (The Order is limited to no more than twenty-four members at one time. Few visual artists flew as high as this: they included Augustus John, Ben Nicholson, Henry Moore, Graham Sutherland and Lucian Freud.)

PART ONE
Britten, Patrick White, Sidney Nolan, and the Opera that Never Was

For most opera-lovers and students of the art form, the greatest sin of omission – and to some, like me, the greatest tragedy – is that Verdi kept on talking about *King Lear* but never composed it. To admirers of Britten,

the world's leading opera composer of the last century, and to students of Australiana, the major un-composed work remains the sadly abortive effort to produce an all-Australian opera with which to open the Sydney Opera House. It was to consist of music by Britten, sets and costumes by Sidney Nolan, and libretto by Patrick White. White was not yet the Nobel Laureate. Significantly when White did get the prize he claimed that illness prevented him from travelling to Stockholm and nominated Nolan to receive the prize for him from the King of Sweden. That happened in 1973, some ten years after the synopsis of a libretto was ready. David Marr's biography gives a good account of the jerrymandering involved in the awarding of the prize.[1]

This bears out something I had written myself in a long and highly favourable review of White's latest novel some months before the 'Nobel season'. I forecast that one day the gnomes of Stockholm (a snide reference to both the Swedish Academy and the gnomes of Zurich playing havoc with the world's bank accounts at that time) would make yet another of their geopolitical selections and thought no more of the matter. Some weeks later at a lunch in Stockholm I sat next to a member of the Swedish Academy who said 'Well, Mr Rosenthal, so you think Patrick White should get the Nobel Prize...?' I did not bat the proverbial eyelid and said only 'Yes, indeed he should', while inwardly shuddering at the prospect of the Swedish Academy's thorough homework in reading the *New Statesman* where my rude words had appeared.

White was, however, by any measurement, the greatest writer, living or dead, produced by Australia. His unwritten novel *A Fringe of Leaves* was to be the primary source of the opera, and Nolan acted as the master of ceremonies or ringmaster, not only to keep the project going but to ensure that it would be ready in time for the grand opening of the highly controversial building which has become, together with Nolan's paintings of Ned Kelly, an icon of Australian culture and civilization.

But it was not to be. Were one writing a blurb for a Hollywood epic one could not avoid the phrase 'the Clash of the Titans'. There was certainly a clash of egos during which neither White nor Britten seemed prepared to give the respect each expected from the other.

In so far as there is a definitive version to be gleaned from the biographies of Britten by Humphrey Carpenter and White by David Marr, Marr's edition of White's letters and the reminiscences of Nolan, the latter took White to a Britten concert in Aldeburgh where the two Australians sat behind a velvet rope with the general public while the Britten entourage sat in front of the rope. Nolan introduced White to Britten in the interval,

and when the subject of the opera collaboration was raised, Britten reeled off his daunting rota of composing commitments which would occupy all his time for the next two or three years, causing White to ask why Britten did not have better control of his output and wonder why he could not alter his own schedule at will.[2] This typical White bluntness did not go down well with Britten and created a more or less instant *froideur*.

In a sense Nolan was not only the catalyst for the proposed opera but also its guiding spirit. He kept it alive to the extent that White wrote a synopsis of the libretto which Nolan sent to Britten in 1963 but which elicited no response from him. There is a certain irony in this sublime, infinitely wished-for non-event in that Nolan was the 'onlie begetter'. It was Nolan who had painted the pictures which inspired White to write his novel instead of the usual reverse order for these things.

The historical event, of course, came first. In 1836 a ship, the *Stirling Castle*, was wrecked on the shore of a sandy island off the Queensland coast. The only survivor was Mrs Eliza Fraser, after whom the island was subsequently named. The entire crew, of which Mrs Fraser's husband was the captain, were killed by the Aborigines who lived there, but Mrs Fraser was not only spared, she was set to labour with the black women in the fields. Nolan's paintings were to some extent fictional, since we cannot be sure that Mrs Fraser was rescued from her slavery by the escaped convict Bracewell, who was as memorably painted by Nolan as was Mrs Fraser. Bracewell undertook to rescue her if she would speak up for him to the authorities, who would otherwise, as a matter of course, sentence him to one lash for each day of his liberty.

Nolan drew White's attention to the island and his paintings of Mrs Fraser and Bracewell when painter and writer met, more or less by chance, in Miami in 1958. The seed was not immediately sown and nurtured but did finally evolve as *A Fringe of Leaves* in 1976, complete with one of Nolan's Fraser Island paintings on the jacket, but this was long after White's opera synopsis.

No matter how brusque and oddly charmless the first Britten/White encounter was, there must have been at least some non-committal, even unvoiced, encouragement from Britten, otherwise why should there be a typescript of the libretto synopsis by White in The Red House? It's difficult to believe that Britten did not read it, if only out of curiosity, even if he made no response to White.

My private interpretation of the absence of a Britten/White collaboration is that both men had – and also knew they had – a titanic ego, and that any collaboration between the two would end with a massive

explosion. Britten, like Verdi, always had the last word on his libretti, and while he could, and did, manipulate librettists like Montagu Slater, Ronald Duncan, Myfanwy Piper and even E. M. Forster, there's no way he could have manipulated White, which I suppose is fair enough since I know from personal experience what a tough character White was. Britten may have been the Verdi of his day – indeed he even toyed, at the suggestion of Dietrich Fischer-Dieskau during the epic recording of the *War Requiem*, with writing *King Lear* himself – but White was not Arrigo Boito, prepared to sublimate his considerable poetic gifts for the 'Maestro'.

For all that the brief extracts from White's synopsis are at the worst tantalizing and at best highly stimulating. White's opening and highly specific stage directions show the dramatic/operatic skills of a da Ponte or a Boito:

> Scene 1. *At the Circular Quay*. A few members of the crew of Bristol Maid are returning late from shore leave singing of rum and doxies and establish something of the atmosphere of Sydney at that period.[3]

Clearly it would, once composed, bear comparison with the opening of Verdi's *Otello* or Britten's own *Billy Budd*. Inevitably, even in an opera libretto, White's deadly contempt for English (and Australian) middle-class snobbery is prominently displayed and honed:

> Mrs Merrivale: [referring to the heroine of both novel and opera] 'Are you convinced that she is a lady?'
> Miss Sibilant: 'Not quite. But she's doing very nicely.'
> Mrs Merrivale: 'Niceness is nicer when it's bred, not learnt.' [Shades of Lady Billows in *Albert Herring*]

Wonderful stuff and, though the synopsis is undated, a letter from Nolan to Britten submitting the synopsis for his consideration is, and indicates that the Sydney Opera House management were absolutely behind the White project, provided that the right composer would come aboard.

79 Deodar Road London SW15
tel: VANdyke 6828 8th August, 1963

Dear Benjamin Britten,

 I enclose the synopsis for a libretto by Patrick White.
 He has suggested that I forward it to you, since he would rather you wrote the opera than any other composer.

The Sydney Opera House opens in 1966 and the Elizabethan Trust Director, Stefan Haag, has asked White for a libretto in the hope that an opera could finally evolve for the opening.

I have shown it to K. Clark who feels that you might be interested.

Patrick White is now in London and will be here until the end of September. If you are interested I could bring him up to Aldeburgh one day for discussion.

I am most hesitant about approaching an artist personally, but my admiration for his work is in the same order as I have for yours, so I hope you will not mind this informal approach.

Yours sincerely,
Sidney Nolan[4]

One can see why White and Nolan were so keen for the opera project. David Marr quotes White as saying: 'One can no longer imagine Mrs Fraser apart from the Nolan paintings... if he can find the right composer.' In England he planned to pursue Benjamin Britten, the only composer who might do justice to 'an opera about the naked lady'.[5]

Sadly, Britten's reticence was justified on purely practical grounds. He was over-committed with other projects. Thus he could not, even if he wished to, be ready for the opening of the Sydney Opera House. Furthermore his health had begun to deteriorate.

White was clearly disappointed and frustrated and wrote a bitter letter to the exquisite minor British writer James Stern, on February 22nd 1970: 'Next week we have the musical queens Britten and Pears: I shall refuse them [i.e. a visit from them] too if any advances are made, though I don't expect they will be. I think Britten is a nauseating county snob and Pears a nauseating voice.'[6]

This is White at his most rancorous. But, to redress the balance, Marr also quotes him as saying that beneath the cranes on Bennelong Point (the site for the Sydney Opera House) he already imagined himself 'at the opening of the Britten–Nolan–White opera with Marie Collier as Mrs Fraser!'[7] As we now know that became just a daydream, but to any of us who knew the putative participants the loss is genuinely tragic.

There is also a strange paradox that only just occurred to me when I looked at my first edition copy of *A Fringe of Leaves*. It is dated 1976, which is also the year of Britten's death. In other words, White, who wrote the novel in two much separated periods, wrote the synopsis for the opera years before the novel had taken its final form; the great writer was therefore much more deeply committed to the opera than the great composer, who indeed remained resolutely *uncommitted*. But what a great

opera it would have been, Britten being the only composer of the period with as sharp a social sense as White and as deep an understanding of human beings at their most grotesque. Both men were masterly expressers of bizarre characters, and had they been willing and able to collaborate the results would have been unsurpassable.

[It is perhaps interesting to note in 2013 that Britten's latest biographer, Paul Kildea, devotes only a single paragraph to the matters discussed here.]

PART TWO
Britten, Nolan, and *Children's Crusade*

Britten was surely the English composer most attuned to language and literature, as we can see from the *War Requiem* and his handling of the dead war poet Wilfred Owen's verse. While he was no writer himself, he had a most discriminating verbal palate which enabled him to get from all his writers precisely what he wanted and needed for his operas. But in what was to become one of his most important joint ventures with Nolan he took an existing poem and simply set it to music. There was no attempt to 'revise' or 'improve' it. The literary work was Bertolt Brecht's poem *Kinderkreuzzug*, which under Britten's tutelage became, in English, *Children's Crusade: A Ballad for children's voices and orchestra*. Britten's great friend and, within the musicological and critical circle, his major supporter, Hans Keller, did an almost magically accurate and haunting English version used by Britten to set to music.

Not surprisingly Brecht, the German master of irony, seems to ignore the original, historical Children's Crusade, an appalling, real, but deeply ambiguous historical event in the year 1212. Contemporary accounts make clear that in 'normal' crusading terms the Children's Crusade was, to put it mildly, a pretty dodgy event. There is an invaluable graphic account by Paula Rego with a text by Blake Morrison, published a whole generation after Britten/Nolan and presented essentially as an attack upon those who misled and exploited huge numbers of children, itself a theme endlessly explored by Britten.[8] As Morrison wrote,

> two very different versions of the legend have grown up: the Sunday school 'Onward Christian Soldiers' version emphasizes the children's faith, courage and determination; the disabused post-modern version sees the children as helpless pawns, exploited by unscrupulous adults, in the grip of mass hysteria, and doomed to catastrophe.

Morrison was not writing with hindsight. According to Aubrey, monk of Trois-Fontaines,

> There happened this year [1212] a practically miraculous expedition of young children coming together from everywhere. They came first from the regions around the castle of Vendôme to Paris, and when they were about thirty thousand strong, they went to Marseilles as if wishing to cross the sea and fight the Saracens.[9]

The Annals of Marbach tell an altogether different story:

> At this time [1212] a frivolous expedition occurred, as children and foolish men marked themselves as crusaders without any discretion, more out of curiosity than for their salvation. People of both sexes, boy and girls alike, not just minors but also grown-ups, married women with virgins, set out with empty purse not only through all Germany, but also through parts of France and Burgundy.

Blake Morrison, in a letter to the author, has pointed out:

> The particular question raised by modern research on the children's crusades, with which Paula Rego is certainly familiar, is a question often raised by her painting: were the 'children' really children, or might they have been adults? How innocent was their crusade? How strong and resourceful were they, how much victims of exploitation, of neglect and abuse? How far were they in charge of their own actions and destinies?

This long digression may seem a long way from Britten, Brecht and Nolan, but I think it to be an essential contrast to their wholly different work of art. In the Rego/Morrison book the cruelty, even savagery, of Rego's illustrations could not be more different from Nolan's, in which he has taken to heart the sardonic, elliptical tone of Brecht, so brilliantly translated by Keller. Erudite as Morrison's text is, it is simply a gentle background accompaniment to Rego's lithographs. As such it is admirable. But the dominant figure in the collaboration is indubitably Rego.

In the Britten version one is deeply aware of four very different and – before political correctness destroyed so many useful words and phrases – differently abled artists. Britten, as so often moved by the fates of children, excelled here in a great wash of emotion. Brecht, the most sardonic and ironic of twentieth-century German poets and dramatists, created a loaded cannon pointed at the Nazis more powerful than most other polemics. The dazzling, scholarly critic Hans Keller produced a translation which reads like an original English work. Lastly, Nolan in his

set of fourteen paintings (of which only twelve were reproduced in the
book published in 1973) created the most interesting of his human figures
since the Kelly gang and Mrs Fraser and Bracewell.

If one considers Nolan's *œuvre* as a whole, or at least as a continuum,
the obvious but nonetheless utterly compelling unifying factor is the need
to paint series. There are relatively few among his best paintings which are
single and one-off subjects. Once his period of juvenilia was over probably
95% of his art was in the form of series: *Ned Kelly, Mrs Fraser, Burke and
Wills, Leda and the Swan, Gallipoli, Eureka and the Miners, Oedipus*, etc.
Any one or more of these might have endeared Nolan to Britten. While
Britten would not, could not, have seen the Kelly paintings, the theme
of Kelly as the heroic outsider, via Kenneth Clark's introduction, plus
Clark's and Bryan Robertson's and Colin MacInnes's essays in the first
book about Nolan, published in 1961 (which was when I met Nolan),
would have made a great impression on him.[10] It will have escaped the
attention of neither man that Nolan was creating *his* masterpiece at the
same time that Britten, albeit 12,000 miles away, was creating, in *Peter
Grimes*, his masterpiece (although Kenneth Clark had remarked to E. M.
Forster that *Billy Budd* was 'one of the great masterpieces that change
human conduct'). In real time Britten had begun to work on *Grimes* in
1945, while the first great sequence of Kelly paintings was done in 1945–6.
(Nolan did produce many later Kelly pictures, including, more or less on
his deathbed, a spray-painted self-portrait with the unmistakable Kelly
outline in black superimposed on it.)

The origin of *Children's Crusade* was a commission for the winter
of 1968–9 to celebrate the 50th anniversary of the Save the Children
Fund, and the piece was first performed on May 19th 1969 in St Paul's
Cathedral. Interestingly enough Britten had composed it to the German
words by Brecht but had then enlisted Hans Keller to produce an English
translation to fit his music. The composer had described it as 'a very
grisly piece'; in a letter to William Plomer he wrote that 'the boys [the
Wandsworth Boys' Choir] made a tremendous impression of passion and
sincerity alongside the asinine pomposity of the established church'.[11]

One could not doubt where Britten's political thoughts were, and both
Keller and Nolan (despite all his decorations and familiarity with royalty
– the Queen Mother and the Duke of Edinburgh both had Nolans on
the walls of their private quarters) were men of the left even though the
Politburo would have condemned them as 'rootless cosmopolitans'.

While one cannot prove this, my suppositions about the birth of this
work are that both Britten and Nolan had what one might call loosely

'experience of the Holocaust', as early post-war knowledge slowly revealed the nature and scope of the atrocities. Nolan himself recollected, in a public interview with Donald Mitchell at the Aldeburgh Festival on June 11th 1990, that

> the clue, in a way, was the fact that Ben had been in a concentration camp immediately after the war – he'd been playing the piano with the violinist Yehudi Menuhin, and I'd gone to Auschwitz about 1960 for *The Observer* to do some drawings of the camps... I think it was Auschwitz really, that... behind our collaboration, in the matter [*Children's Crusade*]... Strangely enough... I got 'flu one year and I had a temperature and I did some illustrations, once again based on Britten – *The Holy Sonnets* of John Donne, and I did a set of drawings which were really scary – extremely tough and tragic and I showed them to Peter [Pears] and he said 'I wouldn't show them to Ben because they're very disturbing' and I said 'Well, I'm sorry they're like that but I had a temperature.' Peter replied, 'Well, the extraordinary thing is that when Ben wrote the music for *The Holy Sonnets* he also had a temperature.' But on *Children's Crusade* that was the terrible moment in Europe when these things happened and of course the awful aspect of it is that it's the children who suffer.[12]

If there were sufficient space here I would quote the whole of Brecht's poem but, inevitably, I can only provide a sample of three quatrains which are not only central to Brecht's theme and purpose but which, in Keller's hammer-like translation (not for nothing was Keller a respected, and, on occasion, feared, music critic, known to those who did not admire him as 'Hans Killer'), convey the remorseless bitterness of the children's fate in that horrendous time and place. Small wonder that Britten, with his affinity for young children and his, at times, overwhelming sense of the need to protect and cherish them, wrote much of his most affecting music for unbroken boys' voices, whether solo or choral.

> In Poland that same January,
> They caught a dog half strangled:
> A cord was hung round his scraggy neck,
> And from it a notice dangled
>
> Saying this: PLEASE COME AND HELP US!
> WHERE WE ARE WE CANNOT SAY.
> WE'RE THE FIVE-AND-FIFTY
> THE DOG KNOWS THE WAY.
>
> The writing was in a childish hand.
> Peasants had read it over.
> Since then more than a year has gone by.
> The dog starved: he didn't recover.

The Brecht poem is, for him, an oddly majestic work consisting of one non-rhyming couplet and thirty-three quatrains in all of which the second and fourth lines rhyme and the first and third do not. Keller in his brilliant translation thus had to surmount two difficulties in producing his English version: reproducing the rhyming pattern, and, much harder in the light of the rhyming restriction, making sure that the rhythms matched those of the verse used in the composition, which, remember, was in German. Therefore Keller had to produce poetry which precisely followed the music. The end product is a remarkable, elegantly carpentered, singable version.

The whole Brecht/Britten/Keller trio is a fascinating example of the eternal Straussian riddle from *Capriccio* in which Flamand, a composer, and Olivier, a poet, vie for the favours of the Countess Madeleine, who is, in Strauss's exquisite musicianship, both a muse and a symbol of opera. The great, highly competitive, debate as to which comes first, the words or the music, is characterized by the Italian phrase 'prima le parole, doppo la musica' ('first the words and then the music'), so soon challenged by 'prima la musica, doppo le parole'. In *Children's Crusade* there is none of the musical by-play of Strauss since the facts are quite straightforward. Brecht's poem preceded Britten's music by roughly two decades, so that, as with his versions of Shakespeare or Hardy, Britten practised only inspiration and adaptation, rather than co-operation; if, that is, one regards Keller simply as the provider of the translation of an existing work of German literature.

Children's Crusade was published in 1973 in a limited edition consisting of a facsimile of the first musical manuscript with the German text handwritten by Britten.[13] He had appended a note:

> The manuscript of *Children's Crusade* reproduced here represents the stage in the evolution of the work when the music was complete in substance and outline and written out in the form of a condensed score, i.e. the orchestral part still awaits its detailed instrumental realization.

(Shortly after, the full score was completed, to which the published version corresponds.) Britten describes the work on the title page as 'Op. 82' and 'A Ballad for children's voices and orchestra'.

The verse is bleak stuff; the music, while powerful, is not. Nolan's paintings are surprisingly apposite; more so than his other Britten-inspired works. My own view of this internal conflict in Nolan's Britten pictures is simple but, I hope, not simple-minded. His other Britten works were on a much smaller scale and adapted to less profound musical

inspiration, based, as we shall see, on shorter, more self-contained literary works which had inspired Britten to create musical adaptations.

Children's Crusade is a long epic poem, and while Nolan was relatively new to the Brecht he was not new to the concept of the Holocaust, nor was he ever blind to the temptations of history. In other words Brecht provided the backbone of a series. Just as some men can be serial marriers or serial murderers, so Nolan was a serial painter: throughout his working life he created few single works and many series. How could Nolan, the creator of major series, some of which grew to a hundred works in various media, do otherwise with Britten/Brecht? Given his extraordinary versatility in multiple media and his sheer, possibly unequalled, facility, he could easily fill an entire gallery with narratives and variations on a single theme. Thus, in a sense, the Brecht was manna to him; he could not resist Brecht's almost overpowering narrative skill. And this poem, which ran to stanza after stanza, each of which could set off Nolan's pictorial mind, had a deep interest for Nolan whom, not entirely facetiously, I can clearly imagine with a grin on his face as he realized that he had the makings of a major series here.

One should remember that when he first became obsessed by the bushranger Ned Kelly, an iconic hero in Australia, who, unlike Robin Hood, really existed, killed a lot of people, and died on a scaffold, Nolan – still in his twenties and still largely unrecognized in his native land – produced in a few months in 1945 and 1946 some twenty-seven major oil paintings based on his life and crimes. (The double Booker Prize-winner Peter Carey has stated publicly that the inspiration for his second Booker winner, *True History of the Kelly Gang*, was a showing of Nolan's original series of paintings at the Metropolitan Museum in New York.)

As the world turns one can note that Nolan's iron-masked Kelly was used as one of the official icons of Australia for its staging of the 2000 Olympics. Theme after theme stimulated Nolan's post-juvenilia work, including a second Kelly series, a series on the heroics and doom of Australian soldiers at Gallipoli, the epic journey of discovery in the first, but partially fatal, north–south crossing of Australia by Burke and Wills. The more astute students of Nolan's serial work cannot fail to notice that what those series had in common was failure itself: Kelly was hanged, while many of the explorers' team on the Burke and Wills adventure died, usually of disease or starvation, and in the end they did not complete the crossing. As for Gallipoli, thanks to some wooden-headed British generals thousands of Anzac soldiers were needlessly slaughtered. And while there were other series not involving doom and destruction, such

as *Oedipus* or *Leda and the Swan*, subconsciously at least Nolan must have seen *Children's Crusade* as another, albeit heroic, failure. When writing my book about him, Nolan by then long dead, I deeply regretted that I could not have found out if this very well-read man knew a superb book by Ivan Morris called *The Nobility of Failure*. In this book, as he was one of the Western world's best Japanologists, Morris analysed the lives of several heroic Japanese leaders and warriors, all of whom deemed their last, fabled exploit to be a failure and, in true and best Japanese style, killed themselves with their swords.

By any standards the original historical Children's Crusade was a failure, and so was the one in Brecht's poem, so that it is not at all difficult to see, even without the friendship with Britten, the attraction, whether consciously or subconsciously, of the agonizing failure depicted by Brecht.

Nolan made fifteen mixed media paintings inspired by both Brecht and Britten. I have puzzled over the number of paintings reproduced in the 1973 limited edition of the book, which was twelve out of fifteen. At The Red House there are fourteen paintings, while the fifteenth is in the possession of the celebrated doyen of Britten scholars, Donald Mitchell. The only possible solution I can think of, assuming that Britten must have liked Nolan's series, since, had he disliked them, the Faber book would not have been published, is that twelve decent-sized reproductions were as many as a single, two-sided colour sheet could in those days comfortably accommodate, and presumably Faber could not/would not afford a second colour sheet for only three reproductions.

Be that as it may, the twelve that are reproduced are a worthy monument to both Britten and Brecht and, not for the first time, Nolan's imagination was fully engaged to produce a serial masterpiece.

For the reader's sake, where I analyse an individual work, I follow the order in which the works are reproduced in the Faber book, giving the line or lines of Brecht's verse constituting the link between text and pictures, and the page number of the text that faces the painting.

'In the blaze and heaps of rubble / Children found their parents no more' (facing page 4) Three children either naked or in rags face us against a background of ruins. The ground they stand on is like the precipitous edge of a flooded stream or even a waterfall. Their lives seem precarious as if the water, like history, will sweep them away.

'They had their little leader' (facing page 5) This is against a similar background done by Nolan in his unique and self-invented medium of oil painting and acrylic applied with a tightly constructed and held ball

of old silk stockings. That enabled him to create a striated surface with a single stroke, whereas a brush, to create the same effect, would have to be used for many strokes. The 'little leader' is a solitary figure, standing in a sideways-on posture with one visible arm as if trying to thumb a lift from God knows what transport is available, let alone safe.

'When they stormed a peasant's empty shack / They left it because it was raining' (facing page 6) is full of movement, the rain depicted in sheets and (Nolan's sense of irony is at work) the three boys forming a group as if they were circus acrobats. Nolan had used quick-drying acrylic paint together with oil crayon to great effect in his *Gallipoli* paintings and drawings in the decade roughly following 1961, i.e. well before the *Crusade* paintings. But both series dealt scrupulously with the effects of war on military and civilian personnel and, as Nolan had observed to Britten in accepting the commission, it's always the children who suffer the most.

'He came from the Nazi legation' (facing page 7) shows a somewhat ambiguous solitary male figure with explosive shell bursts like stars in the background. His clothes imply a civilian but we can't really tell. Other lines in the relevant stanza imply that he too is a refugee, who for reasons unknown the Nazis have let go.

'For how can the saplings blossom / With so much snow to hold?' (facing page 14) is sensually a beautiful picture in the purples and browns favoured throughout the series, but despite the fertile sapling bowing to the wind, it is a picture of the desolate – and surely terrifying – landscape the Crusader must traverse.

'Then there was a war, / War against some other children on the run...' (facing page 15) is a truly mysterious but strangely moving work, depicting again a trio of naked boys (there were, I think, no girls among Nolan's or Britten's Crusaders). The three boys, despite the blighted, wintry landscape, are all in potentially acrobatic postures. They look starved and confused, grim reminders for our pity.

'Velvet Collar it was whom they buried... ' (facing page 20) is 'A little Jew' who 'showed much valour' but was buried, carried to the funeral by Polish and German bearers and in death attended by 'Protestants and Catholics, and Nazis'. No Jews in attendance of course. One wonders who got the velvet-collared coat. The leader perhaps...

However there is no sign of the coat in *'They wandered steadily southward'* (facing page 21). This painting makes you wonder just how many child Crusaders there were and how many survived. The land looks as if it is decanting the boys downwards on a dangerously deep slope. There are four boys, all naked, walking or marching in a solitary rank to

find *'South is there, where the sun / Stands high at midday / For everyone'*.

'To Bilgoray' (facing page 22) constitutes the optimistic dying words of a wounded soldier, nursed by the boys for seven days. This is clearly the Crusaders' leader, grown older and bigger, in the largest image of a human being in the series. Against the perennial purple and brown background he has a properly delineated head with discernible feature: nose, mouth, eyes, etc. He is standing up and his left arm is extended upright as if either to carry out a Hitler salute or to mock that hated gesture. This salute is in my view ambiguous. Only Nolan could tell.

'It must be there' (facing page 23) refers to the boys' leader pointing the way to Bilgoray as directed by the dying soldier. This is a powerful expressionist work showing the leader as careworn, unhappy with his responsibilities, and with a long, emaciated neck betraying his level of near starvation.

Sadly my favourite painting in the series did not make the cut at Faber's and can only be seen at The Red House. It shows the starving boy carrying, like a St Bernard, something round his neck – a crudely painted wooden sign bearing the inscription THE DOG KNOWS THE WAY. Two of the children float above the dog, as if swimming in a slow backstroke in the opposite direction.

But even if one can query the selection, this extraordinarily moving document with its brilliant fusion of music, poetry and painting constitutes a monumental collaboration between three huge talents.

PART THREE
Winter Words

Winter Words: in Various Moods and Metres is the title of Thomas Hardy's last collection of poems, published by Macmillan in 1928. On 8th October 1953 Britten's *Winter Words*, Op. 52, had its première at the Leeds Festival at Harewood House. The song cycle was dedicated to John and Myfanwy Piper and the first performance was by the composer and Peter Pears, thus confirming Britten's own note that the work was for 'high voice' and piano. Nolan, himself a not inconsiderable poet, relished Hardy's work and responded not only to the long dead grand old man of English letters but to Britten's luminous settings, in a series of paintings created in a single day, 11 January 1968.[14] I set out below two of the complete poems for which Britten wrote the music:

'Midnight on the Great Western'

In the third-class seat sat the journeying boy,
And the roof-lamp's oily flame
Played down on his listless form and face
Bewrapt past knowing to what he was going
Or whence he came.

In the band of his hat the journeying boy
Had a ticket stuck, and a string
Around his neck bore the key of his box,
That twinkled gleams of the lamp's sad beams
Like a living thing.

What past can be yours, O journeying boy,
Towards a world unknown,
Who calmly, as if incurious quite
On all at stake, can undertake
This plunge alone?

Knows your soul a sphere, O journeying boy,
Our rude realms far above,
Whence with spacious vision you mark and mete
This region of sin that you find you in,
But are not of?

'Proud Songsters'

The thrushes sing as the sun is going,
And the finches whistle in ones and pairs,
And as it gets dark loud nightingales
 In bushes
Pipe, as they can when April wears,
 As if all Time were theirs.

These are brand-new birds of twelve-months' growing,
Which a year ago, or less than twain,
No finches were, nor nightingales,
 Nor thrushes,
But only particles of grain,
 And earth, and air, and rain.

'Midnight on the Great Western' is not only archetypal Hardy but is also about an abiding theme of Britten's. It is clearly a poem about a boy, a young boy, who, because of his loneliness and the absence of anyone to look after him, is depicted as being at risk: he could, in the wrong circumstances, be prey. Nolan, in his Mitchell interview, recalled a concert

with Peggy Ashcroft doing the Hardy poems and Julian [Bream] playing
the lute … the poems were terribly sombre and represented something that
Hardy had buried in himself for forty years as a result of his first rather tragic
marriage … and as he said they came out as new as the day they went in and
produced these wonderful sombre poems.

Just as Hardy had the deepest, most buried of secrets so did Nolan and
Britten, so that the choice of *Winter Words* for Britten to compose and
Nolan to illustrate produces for listener, reader and viewer a deeply
plotted and indeed sombre work of art. Yet the music is not something
that is difficult to listen to, since being sombre is no vice, particularly
in music. Think of the *War Requiem* and realize that sombre does not
necessarily mean unpleasant or non-affecting. In the case of *Winter Words*
out of sombre verse Britten has made a thrilling moving music in an
absolutely English style and manner.

Interestingly 'Proud Songsters' is where cheeriness breaks out and
the result is joyful rather than sombre. Nolan's illustrations to these two
poems/songs are resolutely English. Given the exotic nature of his native
Australian birds his version of 'Proud Songsters' is relatively subdued.
On the other hand his 'Great Western' painting, while equally subdued, is
darker in colour and in execution. Like Britten he has grasped perceptively
the loneliness and vulnerability of the boy and the awesome nature of the
(possibly) unknown which awaits him at the end of his journey.

In the *Winter Words* paintings, even allowing for critical hindsight,
there is, for Nolan, an almost tectonic shift. If Hardy and Britten are
respectively among the true greats of English verse and English music,
then surely Nolan is, together with his best friend and brother-in-law
Arthur Boyd, the quintessential great Australian painter. Nolan and
also to some extent, although he refused to fly, Arthur Boyd were great
travellers. Both, more or less coincidentally, had strong ties to Suffolk
– Nolan via Britten, and Boyd via his principal residence and studio at
Ramsholt. Boyd was in fact, unsurprisingly, given the life-long but always
friendly rivalry between the two, standing on the same tectonic plates in
that much of the work he did at Ramsholt had distinct English tones and
at times bore a strong touch of Constable in his landscapes. With Nolan
there was a distinct Anglicization in the work he did with and for Britten.
The pictures, as it were tied to Britten pieces, clearly had a European
background.

I use the word 'European' because Nolan was a compulsive traveller
and you can always tell where he had been, be it Africa, Gallipoli, Italy,

China, etc., not merely from the titles of his paintings but from their backgrounds and, of course, their subject matter. In this he was part observer and part visionary, never more so than in *Children's Crusade*, where the landscape backgrounds are evocative of the ravaged countryside around Auschwitz. So in *Winter Words* a very English landscape gives us the background in a way that reflects Hardy's seductive and evocative verse as well as Britten's music, which is the most obviously English since Elgar and Vaughan Williams. If, as a flight of fancy, one could channel Hardy hearing the music and looking at the paintings he stimulated, one could well expect that this otherwise rather gloomy man would be enjoying the two different media he inspired.

PART FOUR
Nolan's paintings in The Red House

Judith LeGrove has provided a masterly survey of the entire art collection at The Red House, with provenance where of interest, dates of acquisition, prices, etc. Therefore I shall concern myself only with works by Nolan acquired by Peter Pears or Britten or both acting jointly. There is, alas, insufficient space to reproduce and/or analyse all the paintings, so I shall restrict myself here to Nolan works which are not related to specific Britten works, since many of those will have been covered in other sections of this essay.

The most obviously relevant picture on The Red House walls, apart from the portrait of Horace Brodsky and Mary Potter's study of bathers in and around The Red House swimming pool, is a Nolan of a literally monumental subject which reinforces the intellectual sparks struck when Nolan and his second wife, Cynthia, made an epic Australian journey with Britten and Pears.

Inevitably they visited the vast rock in the middle of the desert called, since its discovery, Ayer's Rock; that original nomenclature has been banished and today it is called by its original, ancient, Aborigine name, Uluru. Nolan's in Aldeburgh is only one of dozens of representations. One, a lesser work, is a quick watercolour sketch which is not immediately recognizable as a Nolan. On the other hand, his oil and mixed media version of the monument is instantly recognizable, recalling the mass of overpowering landscapes he painted, with an aeroplane view, of the Central Australian desert. His view is what in film would be called a long shot. Just slightly more than half the picture is pure desert, free of any human content. It seems to be painted just before dusk, the dying sun

bathing in light the God-like striations of the surrounding sand-dunes. The background, slightly less than half the picture, shows the already darkening sky with the rock, looking as if some vast power had just turned it out of a gigantic baking tin. One can see, since Nolan makes you see, what an overwhelming sight it creates and why it is an object of worship for the Aboriginal Australians.

Nolan had, on occasion, a sly sense of humour, and in a painting called *Wagtail and Baby* he gives us an equivalent in humour of Brueghel's *Fall of Icarus* in which the high-flying doomed Icarus is about to vanish in a small corner of the canvas while the main image, a peasant ploughing, ignores this tragic cosmic event. So in *Wagtail and Baby* in a scrupulously painted marshy landscape (very English this) you can see the naked baby (looking more like a three-year-old toddler), while if you look hard you can see, quite near the little boy sitting on his haunches, the tiny figure of the wagtail, with head and beak engaged in foraging for a tasty worm or two. Why this very simple and peaceful scene, beautifully lit by exquisitely painted moonlight, is so striking is because the right-hand lower quarter is occupied by a very large goat, watching child and bird. This is no scapegoat but a normal farm animal looking peacefully at boy and bird. An oddly composed but attractive painting.

There is a marvellous painting called simply *Flowers*, which to my non-botanical eyes looks like a tangle of sunflowers having turned in unison towards the sun and just about ready to be harvested for their seeds. Nolan has painted them with such ingenuity, making them more colourful than nature would normally allow, that they look like a very arrogant, but well endowed, peacock's tail.

In another picture our friend the large goat has reappeared; although he might have become a starved cow during one of the horrendous droughts periodically experienced by Australia. This time in the desert there is another view of Uluru, and in the foreground there are two naked men, one in a sitting position, the other lying down flat on the desert floor. The view of Uluru is at the least ambiguous, since it shows a somewhat indefinite, rectangular shape superimposed on the landscape rather than being an integral part of it.

The key Australian painting, in my view, is that of an Aborigine boy seen semi-crouching, with superimposed on his body, and precisely following the bending-forward figure, a completely realistic boomerang. If one wants to see it in a metaphorical sense, the boomerang, which is not a toy but a weapon, can be viewed as an X-ray image, as if it had been swallowed. Is this an image of war? Is it a youth about to be sent into the

bush for initiation rites? Or is it simply a handsome figure to whom a boomerang is added to make it a fitting memento of the Britten/Nolan Australian visit?

There is also a snake painting about 12 inches square which is almost certainly the smallest of all Nolan's herpetological works, for which he had an undoubted obsession (which Britten was doubtless aware of), so that its presence in the composer's house is the equivalent of Britten sending or giving to Nolan the manuscript of a much-treasured brief song. I suspect that snakes meant to Nolan what pre-pubescent boys meant to Britten. While there have been other snake series in which Nolan creates literally hundreds of paintings of Aborigine heads, huge tropical plants and individual flowers, each about a foot square and framed in panels of six, the largest manifestation of the obsession is one called simply *Snake*, done in the period 1970–72. This was only a year or so before Britten and Nolan collaborated on *Children's Crusade*. In *Snake*, which has been filmed and was exhibited in Dublin, there are 1,620 images, all mixed media on paper, and the complete work measures 30 feet in height and 150 feet in width. Provided you can step far enough away from it, in an exhibition hall that is big enough, you can clearly discern the central design factor: out of the many small pictures there emerges the undulating figure of a great snake, one to overtake all the serpents of myth and even to impress the Aborigines.

If this seems like a digression, I believe that it is not. Every great art, in whatever medium, needs two essential things: the creativity that produces major works of art and the high intellectual power needed to keep the work going in one's brain, the sheer need and ability to organize; and, since there was no competition between Nolan and Britten, one can imagine their discussing the enormous magnitude of cerebration that goes into the *War Requiem*, quite as massive and complex in one's head as *Snake*.

It is also interesting to note that another gigantic collection of small paintings made into a huge single form is Paradise Garden. This was 'really done for Britten who wrote songs of Christopher Smart's poems which Smart wrote in an asylum'.[15]

PART FIVE
Britten and Shakespeare and with Nolan in Australia

One of the best sources of information about the Britten/Nolan relationship is the long interview done by Donald Mitchell at the Aldeburgh Festival

in 1990. Nolan relates:

> I had an exhibition here [Aldeburgh] of, I think, 24 Shakespeare Sonnets
> and that was triggered off by the Shakespeare Sonnets of Ben and Ben came
> along and said 'Mm that looks a bit like Peter, and that looks a bit like you
> and that looks a bit like me. Nobody seems to look like Shakespeare.' But
> that was a very sombre exhibition, and it was all about a personal experience
> of mine, you know, rather like the Captain Vere thing. It was a hidden thing
> in me which I couldn't discuss now, but it was a kind of hidden relationship,
> I suppose, in my life that I never discuss – but I was able to put it into the
> sonnets ... Shakespeare was exactly it, and Ben's treatment of the sonnets
> had kind of opened them up for me, so that was that.

Nolan was being deadly serious in what he said about Britten himself and
his secret side but one should remember that Nolan was a considerable
wit and a gifted poet, as witness his short but deadly *Home of the Year*:

> When Iago married
> Lady Macbeth
> they bought a
> house in the country
> and could not sleep
> the first night
> because it was so quiet.

So it was not surprising that he had a welcoming ear for Britten's *Nocturne*
and, in particular, his setting of one Shakespeare sonnet. Mitchell catches,
in the interview, Nolan's drift.

> Mitchell: 'When mine eyes...'
> Nolan: 'When most I wink...'
> Mitchell: 'When most I wink, then do mine eyes best see.'
> Nolan: 'Well that's uncanny.'
> Mitchell: 'Yes, it is... I'm certainly not pressing on the Shakespeare
> matter, but I was interested... in what you said, that this was... a hidden
> thing within you, and I wondered whether in fact this hidden thing within
> you... part of the way this relationship between your painting and music
> works is that you will hear a piece of music by Britten... and that will unlock
> within you – it's a means of unlocking the hidden thing within you and
> expressing it in terms of painting?'
> Nolan: 'Yes, that's precisely it.'

The conversation then turned to the epic journey Britten and Pears
made with Sidney and Cynthia Nolan. It began with Britten and Pears
going with the English Opera Group to the Adelaide Festival to take

and perform the *Church Parables* around Australia. That was when the Nolans showed Britten and Pears Ayers Rock and they had their first proper exposure to how interesting the Aborigines and their culture were. As Nolan has recorded it, 'We got to Alice Springs, which is the closest place to it [Uluru]. Ben saw these Aboriginal boys at the airport, and they're terribly graceful and... not elegant is the word but just... you know beautifully graceful and he said "Isn't that marvellous."'

Nolan went on to describe and rhapsodize about the crystal-clear light and the unusual colours such as purple, amethyst and lavender. Britten was enchanted. Later on the party flew from Sydney to Brisbane, stopping briefly at Townsville. Nolan stood there silently in the great heat and Britten wandered over and asked him why. 'Because', responded Nolan, after one of the long silences he and Britten shared when they had time, 'my younger brother, who died in the war, is buried here.'

Then, after their shared reflections, Britten told Nolan that he had, at least temporarily, scrapped any ideas concerning an Australian opera, but that he wanted to create an Australian ballet based upon the beauty of the young Aborigine boys and the superior way of life they practised and particularly their better way of bringing up their children. Britten became quite excited by the prospect and, of course, the sets and costumes were to be by Nolan. I have had confirmation from Sir John Tooley, who was the General Director of the Royal Opera House, Covent Garden, at that time, that the ROH was keen on both an Australian opera and an Australian ballet in that order, but had acceded to Britten's request that the ballet be composed and performed first.

As so often happens when, after fantastic stimulation abroad, one gets home, the projects become less pressing. But Nolan did feel that Britten seemed, on that night, to be for once boyish and carefree and confiding an episode in his life he had regretted and buried, just as Nolan had had these feelings when creating his Shakespeare pictures.

Author's note: I, alas, never met Benjamin Britten, but ever since the explosion that was *Peter Grimes* just after the war ended I have admired his music and believe that he and Janáček changed the face of opera and that, by a long distance, Britten is the greatest British composer of the twentieth century.

I was, however, lucky enough to have known Patrick White very well and find no difficulty whatsoever in naming him as the great Australian novelist of the twentieth century. I also spent a lot of time with Sidney Nolan and seem, on the principle that in the land of the blind the one-eyed

man is king, to have written the standard work on his art, almost certainly on the grounds that mine is the only comprehensive study there is. As the reader, if he or she gets this far, will have noticed, this essay contains two major regrets: that the opera based on *A Fringe of Leaves* never happened, and, balletophobe that I am, even I will think often of Britten's unwritten Australian Aborigine ballet, since Nolan was a brilliant theatre designer and his sets and costumes for Stravinsky's *Rite of Spring* are masterpieces. In the 'who is the greatest artist in the Western style produced by Australia in the last century' question, I can only duck the issue. Sidney Nolan and Arthur Boyd have to share that prize. Even after half a century as art critic and historian I cannot separate them, and it is fitting that they were friends, rivals, and, in their last decade, brothers-in-law.

[1] David Marr, *Patrick White: A Life* (London: Jonathan Cape, 1991), pp. 532–7.

[2] ibid., pp. 425–6.

[3] Patrick White, 'A Fringe of Leaves: synopsis for a libretto', unpublished typescript, Britten-Pears Foundation.

[4] The letter is in the Britten-Pears Foundation. It is also quoted in Claire Seymour's 'From "The Borough" to Fraser Island', in Lucy Walker (ed.), *Benjamin Britten: New Perspectives on his Life and Work* (Woodbridge: The Boydell Press, 2009), pp. 138–59, which contains a detailed analysis of the Mrs Fraser story and the inter-relationship of the White synopsis, the novel, and Britten's work.

[5] Marr, *Patrick White*, p. 413.

[6] *Patrick White: Letters*, ed. David Marr (Vintage Books, Australia, 1996), p. 358.

[7] Marr, *Patrick White*, p. 413.

[8] Paula Rego and Blake Morrison, *The Children's Crusade* (London: Enitharmon Press, 1999).

[9] ibid.

[10] Kenneth Clark, Bryan Robertson and Colin MacInnes, *Sidney Nolan* (London: Thames & Hudson, 1961). The copy owned and annotated by Pears, inscribed 'Love to Ben & yourself, from us / Sidney', is a reprint from 1967.

[11] Humphrey Carpenter, *Benjamin Britten: a Biography* (London: Faber & Faber, 1992), p. 488.

[12] A recording and transcript of this interview are in the Britten-Pears archive. For a published transcription, see Nancy Underhill (ed.), *Nolan on Nolan* (Penguin Viking, Australia, 2007), pp. 354–77.

[13] *Children's Crusade: Kinderkreuzzug, Op. 82. A Ballad for children's voices and orchestra.* Music by Benjamin Britten, words by Bertolt Brecht, illustrations by Sidney Nolan. A limited facsimile edition of the composer's manuscript (London: Faber Music in association with Faber & Faber, 1973).

[14] Six *Winter Words* paintings were acquired by Britten and Pears soon after their completion. It seems likely there were eight in total, one for each song in Britten's cycle.

[15] Nancy Underhill (ed.), *Nolan on Nolan*. Britten's setting of Smart was *Rejoice in the Lamb*, which inspired from Nolan a series of Australian flower paintings exhibited at the 1968 Aldeburgh Festival.

PAULA REGO I

In 1965 Paula Rego painted a savage picture called *Stray Dogs* (*The Dogs of Barcelona*), an almost Picasso-like, frenzied protest against the city fathers of Barcelona who had just started a municipal mass murder (as she saw it) of the city's vast collection of strays.

She was then, and remains today, a staunch lover of dogs – and other animals, although she has no illusions about dogs being mere lovable pets. If lovable they can also be loved perversely, as in her 1986 painting *Girl Lifting up her Skirts to a Dog*, in which the girl's motivation and action are obviously seductive, as is the relationship between girl and dog in her 1987 etching, *Girl sitting on a Dog*. Yet dogs are not always loved, as in *Misericordia*, her 2001 etching where a girl is beating with a long stick a dog, rearing up in pain on its hind legs. When I asked Paula why this was being done she replied 'Because it's barking I suppose'.

To know Paula either professionally or socially is as far from the canine world as is possible. This slightly built, devoted mother and grandmother, at grand social occasions like Glyndebourne, ever magnificently coiffed and dressed, is a very beautiful woman. If she makes you think of dogs at all she puts you in mind of a labrador or spaniel of Crufts – winning standard. Inevitably this is a serious misreading of her character as an artist and as a feminist. The dogs that spring to mind, particularly as one thinks of the works of the last decade, are the monsters of nightmare, the dobermans, the rhodesian ridgebacks, the pit-bulls, all of whom, whether by nature or nurture, are taught to grip, to be ready to bite, never to let go and, preferably, to kill.

It would take a moral philosopher such as Bertrand Russell or Noam Chomsky to draw any general conclusions about Rego's thought processes and whether she is simply reflecting our time; her career has largely coincided with the peace that was supposed to break out in 1945 – a 'Peace' that has seen warfare and violence brought into our houses by TV live reportage from Vietnam, Iraq, Afghanistan, the former USSR, the former Yugoslavia, etc.

In Rego's mindscape you don't even need to be a dog to bite. In her notable series of lithographs, based on *Jane Eyre* in 2002, there is a splendid one called, simply, *Biting*. As Rego said to me at the time: 'This is a sexy one. That's when Mr Mason visits his sister Bertha and he comes back and says "She's bitten me". That's what we can see and you can't see in the book, but you can see it here. He's feeling her up so she bites him.' Yet this episode and this lithograph are at the milder scale of Rego as mordant canine eviscerator of what her beady, justly feminist, partly

This is the introduction to the catalogue of Paula Rego's 2010 exhibition Oratorio *at Marlborough Fine Art in London.*

compassionate humanist, eye sees, indeed has sought out, for her condign punishment. That women form a disproportionate part of the focus of her anger is natural; not because Rego is a woman and a self-avowed feminist, but because women have always been – and largely still are – the prime victims of the daily cruelties practised at their expense. And if a mere male can offer a comment, thus it always was and thus it always will be, when, even in ultra-sophisticated and advanced Britain, highly intelligent women go on whingeing about glass ceilings and too few female MPs when, worst of all, we have failed to suppress trafficking of under-age prostitutes, female genital mutilation, forced marriages of teenage girls and honour killings, i.e. murders, by male family members who don't like their daughter or sister's choice of boyfriend.

Which is why Rego, with her *Abortion* series of 1999, tried to get Portugal's anti-abortion laws repealed. There was indeed a referendum held but the people, including the women, refrained from voting, whether from inertia or because of pressure from the Church is not known. The referendum was lost and it took several more years before poorer Portuguese women no longer had to resort to illicit back-street abortions whose brutal effects are so vividly conjured up by Rego's etchings.

Last year, having seen the huge and horrific drawings on the walls of her studio, I asked a number of women familiar with her work if they could identify the new subject-matter if I said only that it was unimaginably horrible compared to the *Abortion* works. One suggested murder while the rest could not come up with any subject that could fit that criterion. But all were shocked when, without a single picture to hand, I announced that her subject, on a scale much larger than the *Abortion* sequence and with a much deeper use of physical detail, was female genital mutilation, or female circumcision. Barbarous as it is, and scandalous that it persists at all in our world, it is (along with the multiple houris in Heaven promised to seduce young male suicide bombers into fatal action) also an abundantly clear demonstration not simply of human cruelty but also of male castration complexes and fear of women's sexual power. And that the mutilations are carried out by women and that those women are frequently mothers, grandmothers or aunts of the victims makes the bad seem worse, so that Rego's rage and horror as expressed in these works carry a fiery emotional charge as well as a raw, unforgettable aesthetic impact.

While abortion is horrific for women it is frequently necessary, as the only solution to a larger problem, and is not, by itself, usually evil. The female circumcisions are never necessary and are always wholly evil. We

discussed evil as a subject within art and she spoke of her painting a picture called *Salazar Swallowing Portugal* – 'this fat thing swallowing Portugal. And halfway through painting that picture I felt sorry for Salazar, because there is a perversity in all of us; in painting you are allowed. All these feelings, that are not nice, come out.'

As dictators go Salazar, a bachelor who had trained as a priest, was well up in the Franco league of repressive longevity. I had known well a distinguished French art historian who, it turned out, had himself known Salazar closely for many years, and I asked this worldly man what vices Salazar had. Did he have mistresses; was it choirboys and so on? My friend pounced at once. His pithy answer was 'Yes, of course he had a vice. Asceticism.' To which Paula responded: 'Very interesting and so many people have that. That is good… people change their minds and feel sorry for things they shouldn't and love things they should hate.' Words that should perhaps be hung in pokerwork on the walls of the hags and harridans who mutilate their young, helpless relatives.

In this exhibition of recent work there are two separate strands. One is a group of etchings done in monochrome and printed in editions of 35. A group of proofs were then taken and hand-coloured by the artist, in varied colours. Such is Rego's mastery of this medium that, by altering only the colours but not the outline she can alter the mood of the subject and thus its contents. As she has said: 'They become different parts of a different story. I don't know. Some of them are alike really; I just change the colours. The others have got different kinds of brush stokes and things like that. They look quite different from each other, which is very important of course, because it's like having a different story altogether. Different colours are a different story.'

The other strand, and the highlight of this show, is the multi-media work she did for the Foundling Museum exhibition, earlier in 2010. The exhibition guide made the point that Rego, and her fellow artists in the show, had created remarkable works dealing with 'subject-matter that lies at the heart of the Foundling story: exploitation, loss, grief, sex, love, parenthood and childhood.'

The Marlborough exhibition will show, in addition to the major works shown at the Foundling Museum, her preparatory drawings, all meticulously done, all an essential preparation for the main works and all an essential guide to her intentions and achievements.

Here we have six large pictures, done in conté on paper, with typically expressive titles and shocking subject-matter. In *Rape* a girl with naked legs spread supports the weight of a portly old man lying on top of her,

wearing what appears to be a senior naval officer's ceremonial tail coat. In *Down the Well I* and *II* babies, who will never achieve the happy status of foundlings, are being thrown down the well to death and oblivion. *Birth* and *Pregnant Girl Disposing of the Evidence* are equally grim, but deeply affecting, portraits of the vulnerable, suffering appalling punishment for what was possibly only a single lapse. Rego knows exactly how to expose the lower depths that created the need for the Foundling Hospital and the leadership of Captain Coram, its benevolent head, as well as the sponsorship of Handel and Rego's great precursor Hogarth.

The capstone of Rego's Coram achievement is a mixed media triptych with a central panel and two wings, thus far so conventional as a triptych but differing from the conventional in that in front of the central panel there is a protruding shelf at the bottom, lined with Rego-made soft sculptures in which she creates dolls of the requisite size. She has dressed them in Foundling uniforms so that they become the child-like beneficiaries of the hospital, but are seen against the background of the six panels. These show the usual horror stories of rape, giving birth while solitary in the open air, a caricature based on the notorious photograph of Michael Jackson dangling his helpless child from a high balcony. There's also a dance of death, more attempts to drown new babies, etc. Rego calls this piece *Oratorio* after the personal devotional altar owned by many Portuguese households including Rego's own childhood home. *Oratorio* is, in the best meaning of that hackneyed phrase, a museum piece.

When I began my most recent conversation with Rego in her studio we debated the nature of cruelty in general and its particular relevance to her own recent work. Her answer to my question began with a story:

> A husband and a wife lived in a forest with their children and they were poor. One day there was nothing to eat in the house at all, and the woman felt so sorry for her husband who had been hunting all day, that she cut off one of her breasts and stewed it, and it was delicious. He ate it and said 'Yum, yum this is so good'. The next day she cut off and cooked the other breast. He said 'What's the matter with you? You are full of blood; your shirt is full of blood.' She said 'Well, my darling. I had to feed you and I had to cut off the other breast, as the first had gone.' 'Oh bother' said the husband, 'now we've got to start on the children.' And this is how the story starts; the children hear this and they run into the forest to get away from the parents. This is a Portuguese folk tale, from a long way back. We have a collection of folk tales which are amazingly violent, cruel and marvellous, really. They have a vitality that fills everything else in Portugal; everything is filled with the vitality of the folk tales; that's why I love them so much, and why they have so much to do with the pictures I paint – or try to.

As the rudest of satirists Rego owes much to James Gillray and Gillray's own inspiration, Hogarth, but always her polemics are touched by the profound humanism of Goya.

PAULA REGO II

'Mankind doesn't need art. What he needs is stories.'

– G. K. Chesterton

The author of the *Father Brown* stories was quite often profound and wise, but here the first sentence is nonsense while the second is true, particularly if one applies it to the work of Paula Rego, which we surely need as much as 'art' even if, or rather because, she is obsessed by stories. Without stories her art and our world would be much poorer places. It is no surprise that she has called the building in Cascais devoted to her art not 'The Paula Rego Museum' but 'Casa das Histórias Paula Rego', *The House of Stories.*

These days the word 'literary', when applied to a painter, is, whether intended or not, deemed to be derogatory.

Nor is there much merit in the word 'narrative' which, like 'literary', is an almost automatic down-grading of a 'true artist'. Yet Rego's art is both literary and narrative, and these two unfashionable qualities, when mingled with her extraordinary imagination, combine to constitute her genius and make one wonder whether Dame Paula should be enthroned as 'England's greatest living painter', as she is already her native Portugal's greatest. That she is Portuguese is no bar to the English throne. After all, Francis Bacon was Irish born and Lucian Freud was German (born in Berlin 1922, arrived in England 1933), after which, like Rego, he became bilingual.

In fact there is something alluring in the concept of Rego as a Goya-like colossus, standing majestically over England and Portugal, known after all as 'our oldest ally'.

One of the other risks of labels such as 'literary' or 'narrative' is that one stands accused of being a mere illustrator (as indeed she was by Brian Sewell, eliciting her sardonic comment 'Like Goya and Hogarth') and indeed many competent, even great, artists have been illustrators of books, producing pictures on a page which identify, in all senses of that word, the author's characters and locations. One thinks of Dickens being illustrated by the redoubtable 'Phiz' and his brethren to brilliant effect. Rego is not, of course, *only* an illustrator. She does not *record* the images she reads of in books. She creates wholly original images based not on the earlier efforts of previous illustrators, but goes back to the roots of the narrative she has read and then lets her imagination take over and produce versions of characters and situations which, once seen, are never forgotten. They transform the picture formerly in one's head into something utterly psychologically accurate but often savagely different, even traitorous, but believable. In musical terms she could be compared with Franz Liszt

This is the catalogue introduction to Paula Rego's exhibition at Marlborough Fine Art in London in 2012.

who, without restraint, borrowed or stole themes from other composers, usually those he most admired, and produced endless scintillating piano versions which were actually his own, new and brilliant pieces, by and large pianistically so difficult that other pianists were unable to play them.

Straight narrative painting went out with the Victorian age. It was painfully literal and used a high level of technical skill to seduce an audience who liked that sort of thing. Burne-Jones, Rossetti, Alma-Tadema, Lord Leighton, Frith, etc., were all detailed literary narrators but none of the pre-Raphaelites, whom, incidentally, she greatly admires, was driven as Rego is driven by the original perception of their literary sources. Who else, having done her great series of *Peter Pan* etchings, could have taken Wendy, eschewing all the mawkish sentimentality that normally surrounds her, and showed her standing and stirring a bloody pot full of aborted foetuses? Surely a useful addition to the words spoken in the interval of *Peter Pan's* first night by the novelist Anthony Hope: 'Oh for an hour of Herod!'

Rego, for all the gentleness of her disposition and her close family relationships, has a strong, political and social, savage streak, as in paintings like *The Dogs of Barcelona* (1965). Rego likes dogs and did not approve of the city fathers of Barcelona, who put out poisoned meat to dispose of the city's excessive stray canine population. (No Battersea Dogs Home in Cataluña.) Also much influenced by Picasso – to her the artistic giant of the twentieth century – she owes the vicious political satire of her painting, now at the Lisbon Gulbenkian, *Salazar Vomiting the Homeland* of 1960, to Picasso's 1937 etchings, *The Dream and Lie of Franco I* and *II*. She paid a further tribute to Picasso when she produced in 1964 two etchings, both called *Untitled*, attacking Salazar and his fellow Iberian dictator, Franco. Both etchings go further than Picasso, who uses images familiar in his own usual *œuvre*, such as bulls, horses, picadors etc, whereas Rego's images in these two etchings are more fantasies than lies and show Salazar and Franco hugging each other and dancing on each other's backs; one of them – it's not quite clear which – is being anally raped by a giant Yale key; chance would be a fine thing…

Some artists spend their later years either repeating themselves or, whether subtly or obviously, softening their hostile and crusading attitudes. Needless to say that is not Rego's way. To declare my interest, in producing the new and enlarged edition of my book, *Paula Rego: The Complete Graphic Works,* I have, in covering nearly a decade since the original book was published in 2003, added approximately a third to cover her recent years of prolific graphic output. Far from mellowing with age –

Rego was born in 1935 – she has become even fiercer in her denunciation of new targets, whether it is the trafficking of helpless young women and girls or female circumcision – FGM, to give it its only marginally less shocking title. As with her earlier *Abortion* series of 1994, she is no do-gooding feminist, worried about female promotion through glass ceilings, but a savage yet wholly controlled fighter for women's rights in excoriating these unspeakable practices.

When I spoke to Rego before the additional chapters were written I recorded our conversation:

Rosenthal: There's not a lot in the recent work that's brimming with laughter and cheerfulness. You are exploring some of the most terrible human feelings that exist.

Rego: If that were true that would be wonderful.

Rosenthal: I think it is true.

Rego: Do you?

Rosenthal: Well, female genital mutilation, selling little girls' bodies...

Rego: Yes.

Rosenthal: All of that is delving deep into social evils... It's evil that you are fighting.

Rego: Fighting, you see; you have to say something about it because otherwise no one speaks up. It's like the *Abortion* pictures: you have to legalize abortion otherwise it goes on and on in the most horrendous way.

It was partly because of Rego's paintings, drawings and graphic works that abortion became legal in Portugal. Ironically Rego's work on abortion was done for its protection, for its de-criminalization.

Her work on female genital mutilation (FGM) and sex-trafficking of women and children is done to achieve and retain their suppression and to encourage their abolition since, even if illegal in most of Europe, we can still read in the newspapers their continuance almost every day. Rego will have no truck with the so-called liberals who say that FGM is OK because

it's 'part of their culture'. That it is 'part of someone's culture' does not make it acceptable, let alone good. As Rego's etchings reveal, FGM is a monstrous evil, and that it is still practised in Britain and Europe, regardless of banning legislation, is for Rego and many thousands of other people a terrible stain on our society.

The innocent gallery-goer might well find these images repellent; but the practices they condemn and contemn are repellent. As often Rego is not far from Goya, and one can well imagine how *his* contemporaries reacted to *Los Desastres de la Guerra* when they were first shown. They, and Rego's two series, were not created to be easy on the eye, to please comfortable bourgeois taste, but rather to shock the bourgeoisie and, in Goya's case, ruling class taste. In *Penetration,* one of the child-trafficking lithographs, the sinister child broker, a sexless creature with a death-like head but with woman's clothing, is holding a victim and sticking her hand into the child's mouth, like a horse dealer checking an animal's health and age. This bears an uncanny likeness to Goya's painting *El Lazarillo de Tormes,* drawn from a Spanish sixteenth-century picaresque fiction in which a blind swindler suspects that his carer has fobbed him off with a turnip rather than the meaty sausage that piqued his appetite, and which the carer has decided to eat himself. Therefore he shoves his hand into the carer's mouth and gropes around until the sausage is disgorged and restored to its rightful consumer.

Later this year, the Casa das Histórias will exhibit Rego's new sequence of large, if not actually gigantic, paintings based on a novella by the historian of Portugal, the nineteenth-century writer Alexandre Herculano. It is based on an eleventh-century legend and is called *The Woman with Goat's Feet.* These five canvases are not entirely sequential in narrative form but each tackles one or two aspects of this legendary tale. The central canvasas are so tall, at 240 cm, that Rego had to use a cherry picker to execute the top section, and to watch her being thus hoisted and precariously working in the upper reaches of the picture was an awesome and, nerve-wracking experience.

The best description, or adaptation, of Herculano's novella inevitably comes from the master story-teller herself as it is set down here:

Rego: This man was walking along and he looked up. He was a fighter, a duellist and everything, and he looked up and he saw sitting on top of a hill the most beautiful girl he had ever seen and she was singing and playing a guitar. Then she came down and he took her home and set her on the bed and undressed her.

Rosenthal: As one does.

Rego: As one does, immediately and then he noticed that she had the feet of a goat, but he didn't mind.

Rosenthal: So he was not a foot fetishist.

Rego: [Laughs mischievously] Oh no. After he'd undressed her he bathed her and she said: 'This is very strange, but I'll be with you and I'll live with you for ever provided you never cross yourself. Otherwise something terrible will happen.'

Rosenthal: Well, the Devil sometimes has goat's feet, doesn't he?'

Rego: Well, she could be a relative of the Devil…

Rosenthal: The Devil's niece perhaps?

Rego: *The Devil's Niece* would be a good title. So he stayed with her and they had two children, a boy and a girl.

Rosenthal: And how were the feet of the children?

Rego: [Laughing] I think they were normal. That's where he set her up, near my house in Portugal, in the bottom right-hand corner. And on top of the hill there's a windmill and that's where they used to hang people, where they had the scaffold. It was called the Hangman's Hill.

Rosenthal: Well if you hang someone there everyone can see, it's a warning.

Rego: Yes, a warning. And that's what it was, I could see it clearly from my house. We looked at it… Anyway he loved to hunt. He went hunting every day and he had a big horse that he loved and he had a hunting dog and one day he killed a wild boar. The woman had a cat and while the man is chewing on a large bone from the boar which he is ready to throw to his big hunting dog, probably an Alsatian, her little cat attacks and kills this great hunting dog. Astounded, the man crosses himself. She is horrified. And she seizes the girl and levitates herself, clutches the girl and takes her upwards towards heaven apparently never to be seen again, while the hunter seized hold of the boy to retain at least one of his children. In

fact she has retreated to the mountains whence she came, and becomes again what she always was, a siren, a seductress. He goes off on his horse Onagra looking for her and he goes on a rickety bridge which is a bridge over hell. He is – this is the eleventh century – fighting the Moors. He is captured and imprisoned by them. The boy asks the horse what to do and the horse says, go and find your mother. She will help you. He finds his mother in the mountains and she tells him to get his father out of gaol. In effect he rides on Onagra to the gaol and horse and rider dislodge the bars and his father and his fellow prisoners all escape and the son goes on to fight and kill and drive off the Moors as a natural leader, a proud and successful soldier.

Needless to say Rego diverges from the original tale because she is herself such a brilliant story-teller, and the five canvases are full of images, apart from the modern dress of the characters, which readers of Herculano will not find, such as Mary Magdalene with her cross or the beautiful white house. The house is the one Rego grew up in and, when the family went bankrupt, had to be sold. Even more painful than the enforced sale was the conduct of the purchaser, who had the house – and its capacious grounds which provided the family's fruit and vegetables – bulldozed so that he could build a group of ugly, small, suburban houses in order to make a fat profit. As so often in her *œuvre* Rego has taken a highly specific narrative supplied by someone else and has both interpreted and embellished it with her own powerful imagination. As the Italian proverb has it: *tradutore traditore*, to translate is to betray; but when Rego adapts a story, a legend, even an entire novel, she works with an extraordinary respect for the original, inseparably linked to what amounts to an imagined adaptation. No matter how original and even distinguished the source whether it is the mawkish sentimentality of J. M. Barrie or the chilling, even brutal, satire of the nineteenth-century Catholic church by Eça de Queiros (*The Crime of Father Amaro*), she makes someone else's vision her own, ruthlessly cutting the dross and enhancing the skeleton.

A classic case of this freedom of adaptation is to be found in most of her graphic work of the recent decade. Apart from the FGM and the trafficking of young girls series, which are, as it were, sourced from our daily press, the bulk of the work is, if not actually based upon them, at least triggered off by literary sources.

Moon Eggs is also original and, *inter alia*, manages to turn her partner and most regular male model, Anthony Rudolf, into a chicken. *Prince Pig* is based on an Italian Grimm-like fairy tale by Giovanni Francesco

Straparola, who wrote it in the first half of the sixteenth century. It is a somewhat cautionary tale which mingles love, lust and murder before the highly conventional happy ending. It is in many ways the gentlest and most aesthetically pleasing of Rego's series in colour, and it is almost, but not quite, hard to believe in the Prince turned into a vast, stinking, pig who murders two beautiful, innocent sisters, in order to marry the third and most beautiful who does what's necessary to turn him into Prince Charming. Its luscious imagery is part comical and part ironical and is one of Rego's most subtle series.

O Vinho (*Wine*) has a bizarre history which reveals, wonderfully elegantly, how easily Rego can get up the noses of Philistine officialdom. She was invited to produce some wine labels, did them beautifully, but the jobsworths who ruled the wine trade not only turned them down but threatened court action and possible imprisonment if they were to adorn bottles of Portuguese wine. Which is why these wholly engaging lithographs were printed privately and accompanied the text of a quite wonderful short story about the joys of wine by João de Melo. Rego does of course approve *all* aspects of wine, including giving it to babies to make them sleep and the consequences of excessive consumption, but all the lithographs, far from deserving prison, constitute a sublime celebration of this unique and multifarious liquid.

The Curved Planks is one of the most complex and most varied series she has made. It accompanies a brief text by the French writer Yves Bonnefoy, who had a particular affinity with Rego's *œuvre* and who added to his text for the portfolio, after he had seen the prints, a personal letter full of wisdom and perception: 'Your dark revelations have become the entire sky, the entire earth,' *The Curved Planks* is perhaps the most interesting combination of artist and writer apart from that with João de Melo. Both series have a perfect fit with their respective writers.

In the period that ended with the book published in 2003, there are several striking works not done in series form. The most interesting were sparked off by Rego's meeting with the playwright Martin McDonagh, whose play *The Pillowman* had deeply impressed her when it was staged at the National Theatre. She made a single lithograph called *Scarecrow*, consisting of a girl in the crucifixion posture but with a horned skull for a head. This fearsome image, in my opinion a masterpiece, reflects McDonagh's play in which a girl is horrendously abused by her parents, culminating in her proclamation that she is Jesus, whereupon her parents crucify her. This, in the play, is shown but does not happen. McDonagh's play is not about child-abuse, no matter how much abuse is described or

shown. The play is in fact about the nature of writing, of story-telling, of the difficulty in separating truth from lies. Its appeal to Rego is obvious once you have made the connection, so that it's not surprising that Rego and McDonagh got on so well personally. McDonagh gave Rego the manuscript of a series of unpublished stories, many of which contain some of the same sort of paradoxical spasms of cruelty that occur (or do they?) in *The Pillowman*, and which have sparked off two individual prints of great power, *Turtle Hands* and *Camouflaged Hands*. It should also be noted that Rego was sufficiently impressed by the play to create, in 2004, a large triptych in pastel on board called, simply, *The Pillowman*, replete with the darkness of McDonagh's tenebrous writing.

But as far as graphic art inspired by McDonagh is concerned the key work is a triptych of lithographs, *Shakespeare's Room* of 2006. Inspired by an unpublished McDonagh story, it mocks the absurd statement that if you gave a sufficiently large number of monkeys a typewriter each and sufficient time, they would produce *Hamlet* or *King Lear*... In the Rego triptych the monkeys have clearly failed to produce anything of worth. Three different women (one for each print) have shot them all with pistols resembling wartime Webleys or Colt 45s. As always with Rego, this is a meticulously observed and executed piece of story-telling.

I began this article with G. K. Chesterton. Let me end it with a more recent and more revolutionary writer, David Mitchell, in his superb novel *The Thousand Autumns of Jacob de Zoet* published in 2010:

> The belly craves food, she thinks,
> the tongue craves water,
> the heart craves love
> and the mind craves stories.

THE PAINTINGS OF AUGUST STRINDBERG

It is something of a double delight for an English critic to be asked to write this article; first of all because there is the honour of contributing to a Swedish symposium on Strindberg, and, secondly, because the only close affinity Strindberg had with any other painter was with the greatest of all English artists, J. M. W. Turner. Strindberg himself described Turner in this way and it is an endearing trait in his character that, despite his association with Munch and Gauguin and his wretched and unhappy stay in England, it was really only the Englishman who influenced his style. Yet one must not overestimate the influence of Turner any more than one should think of Strindberg as a writer who also painted. Both concepts would merely underestimate the originality and the dedication that Strindberg brought to his painting.

When one considers that in a striking double bill presented by the Royal Shakespeare Theatre at the Aldwych Theatre in London Strindberg's *Playing With Fire* appeared to be much more avant garde and theatrically sophisticated than Harold Pinter's *The Collection*, written some seventy years later, it is hardly surprising that he was also far ahead of his time as a visual artist. There is a fascinating description in his autobiographical book *Inferno* of Strindberg experimenting with coals taken from the fire and thereby creating what were probably the first *objets trouvés*. In 1894, the year when he did some of his best work, he wrote in a moment of self-vindication to the violinist Leopold Littmansson: 'I had an exhibition (in Sweden), was slated, but not by advanced artists. The funny thing is that I was the first to paint symbolic landscapes and lived to see how the whole band of realists turned with the wind.'

While it is impossible ever totally to separate an artist's life from his work, and Strindberg's writings are probably more compulsively autobiographical than those of any other European writer of comparable stature in the last hundred years, I think an autobiographical interpretation of his painting, while with a certain amount of ingenuity quite possible, is not really either relevant or correct. It would surely be much truer to say that the paintings were very much like the man himself, something altogether different from 'autobiographical pictures'. In other words the turbulence, the storm and stress, the lack of compromise of Strindberg the man are clearly reflected in his canvases. But it would, I think, be fanciful to interpret specific paintings in terms of specific events in his life or to seek in them visual manifestations of the writer himself. Perhaps the most striking aspect of Strindberg's work is that in many of the pictures

This essay appeared in English and Swedish in Strindbergs Måleri (Strindberg's Paintings) edited by Torsten Måtte Schmidt published by Allhems Förlag Malmö in 1972.

there is a focal point which is not necessarily either the true centre or even the 'optical' centre, nor is it the stated subject of the work. Instead it is a centre of turbulence, either turbulent itself or perfectly calm, a source or centre of movement from which the picture seems to take its energy, e. g. in *The Danube in Flood* where it springs from what looks like an isolated clump of trees, reflected also in the water which has surrounded them and which sets the rest of the picture in motion. One has this even in so apparently static a picture as *Wonderland* or *The Sea,* where there is a blue–grey patch of dark cloud which has the same effect, and, of course, in the canvas called *Inferno* the huge central mass of greyish white is like a gigantic and sinister waterfall around which the peripheral movement is suggested both by the hectic quality of the painting and by the violence, despite the apparent sub-fusc tones, of the colouring where the flecks of dark crimson and white and green are almost fighting with each other.

In *The Town*, the town, looking like Venice and therefore definitely conjuring up visions of Turner, is a mere two inches high, a slender, isolated strip running from the left hand edge of the picture to the middle, with, in front of it, a patch of calm water and, drawing to it like a magnet, a wild black sea and a stormy whirling sky. Immediately above the town is one much denser, darker patch of cloud like a sudden squall of rain; yet the town itself is illuminated with a clarity of light which has almost the dazzling technical mastery of a Rembrandt. Thus one has the impression that this is a painting of a town seen literally in a prodigious lightning flash and metaphorically in one of those terrible flashes of insight which sometimes hit Strindberg so that with a sentence or even a phrase or, in this case, with a few impassioned brush strokes he took your breath away.

It is in this aspect of his work that the relationship to Turner can be most closely observed. It is not only a question of the fascination for both of them of sea and sky and all the terrible, beautiful havoc they could create. It is rather in this use of a seemingly insignificant 'storm centre' such as we find in Turner's *Snow Storm* where he uses a patch of blue–grey sky seen through the storm, just above the ship, as the focal point of calm around which revolve the clashing elements of the whirlwind. Strindberg would certainly have understood and approved Turner's action in having the crew lash him to the mast during an actual storm so that he could make the sketches for this work. There was a wildness of temperament in both men which made their responses to the wildness of nature so powerful and so similar. In the paintings done in 1894 Strindberg perhaps comes nearest to the fashionable abstract expressionism of the 1950s, to a kind of action painting. But of course the work is not in any way abstract and

the action is in the subject-matter and in the picture itself, not in the technique which has so frequently retreated into absurdity in our time and which is here, in the 19th century, a model of controlled freedom with the paint thickly and daringly applied but achieving a positive aim which is, ultimately, almost purely figurative.

The paintings constitute a marvellous example of that combination of observation and imagination without which all art is valueless. Here they have combined into a vigorous synthesis of the real and the visionary so that we know that this is a storm at sea or a high tide done in the spirit of Turner, painted with the same sense of awe and with a similar mastery, springing from true knowledge, of the nature of the elements.

Strindberg as a man was indeed elemental. Nothing in him was half-hearted and everything was almost ruthlessly clear-cut. So it is with the paintings, which are stripped to the bare essentials, not in the manner of the geometrical abstractionists but in the sense that the only things that matter are his beloved nature, a wood or a grotto, and the sea and the sky which simultaneously terrified and inspired him, because he understood them and was able to recreate them on board or canvas with his own powerful imagery.

Even the early *After Sunset, Storm at Sea* (done in the 1870s) shows already a remarkable grasp of technique with great subtlety of colouring. But in later works like the rather wryly titled *Single Poisonous Toadstool* the affinity with Turner has already started, and, although this is an oil, one can see in this work and in *The Danube in Flood* the colouring of Turner the watercolourist, the pinks showing through the delicate whites and blues and the whole painting demonstrating an extraordinary, almost precocious ability to handle paint and make it obey his instructions. As if paint, any more than a human being, could fail to obey him!

It is not, perhaps, surprising that so many of his paintings are of floods and storms. Only rarely is there a complete sense of peace as in *Apple Trees,* which looks rather like an early Van Gogh. Usually from his earliest work onwards the keynote is some cataclysmic natural disturbance to match his own troubled soul. In *The Storm,* the slender trees are bowing before the might of the gale and he has marvellously caught the rain-loaded power of those lowering clouds, a power occasionally shown in a diagonal, slanted, leaning effect as in *The Wave* but usually shown as a world in constant motion, a world ready to collide with any other world that dares to interfere.

In the final resort, coming, as most of us do, to his paintings long after his writings, one can say that Strindberg painted much as one would have

expected. But there is in such a judgement a certain patronising note of smugness. It is much more to the point to say that Strindberg painted as one expected him to do because his temperament and his feeling for the visual aspects of things were eminently suitable for a painter and that the only thing that really matters is whether or not he painted well. This he undoubtedly did and if, heaven forbid, circumstances had been different and he had never written a word he would have been thought of, quite simply, as a painter in his own, undisputed, right. Had he lived at a different time, a time when he might perhaps have been part of a *scuola di* Turner, then the greatest of English painters would surely have seen in the greatest of Swedish writers a disciple on whom he could look most favourably and an artist who, as in so many other fields, was a genuine original.

JACK B. YEATS

'Colour is Yeats's element in which he dives and splashes with the shameless abandon of a porpoise.' – Kenneth Clark

'It doesn't matter who or what I am,' said Jack Yeats, 'people may think what they will of the pictures.' Yet, despite the artist's splendid disregard for the facts of his own life, Yeats did actually have a full, exciting, happy and enviable time on earth even if, as with so many painters, recognition came too late to do him much good.

Yeats was born on 29 August, 1871, at 23 Fitzroy Square, London, where his father, the Irish portrait painter John Butler Yeats, had gone to try and acquire some suitable English clients. John Butler Yeats was a sound and successful, conventional painter of much foresight and more humility; although he had also fathered Jack's brother, the poet William Butler Yeats, he once observed, deprecating his own far from negligible talents, 'I shall be known, one day, as the father of a painter.'

From the age of eight to sixteen, Jack Yeats spent an almost idyllic childhood in Sligo on the north-west coast of Ireland. He has described his life there, and the countryside itself, in the book *Sligo*, published in 1930, with a painter's eye and with the painter's (and perhaps the Irishman's) idiosyncratic ear for words that we so often find in artists who write. In Sligo he showed a precocious talent for drawing and for the writing and acting of plays – a passion that was to last all his life – and produced such dramatic blood-and-thunder episodes as the plays for the miniature stage, published in the early years of the last century. They had titles like *The Scourge of the Gulph* and *James Flaunty or the Terror of the Western Seas*. These plays have much of Yeats the painter in them, particularly his deep involvement with the sea, which shared his artist's vision with his all-but-native Sligo. 'Sligo was my school,' wrote Yeats, 'and the sky above it', and he once said that the most stirring sights in the world are a man ploughing and a ship on the sea.

Despite his romantic fervour for the ocean, Yeats denied the rumour that he had quarrelled with his poet brother and run away to sea; in fact he attributed his feelings for the ocean to John Masefield, whose poetry and whose friendship had a profound influence on him and to which his portrait of the poet is a moving tribute. His other great literary friendship was with J. M. Synge, since, although relations with brother Willie were not actually bad, they were rarely cordial. Among Jack Yeats's earliest and most interesting drawings are the illustrations to books by Synge, notably *The Aran Islands* (1907) and *Wicklow, West Kerry and Connemara* (1911).

In 1897 Yeats had done his first oil paintings; in 1898 he visited Venice and, in the same year, he married Mary Cottenham White. In 1899 he had his first exhibition in Dublin. In the first two decades of the 20th century

Yeats's work began to be known to the literary public of Ireland through the broadsheets, some of them edited by his brother, issued by the Cuala Press. Probably Yeats's first major distinction was the selection of five of his works, including *The Dwarf of the Circus,* for the now legendary Armory Show in New York in 1913. Here he was keeping company with Picasso, Matisse and Marcel Duchamp among others, in an exhibition which brought modern art to the United States for the first time and caused such a furore that Matisse was burned in effigy by the students of the Art Institute of Chicago.

From the time of his very happy marriage Yeats's life was tranquil and contented. While he never enjoyed the rewards of the fashionable artist he never went short. He had recognition from those who knew his work, and a number of discerning Irish patrons. He had regular exhibitions, many of them in Dublin which, from about 1900, was his permanent home, apart from visits to England and one trip to the U.S.A. In 1923 he went to Paris to read a paper at the Celtic Races' Congress, and many years later, in 1950, the French, with their great sympathy for the Irish, created him an Officer of the Legion of Honour.

In 1940 Yeats joined the Victor Waddington Galleries in Dublin and from that time on was given a series of important retrospective exhibitions, including one at the National Gallery in London in 1942. This he shared with William Nicolson and the catalogue introduction was written by Sir Kenneth Clark. In 1948 he had an exhibition at the Tate Gallery and in 1951 and 1952 a retrospective exhibition toured the United States and Canada.

Oscar Kokoschka, the only European artist similar in style and temperament who can be called, if the phrase has any meaning at all, greater than Yeats, visited Yeats in Dublin several times in the last ten years of the Irish painter's life, offering him great friendship and unstinted admiration. Kokoschka, in a world where professional jealousy is not unknown, worshipped Yeats's work and would address letters to him as 'Jack B. Yeats, The Last of the Great Masters in the World, Dublin, Ireland'. Sometimes he did not even put 'Dublin' on the envelope, but the letters always arrived.

In 1956 Jack Yeats, then eighty-five years old, fell ill. Shortly before this a close friend had asked him what advice he would give to a young man embarking on an artistic career. Yeats paused for a long time before sighing and saying, 'Ah well'. He died in Dublin on 28 March, 1957.

That Jack Yeats is one of the great 20th-century European masters is probably beyond dispute; few art critics and historians, if asked a direct

question on the subject, would hesitate to answer in the affirmative. Yet few, if asked to name at random the great of the century, would name him. The reasons for this paradox are manifestly absurd – Yeats was the brother of a world-famous poet and hence, all his life, was in the shadow of a more celebrated sibling; and he was Irish – an inestimable advantage on the printed page and an almost insurmountable handicap on canvas.

No country as small as Ireland has produced so much literary talent in the last three hundred years – Congreve, Sheridan, Swift, Wilde, Shaw, Synge, O'Casey, Joyce, W. B. Yeats *et al.* – and few, in the corresponding period, have been visually so barren. Ireland's visual glory was in her landscape itself, in the anonymous carvers who created the Celtic crosses and in the medieval monks who illuminated the Book of Kells. Other Irish painters were, when they existed at all, solid and worthy craftsmen like the father of those two extraordinary brothers, the portraitist John Butler Yeats. But occasionally even the poorest country artistically will produce, apparently from nowhere, a painter of genius. Sometimes, as in the case of Norway and Edvard Munch, there is little nationalistic rhyme or reason; Munch could well have been a German or an Austrian. In the case of Yeats he could have come from no other country. Ireland was in his blood; his whole *œuvre* is redolent of Ireland and, as is so often the case, his localness was part of his genius and his genius transformed – as it did with Cézanne and Provence – his localness into universality.

Yeats's work falls really into two distinct halves: the early drawings and watercolours and the first, almost hesitant, oil paintings, and the mature oil paintings in which he found his own language, his own technique for covering a canvas with paint in a manner different from that of any other artist. One could say that in the early work he was recording Ireland as he knew it, and in the later work he was using Ireland, as Cézanne used Provence, to record the world.

What is so interesting about Yeats's development as an artist is that his early work is, in its way, as good as his last. This is not because he began and ended his career as a full-blown genius, nor because he was unambitious at the end. It is rather that he rarely – and in a painter this is almost unique – bit off more than he could chew. Few painters are born mature; among the juvenilia of most great artists one finds grandiose or pretentious tyro efforts at important subjects which are of interest primarily because of the subsequent fame and excellence of the later work. In the case of Jack Yeats, he started with small-scale-works on small scale themes and in them found perfection. One beautiful emerald is always infinitely preferable to a gigantic confection of paste diamonds.

Yeats found himself in drawings, graphic work and watercolours, and the Yeats of the period 1890–1914 is not so much Irish as Ireland itself. Up to the time of the First World War, Ireland was a country full of characters and institutions which today one would only find in the remote west, and then not often. It was a country prolific in tinkers, circuses, horse-fairs, villages and small towns which came alive at the temporary invasions of various itinerant groups, gypsies, horse-traders and the like. It was a romantic Ireland which appealed to Yeats and which he recorded faithfully – an Ireland much as one finds it in the plays of his friend Synge, full of riders to the sea and playboys of the western world, speaking, and, in Yeats's watercolours, posing in extravagant language and attitudes and sporting (surely the *mot juste*) bright and handsome clothes. This is not the Ireland of potato famines and sons having to wait till their forties before they can inherit their fathers' mean plots of land and finally get married. It is a romantic land, but at the same time a convincing and vital one. The deft illustrative power of the boxing sketches, the brave optimism of the young man striding off to heaven knows what excitement, the intense muscularity of the hurley player and the grim pathos of the blind beggar wearing round his neck a placard reading:

PITY THE DARK MAN
CHRISTIANS YOUR CHARITY ON THE DARK MAN BESTOW
THAT HIS AFFLICTION YOU MAY NEVER KNOW.

These drawings show Yeats's powers of observation and also something of his humanism, a quality perhaps best summed up by another Irishman, Thomas MacGreevy, in his pioneering monograph on the artist: 'His humanism comprehends the wonder of nature but he is no tasteless Wordsworthian pantheist moralising about the meanest flower that blows.' Yeats's humanism also comprehends people and their natures with compassion but without sentimentality, with understanding but also with knowledge of man's essential fallibility. In his recording of people Yeats was what the Irish would call 'a lovely man'. Nowhere is this more apparent than in the watercolours in which he deployed as much skill as an Elizabethan miniaturist. It is significant that Kokoschka alone among 20th-century artists has the same reverence for, and skill in, the medium of watercolour. There is no looking back in a watercolour; it is an all-or-nothing form of art in which one has either to be instantaneously truthful or to compound a lie by changing one's mind and spoiling the painting. No doubt Yeats often spoiled the painting, but in the watercolours

still available to us he rarely made a false brushstroke, and these small paintings are, in fact, an integral component of his artistic personality, instead of being, as they so often are, an incidental part of his work.

If one looks at, for example, *The Grain Ship*, one sees immediately the originality of the composition, the intrinsic interest of the subject, the characterisation of all three figures – the dust-blackened loader in the hold, the muscular worker leaning over the yellow grain, and, vanishing into the distance, the elegantly hanging trousers and polished boots of the man, probably the owner, looking on. Combined with these is a careful sense of colour with a self-limiting range of blues, greys and yellows. There, in microcosm, is the whole of the early Yeats and one senses this microcosmic quality in so many of the other watercolours such as the brilliant, individual character studies contained in *The Country Jockey* or *The Rake*. Both these anonymous men exude in Yeats's marvellously skilled painting their forceful personalities. These are not men to be put upon; each is in his own way prideful without being sinful and tinged respectively with dignity and a slightly ridiculous mockery. Both these sketches become deeply etched on the memory, as does the portrait of John Masefield which not only conveys the poet's personality but, as in all great portraits, conveys the personality of the painter. It is impossible to know Ireland fully at the end of the 19th century and the beginning of the 20th without knowing Yeats's watercolours. He has recorded it visually as his friend Synge recorded it in words; and while doubt has been cast on the accuracy of Synge's portraits, doubt can have no place in one's assessment of Yeat's exquisitely true evocations of a people and a landscape which were his whole life and which he invested with the nobility of a true artist.

The early oil paintings are fascinating because, basically, they represent an extension of Yeats's watercolours. *The Dwarf of the Circus* is, in feeling and in the relative flatness of the paint surfaces, similar to watercolours done a few years earlier, and one can say the same of such works as *The Kerry Mascot* or the haunting *A Westerly Wind* of 1921. In *Bachelor's Walk (In Memory)* one still has the unity of style between the two media, but here, as in *The Dwarf of the Circus*, the unquestionably greater freedom to alter and to experiment that oil permits has enabled Yeats to go into more detail of characterisation and situation. The dwarf, as depicted by Yeats, is, for all his individuality, an archetypal creature whom Yeats has made at once pathetic by his draughtsmanship and defiant by his sense of colour. This painting is, in fact, a symphony of different reds subtly contrasted: the stripes of the tent, the rose-decked hoop, the dwarf's lips

and hair and, finally, the defiant sweater. The girl in *Bachelor's Walk* is both an individual and an archetype representing all Irish womanhood mourning the loss of their men. These paintings, fine as they are, are paintings where the content – and the images and thoughts it arouses – is paramount.

It was only in the middle and late twenties that Yeats developed the rich, impasto style which was to revolutionise his work and make of it a symphony of shimmering colour whose vibrant vitality was unequalled except by Kokoschka. The paintings done between 1925, the date of *The Breaker Out*, and his death in 1957 present a remarkable resolution of the conflict between his rapidly loosening technique and the concentration of his imagery, in which ideas are sparked off and reverberate in the spectator's mind at the same time as the sheer *joie de vivre* of the paint surface beguiles his senses.

The later Yeats almost deceives one into thinking that one is looking at abstract expressionist work by someone like Pollock or Tobey, so freely is the paint applied, so apparently unfigurative are the shapes. Yet beneath the riotous paint and the exuberant colours lurk strictly figurative paintings; like many a great work of art, a late Yeats requires more than cursory study. Yeats's figures are often skeletal, like the sculpted ones of Giacometti, and again like Giacometti's, they turn out to be substantial and the apparent homunculus is revealed for a Yeatsian giant as in his masterpiece *Glory*, one of the last paintings he did, in which the diminutive figures on the shore are so full of life and the glory of being alive that the canvas can scarcely contain them. The glowing pigment, some of it put on with a knife or the paint tube itself rather than a brush, leaps out at you singing with all the joy the artist himself can summon.

Life, joy, glory – these are all words impossible to avoid when writing about Yeats. Few great artists have been so affirmative, so—to use Berenson's phrase – 'life-enhancing'. Even in those paintings such as *Helen* and *The Blood of Abel (Tinkers' Encampment)* which are full, respectively, of foreboding and grim realisation of the holocaust of 1939–1945, Yeats could not, nor did he try to, suppress the splendour of his paint. Paradoxically the sensuous release of the paint itself highlights the grimness of the subjects. Allegorical painting has not been fashionable for many years but Yeats, like Kokoschka, can create allegories on canvas, even using themes, such as Helen, from classical mythology and history, in purely modern terms. John Berger once observed of Yeats that 'he teaches us to hope', and this remark is particularly apt in the case of these two paintings because Yeats the painter, in the end, triumphs over Yeats

the historical pessimist. The forecast message is clearly there, as it is in Vaughan Williams' Fourth Symphony (which also anticipates World War II), but the undertones of war surrender to the sensual beauty, as in the music, of the dazzling surface.

As a young man and a young painter Yeats was fascinated with the present and as he grew older that present of his youth became a past of even greater fascination. Many of his finest paintings are evocations of that past, such as *Going to Wolfe Tone's Grave* of 1929 or that wonderful tribute to Irish romanticism, *In Memory of Boucicault and Bianconi*. This last is a luxuriant work in every way – luxuriant in its wallowing in the past when such meetings between rural mail carriers and strolling players were possible, keeping alive the memory of that glorious, hammy dramatist whose romantic, comical-tragical melodramas must have influenced Yeats's own plays, and luxuriant in the paint applied with such controlled vigour. And few pictures are more evocative of the theatres and circuses he used to visit with John Masefield than *Now*, and *The Scene-painter's Rose*. *The Scene-painter's Rose*, with the subject of the title occupying such a minute part of the painting, is an excuse to paint the beauty of back-stage as Bruegel similarly depicted a leg disappearing into the sea in *The Fall of Icarus* so that he could get on with the business of painting a forceful pastoral scene.

If one has to sum up Yeats's achievements in a few words, they lie in his transposition of particularity into universality and in his almost heroic affirmation of life and its forces. The minute rose of the scene-painter could hardly be more particular; yet as a symbol of beauty it is universal. A painting like *Glory* is not simply of three human beings standing looking at the day. It is at the same time that archetypal trio of son, father and grandfather which meant so much to Yeats and it is also youth, maturity and old age all talking and rejoicing in the glory of life. Inevitably one recalls that Yeats was eighty-two when he painted this masterpiece and was only four years away from death. He was surely recalling that the child is father of the man and recording something of his own life and his attitudes towards it.

Samuel Beckett once observed of the late Yeats that 'he grows Watteauer and Watteauer' and there is something in this apparently fanciful remark, for Watteau also combined with a heightened sense of colour a sense of the joys of life – joys which he too recorded with a sense of wonder at their glory. Although Yeats knew that on occasion life could be brutish and short, and although, as we know from *Helen* and *The Blood of Abel* and *Bachelor's Walk*, he knew and was pessimistic about death and

the destruction of war, he used his gifts as a colourist and painter to create an affirmative vision of the world. He did this not as a wild Hibernian Dr. Pangloss assuming that all was for the best in the best of all possible Irish worlds, but as a humanist who knew the best when he saw it – the best of man and the best of the earth. Triumphantly, with a dexterous draughtsmanship and a virtuoso and daring colour sense rarely equalled in the 20th-century, Jack Yeats recorded with a passionate genius what was beautiful and exciting in a world which, as he had known it, was on the wane.

WALTER AND EVA NEURATH
Their books married words with pictures

Having joined Thames & Hudson in 1959, Tom Rosenthal eventually became Managing Director of Thames & Hudson International, the co-publishing arm of the company, and a Director on the main Board. He left in 1971 to run Secker & Warburg and became Chairman of that firm and of William Heinemann. In 1984 he acquired André Deutsch Limited. He retired in 1996 to become a full-time writer. Since then he has published three art books with Thames & Hudson.

This is the story of two remarkable people and one great publishing house. The story of Thames & Hudson is to a large extent the story of Walter and Eva Neurath and, as they met only as mature adults, each becoming the third spouse of the other, it is necessary to begin with their two separate life stories before dealing with the history of the publishing house which they founded, and in which their lives were inextricably mingled.

Walter Neurath was born in Vienna on October 1, 1903, the only child of Alois Neurath and Gisela Neurath (née Frölich). The Neurath family came from Bratislava in Czechoslovakia. Alois Neurath had arrived in Vienna aged twenty-one, and worked in a bank until he was twenty-eight, when he founded his own business as a wholesale importer of tea, coffee and luxury foods. Walter spent his entire childhood in Vienna, where he was educated at the Volksschule and the Realgymnasium, from which he matriculated with distinction.

At the University of Vienna he studied art history, archaeology and history, becoming, in 1922, a member of the Institute for Art History. At the same time, he worked for the art book publisher Würthle & Sohn and organized art exhibitions, including one in Paris of 19th-century French paintings from Viennese collections. He also lectured on art history to the Austrian equivalent of the Workers' Educational Association.

He was a founder member of *Neustift* (New Foundations), a small left-wing commune of intellectuals with a radical approach to both life and culture, which included the future world-famous psychoanalyst Bruno Bettelheim, whose seminal work on the German concentration camps, *The Informed Heart*, Neurath was to publish with great success nearly forty years later.

In 1925 he married Lilly Kruk and, because of his father's ill health, joined and ran the family firm, thus acquiring business skills which were of great value in his later career. On his father's recovery in 1929, Neurath turned to full-time publishing, with a strong interest in printing and typography. He joined the Verlag für Kulturforschung (Publishing House for Cultural Research) and Zinner Verlag, which published fiction

and where, after six months, he was made Production Director. There he published a number of illustrated books and also the German-language translations of such British and American books as *The Water Gypsies* by A. P. Herbert, *Mutiny on the Bounty* by Nordhoff and Hall and *The Good Earth* by Pearl S. Buck.

The rise to power of the Nazi party in Germany effectively closed the main German-language market for this Jewish firm, which therefore decided to close down. From 1935 to 1937, Walter worked as an educational publisher in Vienna, developing new illustration techniques and creating, as General Editor, a series of illustrated textbooks for children, designed as an educational counter-influence to the all-pervasive Nazi ideology. The books had a strong democratic and anti-totalitarian bias and were translated into seven foreign languages by like-minded publishers abroad.

In 1937 Neurath was appointed Manager of the Wilhelm Frick publishing house, where he continued to commission and publish both illustrated books on the arts and anti-Nazi propaganda. Upon the occupation of Austria by the Nazis, he was ordered to cease his activities immediately, and a Nazi-approved "Commissar" was appointed to run the publishing house.

Because of his anti-Nazi publishing activities, he was soon on the Gestapo lists. After several near misses and a period in hiding, he managed to get to England on June 1, 1938, along with his second wife, Marianne. (His first marriage had been dissolved in 1933.) His sponsor for entry into England as an alien was Frances Margesson, wife of Captain, later Viscount, Margesson. The Neuraths stayed with the Margessons at Boddington, near Rugby, for some five years, and their son Thomas was born there.

Neurath could not of course spend all his time in the country and was soon offered work by a company called Adprint, run by a fellow refugee, Wolfgang Foges. He soon became the Production Manager and designed and produced the celebrated King Penguin series. It was originally intended to print this series in Czechoslovakia but Germany's invasion of that country meant that the books, published by Allen Lane of Penguin Books, were printed in England.

Neurath belonged to a European tradition of publishing where the series, or what the French call a *collection*, was the norm if not the rule. Thus, after the success of what were in effect Penguin's first hardcover books, the beautifully made jewel-like King Penguins, he developed a larger and more ambitious series called *Britain in Pictures*, edited by W. J. Turner. A formidably scholarly and erudite man, Neurath had a

genius for making illustrations an integral part of a book, i.e., placing them prominently on the page together with the words to which they were related, rather than banishing them to the 'plates' section in the centre or, worse still, to the back of the book. He knew how to enhance pictures which asked to be looked at with words that demanded to be read. Thus *Britain in Pictures* married skilful picture research and fine design and printing with significant texts from writers such as George Orwell (*The English People*), Rose Macaulay (*Life Among the English*), John Piper (*British Romantic Artists*), Michael Ayrton (*British Drawings*), Jacquetta Hawkes (*Early Britain*), etc. The series eventually comprised more than a hundred volumes.

As the series became ready to launch, World War II arrived and so did paper rationing, which, reasonably enough, was based on publishers' output in preceding years. Adprint, being a new firm, had no track record with which to get any paper ration. This led to the concept of 'book packaging', which was to become a significant part of book publishing in the second half of the 20th century. The 'packager' puts together author and subject and looks after design, typography, etc. all the way through to complete production. The books were licensed to publishers with adequate paper rations and their names appeared on the jackets, spines and title pages. *Britain in Pictures* was published by Collins, who also took on Neurath's next, even more numerous and more long-lasting successful series, *The New Naturalist*, edited by Julian Huxley.

Thus, at a stroke, Adprint and Neurath had become a significant force in high quality illustrated book publishing in this country. The path was, however, not wholly smooth or unbroken. Neurath was not yet a naturalized British subject, and the powers that be, failing to distinguish between Jewish refugees who had fled virtually certain death in concentration camps and other non-Jewish 'Enemy Aliens', dispatched Neurath to an internment camp on the Isle of Man, alongside the Amadeus Quartet and other distinguished European artists and intellectuals.

Happily, a relevant civil servant, Richard Cowell, aware that the *Britain in Pictures* series had considerable propaganda value, managed to get Neurath released rapidly (he was an internee for only two weeks) and he was soon back at work with eventual naturalization to follow.

Adprint was less successful once the war ended. The firm had been financed by Tennants, whose head, Lord Glenconner, lost faith in Foges and offered the Managing Directorship to Neurath, who declined. He had more ambitious ideas and, on modest capital of £7,000, went off to found his own publishing house in September 1949. He signalled his

transatlantic vision by calling the company Thames & Hudson, after the rivers which flow through London and New York. His own contribution was his life savings of £3,000. His co-directors included, shrewdly on Neurath's part, the printer John Jarrold and the process engraver Wilfrid Gilchrist, and also his Adprint colleague Eva Feuchtwang, who contributed her savings of £150 to the new venture.

<div align="center">*</div>

Eva Feuchtwang, the child of a Jewish clothier, Rudolph Itzig, was born in Berlin on August 23, 1908. Her father died when she was eight and her mother married a lawyer called Kahn, who worked for UFA, the great German film studio, thus paving the way for Eva's easy and early *entrée* into cultural circles. She worked as a child extra, receiving an Alsatian puppy as her fee, and met the likes of director Ernst Lubitsch and early screen siren Pola Negri, who was the mistress of her stepfather's banker brother. She left school, voluntarily, when she was fourteen, to show solidarity with friends who were expelled.

After various unsatisfactory odd jobs, she went to work for a celebrated antiquarian bookseller called Paul Graupe, where she was employed on collation. Graupe also ran auctions, and Eva had to check the references and credentials of new bidders. When one day she was unable to do all her work because she was feeling ill, she was, as in a scene from a Victorian novel, dismissed on the spot. She then worked on art auctions at the Künstlerhaus.

At Graupe she had met her first husband, Ernst Jutrosinski. This marriage lasted only a year. After that she went to work for an antiquarian bookselling couple called Rosenberg who, when Hitler came to power, killed themselves.

Jutrosinski did at least one good deed when he introduced Eva to Wilhelm Feuchtwang, whom she married in 1934 and by whom she had one son, who became the distinguished Chinese scholar Professor Stephan Feuchtwang. On the day of the Anschlüss, Hitler's invasion and instant acquisition of Austria, Wilhelm said to wife and son, 'That's it. We're off.' They fled to Rotterdam, where Feuchtwang, whose father was Chief Rabbi of Vienna, had a sister who was married to the Chief Rabbi of Rotterdam. The next day the Gestapo came to Eva's Berlin apartment.

After a year in Holland, the family travelled to England. Wilhelm was, after the outbreak of the Second World War, interned on the Isle of Man, while Eva had to contemplate working as a charwoman to feed herself

and Stephan. Before this unlikely, but for those days not untypical, professional activity could begin, Wilhelm had met, in his internment camp, his fellow Viennese, Walter Neurath, who had more influential contacts and allies on the mainland. Neurath after his release sought out Eva to bring her greetings from Wilhelm and an introduction to the world of book publishing.

Walter got Eva a job at Adprint, where she made many contributions, particularly on design and typography and the essential 'look' of a first-class illustrated book. Therefore, she too understood from the beginning the dynamics of illustrated book production and the virtues of co-production.

It was in fact Eva's sharp eye that brought Thames & Hudson its first book. While on a routine visit to Billy Collins at Collins she spotted the proofs of a beautiful book on English cathedrals by the Swiss photographer-publisher Martin Hürlimann. She asked Billy if he was going to publish it, and he replied that, handsome as it was, it would be too expensive to be successful in the British market. Eva whisked it over to the fledgling Thames & Hudson, and the book, printed in Switzerland in wonderful velvety monochrome photogravure, was an instant steady seller and, after many editions, is still in print.

After Walter's second wife died, he married Eva, and the name Neurath and Thames & Hudson became synonymous. In their field they were at least as formidable a couple as Alfred and Blanche Knopf in the US.

In the firm's early days, Walter and Eva became the UK representatives of New York publishers such as Abrams and the great museums there such as the Metropolitan and the Museum of Modern Art. Not only did Thames & Hudson publish their books under its own imprint in the UK and the Commonwealth, but because American editing, designing and printing costs were then much higher than those in England and Europe, Thames & Hudson would 'package' the entire print run.

The growth of the firm from those small beginnings goes back to the extraordinary talents of Walter and Eva. Both had genius. Walter was the charismatic, hard-driving visionary who was the engine of the firm; Eva was steering wheel, engine oil and, above all and frequently, the brakes. She particularly saw the virtue of marrying words and pictures and created the 'integrated' page or spread of text and illustration, so much the norm today, so revolutionary and so demanding of printers in the creaky technology of the 1940s and 50s. Together they created the template of the finely designed and well printed art book with plentiful

colour which is taken for granted today. And, throughout, it was Eva's remarkable eye and taste which ensured that high quality. She was the one who could spot in seconds that a design was not working: that the wrong weight had been given to either words or pictures. It was she who made block-makers and then filmmakers re-proof colour illustrations time and time again, until they related properly in her eyes to the transparency or, if the original was to hand at the National Gallery or the Tate, to the painting itself.

Eva also practised for more than five decades her conception of the visual world, built up from her early days in the Künstlerhaus and from her friendship with the art historian and philosopher Rudolph Arnheim. Her close publishing relationship with Herbert Read was also a factor in her credo that it is essential to create not only a visual picture of one's work but also to document it with the visual experience of the subject in historical terms. The legacy of *Britain in Pictures* was brought over to Thames & Hudson and expanded into thousands of books where words and images complemented each other to make an intellectual whole which would have been impossible had either component been absent or neglected. For Eva, pictures were neither decorative nor the icing on the cake but the provision of essential information. There must by now be millions of academics, students and amateurs of art, photography, architecture, archaeology, history and topography all over the world who, without knowing her or Walter, owe her a tremendous intellectual debt.

When Thames & Hudson was founded, the leading art book publishing house in England was the Phaidon Press, established by Neurath's fellow Viennese refugee, Bela Horovitz, who had transferred his already existing business to London in 1938. His books were of the conventional kind, separating text and plates and rarely using colour.

The Neuraths, having established the integration of text and illustrations, also pioneered the use of a much higher proportion of colour illustration, which, because of its greater engraving and printing costs, was a brave thing to do in the 1950s. Today it is standard practice.

Neurath invariably planned his books on an Anglo-American axis but also aimed at the European market, producing books which were simultaneously translated into the principal Western European languages and printed for publishers in these languages, but also, provided that the subject was sufficiently accessible, in Dutch, Finnish and the three Scandinavian languages. Eventually even the problem of publishing key illustrated and design-led books such as Herbert Read's *A Concise History of Modern Painting* in Japanese was mastered.

Read's volume was part of a series, the *World of Art*, which was to be, and still is, one of the mainstays of the list. Neurath was the first publisher not only to produce art books at readily affordable prices – a *World of Art* title with copious colour illustrations would, typically, cost no more than a decent biography – but he was also the first to foresee the rise of the high quality original paperback. By putting the *World of Art* into paperback form, he could issue the books at prices which fitted student budgets. The best titles in the series, such as the Read or Michael Levey's *From Giotto to Cézanne: A History of Western Painting* (which had over 500 colour illustrations), went on student reading lists all over the world, in as many as twenty languages, and sold by the hundreds of thousands.

This had as powerful an impact on international art education as Allen Lane's Penguins had in making the possession, as opposed to the library borrowing, of literature, biography, etc. open to all, regardless of income – a point once made appreciatively to Neurath by Lane himself.

Neurath also published, on the same principles of international co-production, in the fields of architecture, photography, archaeology and history. Distinguished scholars responded to his enthusiasm, to the prospect of escaping the confines of a university press, to the idea of seeing their words sensitively illustrated by staff picture researchers who had studied their own disciplines and, above all, to having their work reach an international market not normally available to them.

Neurath had a considerable persuasive gift in attracting the leading figures in their subjects. Historians such as H. R. Trevor-Roper, Asa Briggs and A. J. P. Taylor were happy to join their art-historical colleagues in these ventures. When Neurath got Glyn Daniel, then the Editor of *Antiquity* to edit for Thames & Hudson a new series of archaeological books called *Ancient Peoples and Places*, neither could have foreseen the publication, over half a century, of more than 100 titles.

Never a man to forget a favour, Neurath engaged Richard Cowell, the man who had arranged his release from internment, as a consultant editor, and he created a successful series of books on the classics entitled *Aspects of Greek and Roman Life*.

One of the keys to the success of Thames & Hudson was the use of open-ended series to build up in the public the collecting spirit, so that once interested in, say, archaeology the aficionado would buy every new volume in the *Ancient People and Places* series as it appeared. Anyone who wanted to build an art library could do a lot worse than buy every single volume in the *World of Art* series, whose familiar black livery ushered in over 300 titles, of which over 180 are in print at any one time – a

formidable tree to have grown from the acorn of the original volume on Picasso, bound in real cloth, at thirty-two shillings and sixpence, with hundreds of illustrations, many of them in colour. This series mentality is a classic European concept, which can lead to a certain intellectual rigidity, something of which one could never accuse the Neuraths.

Indeed among the great series and the welter of colour there were many important books which, virtually unadorned by illustrations even in black and white, made substantial individual impacts. Apart from Bettelheim's *The Informed Heart* there were Gordon Rattray Taylor's immensely influential *Sex in History* and two titles that entered the English language: Michael Young's *The Rise of the Meritocracy* and Milovan Djilas's *The New Class*.

Like every publisher, Thames & Hudson made mistakes, but they were less financially damaging than in general publishing. In the first place, while Thames & Hudson always pays its authors royalties and does so promptly, it does not go in for the grotesque and unearnable advances which have bedevilled general trade publishing in the last thirty or so years. Furthermore, because the books are so beautiful, if they have to be remaindered, there is a strong likelihood that anything from 15 to 20% of the original retail price can be recovered, as opposed to the wretched sums of a few pence paid by remainder dealers for unsuccessful fiction or general books.

*

Walter was, as one might expect, a connoisseur of art. He was often the first publisher to recognize the talents of new artists, and published the first books on painters such as Sidney Nolan, Arthur Boyd, Jackson Pollock and many more. He also had an enviable collection of drawings by Egon Schiele and works by Oscar Kokoschka, who was a lifelong friend as well as author.

He and Eva built a beautiful house in Tuscany (long before Chiantishire was invented) called 'Dolphin Villa' (the emblem of the firm is a dolphin), and lived in a fine 18th-century house in Highgate Village, London.

On September 26, 1967, aged only sixty-three, Walter succumbed to cancer, which he had fought heroically for many months, working to the last to ensure that the substantial business he had created would continue without him but on the principles he had established. His widow Eva became Chairman, his son Thomas Managing Director and his daughter Constance a Director. He was buried in Highgate Cemetery, not far from

the grave of Karl Marx, to whom he always granted a certain sceptical admiration.

Walter was a tall, strongly built man who, with his heavy beetle brows and glasses which partially concealed intense, deep-set blue eyes, could be saturnine in repose but, when energized, became formidable, immensely charming and indeed lovable. Almost until his death, the working day began with all the departmental heads assembled in his office, to be confronted by their own piles of the day's post, opened by the office manager (for the early years his ex-brother-in-law Fred Kruk), and already read by Walter, who would comment and question all present volubly in an English which, although his second language, was sharply elegant and larded with telling neologisms. 'This book', he would proclaim of the occasional failed title, 'has not been published. It has been *privished.*' Of another: 'It's been published to the *exclusion* of the public.'

A generous and supportive employer, he could be quick to anger but the explosions were soon over. He did, however, have an almost phobic inability to say 'Well done' to a subordinate or colleague. On one occasion, when one of his staff had just pulled off a considerable commercial coup, he asked what currency had been used for the transaction. On being told that it was in sterling on the day that the Germans had just massively revalued their currency, his only comment was: 'What a pity you didn't do the deal in Deutschmarks.' An hour later the employee was summoned, given an immediate rise and a significant sum to be used to buy paintings.

After his death, Thames & Hudson endowed an annual Walter Neurath Memorial Lecture, first at Birkbeck College in the University of London and then at the National Gallery. The lecture was always published as an illustrated book and, for the first thirty years at least, was delivered by a scholar who had been published personally by him. The Lecture as well as the continuing publishing house are a fitting memorial to one of the many German-speaking Jewish refugees who had such a deep influence on English cultural life. He was, a little shamefully perhaps, awarded no English decoration, but his native Austria gave him the Goldene Ehrenzeichen, the approximate equivalent of the Commander of the British Empire.

Eva happily lived to be over ninety and remained Chairman of the firm until her death on December 27, 1999. She too is buried in Highgate Cemetery.

*

Eva's extraordinary skills in the making of beautiful books helped to attract from art historians and other scholars the respect and empathy that enabled institutions as fussy as Trinity College, Dublin, or the town fathers of Bayeux to entrust to Thames & Hudson such treasures as *The Book of Kells* (1974) and *The Bayeux Tapestry* (1985) for faithful reproduction, flawless design, scholarly text and responsible publication throughout the world.

Eva was deeply involved with H. C. Robbins Landon's monumental five-volume biography of Haydn, one of the musicological wonders of the publishing world, and the sumptuous and ravishing photographic works of Roloff Beny. She was immensely gifted in her handling of authors and artists, whether they were Europe's leading painters and sculptors, notoriously difficult photographers, archaeologists more at home in a trench than a drawing room, or prima donna-ish art historians. To the hard-working, serious professionals good enough not to have to practise the arcane arts of being difficult, such as Herbert Read or Glyn Daniel, she gave a level of intellectual and social support which made her an ideal publisher and companion.

The villa in Tuscany and the house in Highgate were wonderful centres of intellectual hospitality. No Bloomsbury nonsense of high thinking and plain living. Eva had taken up cooking in her later years, partly to entertain her three grandchildren and five great-grandchildren, as well as her friends. The food and wine and the walls covered with paintings by Kokoschka or Arthur Boyd were all as good as the talk – which was very good indeed.

Even in her late eighties, authors would visit her as much at Highgate as in her office. She and Evelyn Silber worked in the house over an entire weekend to perfect the book on Gaudier-Brzeska published in 1996. It's hard to believe that for two decades she had trouble with her eyes and, for the last years, significant heart trouble. Yet her sense of visual detail never deserted her and her social vivacity always belied the fact that she was a very old lady.

A woman of beguiling charm and beauty; always conscious of fashion but without being a slave to it, she had impeccable taste and style. Only once did her sartorial instincts go wrong – and that wasn't her fault. In the days of the Shah of Iran, Roloff Beny created one of his richest photographic albums and he and Eva went to Tehran to present the first copy to the monarch. Eva did not like hats so did not possess any. Feeling, however, that a hat would be *de rigueur* at the Court of the Shah and, flying via Paris, she went shopping but failed to find anything to her

liking. Having also failed at improvization with scarves back in her hotel, she finally bought what she considered to be the only acceptable hat in the whole of Faubourg St Honoré. When they assembled at Court, awaiting the arrival of the Shah, she was horrified to realize, as the Shah's wife swept in, that she was wearing the same hat. Eva ducked behind two tall courtiers and embarrassment was avoided.

Like all of us she had her foibles, among which was an unwarrantably strong belief in graphology and an insistence on studying the handwriting of job applicants. I think it was I who got more pleasure out of the standing joke between us that if my job application in the 50s had not been typed, I never would have been hired.

Her prodigious charm was allied to an entirely original mind, well-stocked with everything from Jungian analysis to the contents of the world's museums. While she always regretted her lack of a formal education, her demeanour and conversation belied it. In forty years of knowing her, I never heard her emit a single received idea. Cliché and platitude were anathema to her. You had to be constantly alert to keep up – and all this in a second language which she had had to learn as an adult.

The world of publishing is very fortunate that she was born in the last century and allowed to work as she did. Had she been born in the 19th century she would have been merely a great hostess, but what a salon she would have provided. One cannot doubt that she could have made great careers and toppled governments had she turned her mind to it.

As it is, she represents that pinnacle of German/Jewish culture and civilization which Hitler either destroyed or drove away. Ironically she and others like her proceeded to enhance the culture and civilization of the countries which gave them refuge. She was a great publisher and a remarkable woman, never dauntingly overwhelming as she might have been but always endearingly enchanting.

After Walter's death the firm continued to expand under his son Thomas and daughter Constance, as well as with Eva's guidance, and had its own enviably efficient warehouse and distribution centre in Farnborough. It also has a wholly owned subsidiary in Australia, a Paris office and a distribution company in America.

The senior Neuraths' legacy of art, architecture, photography and archaeology has been steadily expanded and built on. There has been a solid expansion in crafts and design books. The *Hip Hotels* series has been a glamorous as well as a profitable adjunct to the core publishing activity. But, overall, the house has expanded and flourished entirely in the mould created by Walter and Eva in 1949. One of Eva's last major

public appearances was to preside over the dazzling Thames & Hudson 50th Anniversary party at the National Gallery in London. Throughout that time, as conglomerates have grown and publishing has become ever more impersonal, it is a joy to be able to salute so distinguished a private family business and to wish it at least a further fifty happy and successful years.

This essay first appeared in the publishing journal Logos *in Volume 15 in 2004 and was subsequently collected and published in book form in* Immigrant Publishers: The Impact of Expatriate Publishers in Britain and America in the Twentieth Century, *edited by Richard Abel and Gordon Graham by Transaction Publishers in 2009.*

ON ANTI-SEMITISM IN BRITAIN

The son of German Jewish refugees, Tom Rosenthal has flourished in Britain, despite the 'little hurts' of anti-semitism. Here he recalls his experiences including a disturbing comment from the head of the Race Relations Board.

It was my first day, at my first job, in 1959, as assistant sales manager at a Jewish-owned publishing house in London. My non-Jewish boss, an immensely affable man, welcomed me to the book trade and told me that while I would never get rich I would, if I succeeded, have a moderately comfortable and highly civilised existence. As he put it, I would never have a Rolls-Royce but I might aspire to a Rover or a Jaguar, 'the Jewboy's Bentley'.

I was, to use an idiom then not in use, gobsmacked. This was clearly not the time to remonstrate so I let it ride. My boss was in fact married to a German Jew and we became sufficiently close friends that he asked me to become his executor should he die before his children became adults. But if he could use a phrase like that, to me, without either quotation marks or blushing, then perhaps English anti-Semitism was more pervasive and entrenched than I thought.

Although born in England, I was the child of German Jewish refugees who had fled Hitler in 1933. Via scholarships, I went to a good school and to Cambridge, had a commission in the Army during National Service, and went to work. I was 24 and I thought that I had come to terms with being different –having a foreign name, not eating bacon, being assimilated yet still being a stranger. I had had the satisfaction of being that peculiarly English middle-class creature, an Army officer.

At Cambridge, I had had a tiny triumph. In those days, the ultimate for arty types was the BBC general traineeship, of which there were then only five a year for the entire graduating population of all Britain's universities. I got the first one awarded that year and turned it down because a publishing opportunity had occurred and books won over broadcasting. But the offer of such a much-prized Establishment job made me feel confident, for the first time, that being a German Jew seemed not to matter and that England was a wonderfully tolerant country. It had, after all, enabled me to be born in the first place and it looked as if my origins and my religion really did not count.

But that casual, almost innocent, remark about cars just a few weeks after I had thought myself cured of my Jewish paranoia made me not only replay episodes from my Jewish past but made me alert – perhaps too alert – to those niggling little events in my life and the frequent biting

This article first appeared in The Daily Telegraph *of Saturday May 16th 1998.*

of my tongue. It is relatively easy to deal with the man who calls you a
'****ing Yid'"to your face. You have a simple choice then. You can fight
him physically, you can fight him with words, or you can walk away. But
at least that man is an overt enemy; he is beyond the pale in all senses.

What's difficult is coping, when you are 10, with your non-Jewish
best friend's mother. This jolly Northern woman once fed me a high
tea of thinly sliced cold pork, letting me believe it was chicken. When I
reached my intellectual peak a few months later and got a scholarship to
Manchester Grammar School, she congratulated me sincerely with the
words: 'Oh, you lucky Jew.' Even at 10, that is harder than dealing with
the boys who, when I was one of only two Jews in a Manchester primary
school, used to chase me home shouting, in the middle of the war: 'Dirty
Jew, dirty Jew.'

On learning of this, my father, a mild scholar, sought the advice of
the rabbi and we were both summoned to visit the synagogue militant.
The rabbi, a splendid, bearded patriarch, introduced me to a young giant
in a blue uniform. 'This is my son', he said. 'He's a physical-training
instructor in the Royal Air Force. He'll take you next door and show you
what to do.' Which he did.

When the ringleader of the juvenile pogrom in the playground of
Beaver Road Primary School started on me again, I so surprised him by
retaliating at all that a lucky blow drew blood from his nose and, after the
only fistfight of my life, I was left alone.

My next school, the wonderfully eccentric day preparatory school for
which my parents made great financial sacrifices and which propelled
me to that Manchester Grammar School scholarship, obeyed my
father's injunction that I was not to attend religious instruction. I would
therefore, if the weather was fine, sit in the playground and read a book
for 40 minutes.

One day the playground door burst open and I was surrounded by
15 of my peers shouting at me in a quite terrifying unison: 'Christ killer!
Christ killer!' I was not only frightened but puzzled. What had I done and
to whom? Only Kafka could do justice to such a scene. No wonder Jews
tend to paranoia.

I think it was then, when my ever-patient father, after expostulating
about ignorant goyim, explained the basics of Christian theology to me,
that I got my next and infinitely more important lesson from him.

Why, after I had learned all about the Crucifixion, I asked him, didn't
he change our name as so many other Jews had done? Already in those
days I knew about the Cohens who had become Cowan and even, a

minor celebrity in the region, a Rosenfeld who had become Ross-Enfield. In words that, at an appropriate time, I passed on to both our sons, he explained that the family could trace its lineage back for at least 300 years, that it was the name under which he had published, in both Germany and England, his early scholarly books and articles, and that it was also a beautiful name – 'valley of roses'. I never raised the subject again.

In the Army, it was not considered a beautiful name, except by sadistic drill sergeants to whom it was beautiful only as a springboard for the creative, screaming invective hurled at those pathetic creatures who could not march properly. (At Officer Cadet School I had to be carefully hidden in the middle of any marching group.) Apart from the usual insults such as 'Pregnant fairy', I was named, in a full sexual gamut, either 'Frozenballs' or 'Risingtool'. But in the ritualistic breaking and making of all soldiers everywhere, it was the name that gave the game away.

In my barrack room, where I first heard the phrases 'Jewed him out of it' and 'Jewed him down', I was one of two Jews and one of eight potential officers who passed the Unit Selection Board, which enabled us to go on to the three-day test called a War Office Selection Board. Six went a few days later. The two Jews were held back a fortnight.

In all fairness, not even the most paranoid Jew could construe this as anti-Semitism. We both had foreign names and parents born in Germany. Thus, the same sort of people who had cheerfully dispatched art historians and violin virtuosi to internment camps on the Isle of Man during the early days of the Second World War were simply using the extra two weeks to check on a couple of 18-year-olds as security risks.

I survived Mons Officer Cadet School and got a much-coveted overseas posting, in this case Malta. A single pip on each epaulette made me absurdly proud and went some way to reducing the weight of the various chips on the shoulder I had by then accumulated. Or so it seemed until one afternoon.

The bachelor National Service second-lieutenants were having afternoon tea in the mess. As we were all in temporary exile, talk turned to life at home and then focused on siblings. One said that he had a sister out in Kenya, something that rather worried his father, who was concerned that she 'might do something silly, like marrying a Jew or a Nigger'.

I remained silent and, I trust, inscrutable. I waited for 10 minutes or so and then asked this genuinely charming fellow if, by the way, he would be terribly upset if his sister married me. 'Of course not. Jolly good idea, actually. Why do you ask?' So I told him. I think his consternation was genuine. He replied convincingly that he had no idea I was Jewish.

I said that with a name and a nose like mine it must surely be obvious. He denied it. The episode passed and we continued to enjoy each other's company.

As my responsibilities in publishing grew, I found myself working with Arnold Toynbee, and proudly told my father of my modest and entirely peripheral association with the sage. My father was much less impressed than I was. 'That anti-Semite!' I was stunned and accused him of being intolerant. He then explained that Toynbee's anti-Semitism was not of the jackboot variety but was an erroneous but carefully reasoned argument to the effect that the Jews were actually an inferior civilisation and culture compared with the Christians and the Arabs. So I felt thoroughly chastened; a case of guilt by association.

A few days after this paternal rebuke, I received Toynbee's introductory essay to a symposium called *The Crucible of Christianity* that he was editing. It contained the phrase, 'the Jews, for so long having practised a policy of apartheid'. I was barely 30 and the sage was nearly 80, but I gritted my teeth and spent several hours drafting a letter, which I would hate to have to reread today, composed more or less equally of flattery and egregious circumlocution.

The nub of it was that, given the universal abhorrence among right-thinking people for the current South African regime – this was in the late Sixties – he himself would surely be attacked for such an association. Could he not perhaps use an expression such as 'separateness' or 'otherness', without in any way compromising his opinion? To do him credit, he immediately and graciously thanked me for saving him from error and amended the phrase.

Oddly enough, one of my other experiences of the subtleties of middle- and upper-class English anti-Semitism arose out of my no doubt absurd love of cricket. I was lunching with Mark Bonham-Carter, a remarkable man who was a life peer, the first chairman of the Race Relations Board, a vice-chairman of the BBC and a grandson of a prime minister, Asquith. I was expanding on some arcane cricketing issue of the day and he mused: 'It's a funny thing about you people.'

I froze. I hadn't encountered that phrase before, except in the pages of Philip Roth. Very quietly, I asked: 'You people?'

'Well, you know, Harold Pinter, Tom Stoppard, you, lots of you. You all seem to be so keen on cricket', he said in a faintly surprised tone, not entirely unlike someone noticing that we were all wife-beaters or worse.

For once, the *mot d'escalier* came when it was needed. 'Of course', I said. 'And there's old Siegfried Sassoon as well. He was a Jew once

upon a time, before he became a country gentleman with his own cricket team. I suppose it's because we're all so desperate to win the approval of you people.' The silence was long. The colour of his complexion changed visibly, but he did not insult either of us by apologising or explaining.

Contact remained unbroken and our last encounter was when, as chairman of an appeal for the London Library to set up a T. S. Eliot fund, he sent to me, in my capacity as head of a publishing house, a formal letter asking for money. I replied that I had the greatest respect for him, the library and Eliot's poetry, but that as he was a former chairman of the Race Relations Board I knew he would understand that Eliot's appalling anti-Semitism made it impossible for me to contribute.

I dare say he had by then classified me as one of those chippy, over-sensitive Jews, always on the lookout for slights. Perhaps that is what I always was; still am. Perhaps that is why I am writing this as a way of ridding myself of all those little hurts. Clearly, I would not remember them with such clarity and doubtless tedious total recall over a period of more than 50 years if they had all merely bounced off a thick skin. In mitigation, I can only say that it is a fairly heavy load to bear as a child, whether you are the 'Dirty Jew' of Beaver Road Primary School or the 'Christ killer' of Moor Allerton Preparatory School. And the child is the father...

When I started to write this, Isaiah Berlin was alive, so that five Jews, i.e. nearly a quarter of the statutory limit of no more than 24 members, were holders of the Order of Merit. We have recently lost a Jewish Lord Chief Justice and, as the importance of state religion in general and the Church of England in particular wanes, it is probably only a matter of time before we have a Jewish Prime Minister who can get his Home Secretary or Lord Chancellor to appoint the bishops.

In other words, we should draw a distinction between anti-Semitism and discrimination against Jews. If asked whether there is discrimination, I would confidently say no. If asked about deeply held racial prejudice, which still pops up in the most surprising circumstances, I would have to say yes.

So, am I surprised by those, in the broad scheme of things, rather petty little anti-Semitic episodes as experienced by me? Given the hindsight of 60 odd years, no. Was I upset by them? Manifestly, yes, although, with the passing of the years, one can begin to laugh as well as cry. Will this sort of thing ever disappear? Certainly not in my or my sons' lifetimes.

Was I personally ever discriminated against? I can only answer no. In that archetypal Jewish phrase, I mustn't grumble. But if I have grumbled

at length about my experiences of anti-Semitism, it is because I believe it is still out there, inbred and lurking in the thickets of the essential English character, not necessarily intended to wound, not necessarily entirely innocent either.

MATTHEW HODGART

Matthew John Caldwell Hodgart was born in Paisley in 1916 of a well-known Scottish family of engineers and lawyers. He came up to Pembroke College, Cambridge, as a Scholar from Rugby in 1935 and after a distinguished academic undergraduate career began research with the award of a Jebb Studentship in 1938. By then, like most of his generation, he had a distinct leaning to the left. He was an active debater at the Union from a strongly leftist stance and was a member of the Apostles. It was certainly part of the Hodgart mythology in the late fifties that my rooms, L1, when he occupied them, were a major storehouse and collecting point for supplies to the beleaguered Republicans during the Spanish Civil War.

By 1939 he became a more active soldier. He joined up early because his father, whom he had never known, was killed in France in World War I. He was commissioned into the Argyll and Sutherland Highlanders and had a characteristically idiosyncratic and distinguished war, serving with Intelligence and various clandestine outfits in French North Africa, Corsica, and India. Mentioned in despatches, he was awarded by the French government both the Croix de Guerre and the Légion d'Honneur.

After the war, he was appointed as University Assistant Lecturer in English, and in 1949 he became a Lecturer and was appointed a Fellow of Pembroke. He proved a most effective Director of Studies in English.

Some dons are born scholars and others born teachers. Hodgart, happily, was both. As befitted a Scotsman, he was a great authority on ballads; as befitted a fellow countryman of Boswell's, a noted Johnsonian, whose services to the Doctor's reputation resulted in his presidency of the Johnson Club of Lichfield. More important, and of much greater interest to him, was his membership of the Johnson Club of London, where learned papers were read by academics and other interesting students of Johnson, of whom, of course, he was one. There were indeed many affinities between Hodgart and Johnson, for Matthew was a considerable wit, a master of aphorism, and, while never fat, a pleasantly rounded man who certainly had bottom.

He was also, in a completely unshowy way, a man of considerable erudition. The only time I ever heard him utter anything remotely boastful was when, apropos of the extraordinary critical and commercial success of Colin Wilson's *The Outsider*, he maintained that he had stopped reading it after he had noted more than 200 misquotations and errors of fact.

Sadly for Pembroke, he left Cambridge in 1964 when his friend and former Cambridge colleague David Daiches lured him to the University of Sussex with a chair. He left Brighton for a lucrative part-time chair in

This obituary appeared in Number 70, the September 1996 issue of the Pembroke College Gazette.

Canada and became mildly peripatetic, with visiting chairs at U.C.L.A.,
Stanford, La Trobe, Cornell, Johns Hopkins, and other places, but always
kept his beautiful Regency-style house in Brighton.

One of his obituarists suggested that he had moved far to the right
politically, but this is perhaps a misperception. As they say in America, a
conservative is a liberal who's been mugged, and Matthew's quintessential
liberalism, both academic and human, was sorely tried during his second
stint at Cornell, in the world-wide aftermath of *les événements de 68*. That
was a scoundrel time indeed. I remember my father, himself a Fellow of
Pembroke, when he took his sabbatical as a Visiting Professor at Columbia,
silencing his new and temporary colleagues by saying that he refused to
be denied access to his college office by students or campus police: it
had been done to him once, by Adolf Hitler, and wasn't going to happen
again. Matthew had it much worse at Cornell, where he got caught up in
the academic madness of Affirmative Action; the Architectural Faculty
frantically admitted students who could neither draw nor comprehend
the equivalent of A-level maths, solely on the grounds that they were
deprived blacks.

Architecture's loss was happily literature's gain. Not for nothing was
Matthew Hodgart an acknowledged authority on satire. While his works
on ballads, Dr Johnson, and other obviously more academic topics were
widely and properly respected, many will remember him for two things
in particular: his contributions to the ever proliferating studies of James
Joyce, and his *A voyage to the country of the Houyhnhnms, being the fifth part
of the travels into several remote parts of the world by Lemuel Gulliver, first
a surgeon and then a captain of several ships, wherein the author returns and
finds a new state of liberal Horses and revolting Yahoos; from an unpublished
manuscript, edited, with notes, by Matthew Hodgart, M.A., sometime Fellow
of Pembroke College, Cambridge.* To attempt, as a twentieth-century satire,
a pastiche of one of the greatest satirical works in our language, is at worst
folly and at best hubris, but Matthew rode the two horses of homage
and rage with wondrous skill. Re-reading his ninety-page squib of 1969
today, when the idiocies of Affirmative Action have been replaced by
the horrors of Political Correctness, is a salutary as well as a pleasurable
experience. What dweller in the groves of academe could fail to respond
to this passage?

> The Master began by making a general Oration about Progress, Liberty and
> the Need for Compromise, which was greeted with no little Applause. When
> he had finished without saying anything about the recent Happenings, the
> Dapple-Grey asked him just what the Yahoos had been trying to say. The

Master replied that the precise Meaning mattered not, but he felt that they had had a meaningful Dialogue.

Hodgart's *Fifth voyage* belongs with F. M. Cornford's *Microcosmographia academica* as one of the great satires on academic conduct.

One of the more ridiculous aspects of the plethora of mainly time-serving and promotion-seeking effusions called James Joyce scholarship is that, while Joyce was a mimic of genius, the majority of his would-be exegetes have manifestly got tin ears. Not so M. J. C. Hodgart, whose seeking out of the musical sources of so many of Joyce's best lines was a delightful work of genuine scholarship, as seductive to listen to in the radio programmes he did for the BBC. as fascinating in the later publications. Sadly, he died before he could see in print what Joycean operaphiles (doubtless a very small group, but this obituarist is one of them) will regard as a seminal work: his collaboration with Ruth Bauerle, *Joyce's great operoar: opera in Finnegans Wake*.

How fitting it was that instead of a memorial service there was a memorial seminar held for Matthew in Brighton on June 15th, the closest the organizers could get to Bloomsday!

Matthew was a great college man. Apart from his academic duties, he was a most knowledgeable and conscientious Wine Steward, devoting entire long vacations to studying the college cellar's sources of supply on the spot, particularly in Burgundy and Germany, in pursuit of hock. Without making an obnoxious fuss about it, he was very Scottish indeed and proud of it and particularly enjoyed Burns Night dinners, not least when James Campbell played the bagpipes. He was also for some years Librarian, when he had to cope with the pathological ingratitude of one of his star pupils, whom he also taught to drive so that he would qualify for a certain rural teaching job. This man, who owed the job to him, subsequently repaid his trust by vandalizing various Speed and Ackerman volumes in the library, and, no doubt subconsciously wishing to be caught, sold the torn out maps and prints to the local antiquarian shops. Matthew, as teacher, thus sent out into the world the only Pembroke man in living memory to be removed from the college list.

Fortunately, he had more notable and reliable pupils, including Ted Hughes, the polymathic American academic Harold Bloom, and Bob Gottlieb, the former head of the American publishing house Alfred A. Knopf and editor of the *New Yorker*, and many more. He always had a particular affinity for bright Americans, and, the Cornell débâcle apart, this was reflected in the American academic appreciations of his often Johnsonian qualities as teacher, researcher, and intellectual catalyst.

His first wife, Betty Henstridge, by whom he had a daughter and a son who went to Pembroke, died in 1948, and in 1949 he married Patricia Elliott, who although not a university teacher was an elegant and much sought after supervisor in English and whose daughter he adopted.

The best dons, certainly of that period, were a combination of Grand Inquisitor and surrogate father. That was certainly true of Matthew, who could, and would, stretch one's mind on the rack of his own huge intellect, so that it would do things it did not know it could do, and thus did one truly learn from him. But it was always done with courtesy, sherry, or more likely some interesting wine he was forced to test during his onerous duties as Wine Steward and, if one was lucky, at the ever hospitable Hodgart table in Milton Road.

Rarely has that old cliché about the privilege of knowing such a man been more true. He really was a most distinguished and most delightful part of Pembroke life.

442697